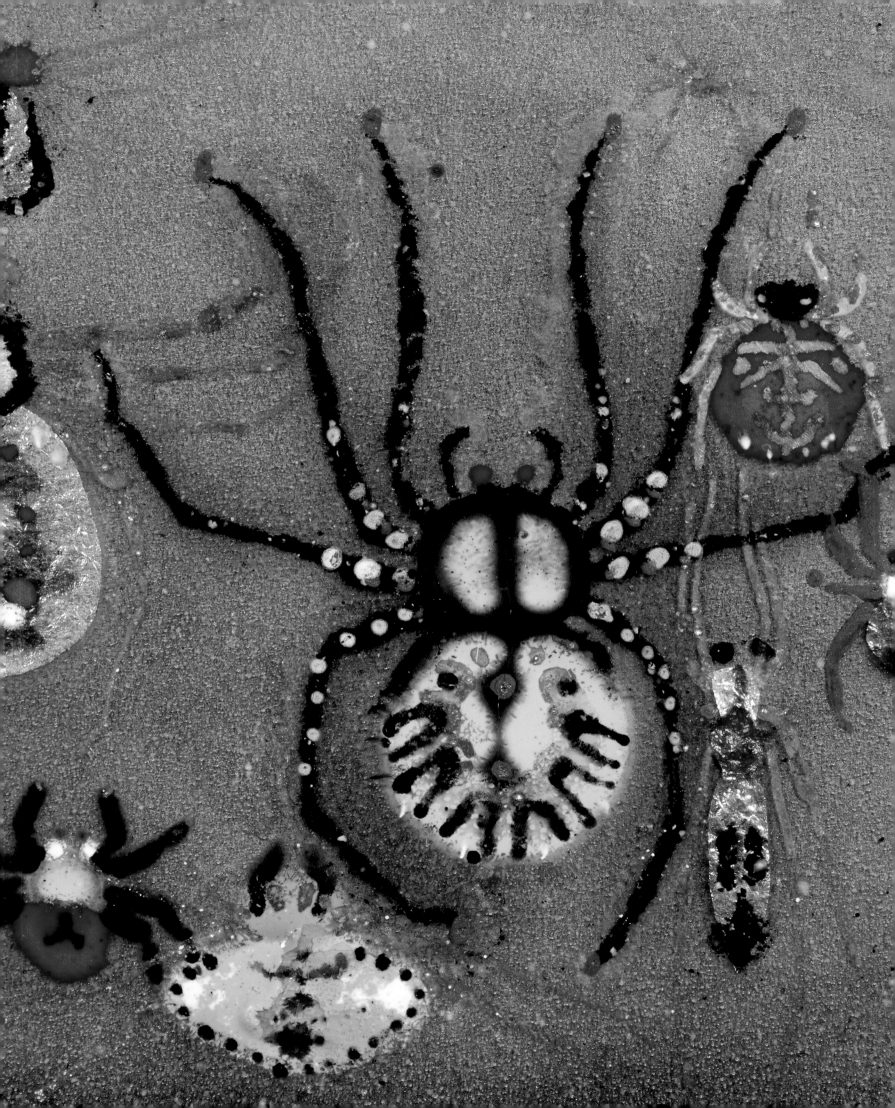

# Little Dreams in Glass and Metal

## ENAMELING IN AMERICA, 1920 TO THE PRESENT

Bernard N. Jazzar and Harold B. Nelson

From the collection of the

**ENAMEL ARTS FOUNDATION**

Los Angeles, California

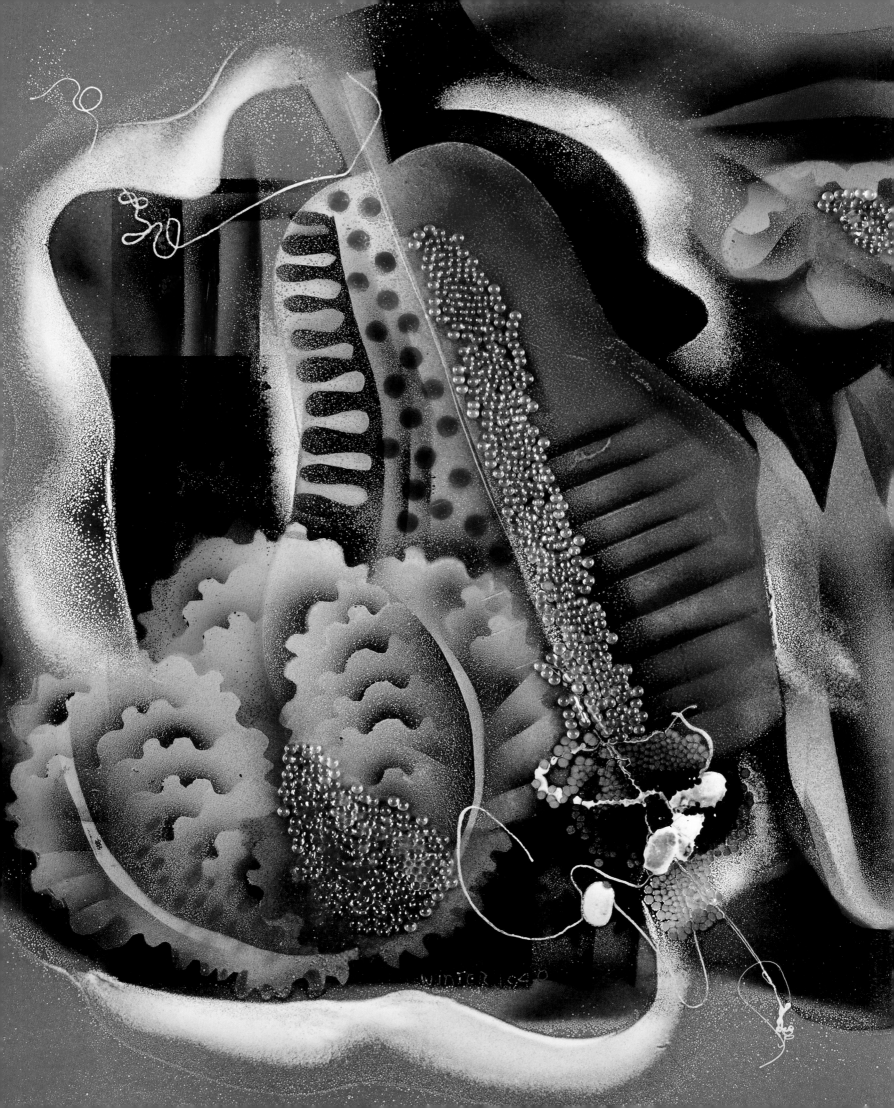

# Acknowledgments

NO PROJECT OF THIS SCOPE COULD TAKE PLACE without the encouragement of numerous individuals and organizations. We want to take this opportunity to thank all those who have helped make this exhibition and its publication a reality.

First we want to acknowledge the members of the board of the Enamel Arts Foundation for their dedication. They include Susan E. "Beth" Coccari, Marianne Hunter, Harold "Jack" Jackson, and Steve McLeod. Their support has been immensely encouraging to us as we worked on this project.

We also want to express our most sincere gratitude to the sponsors who helped make *Little Dreams* possible: the Windgate Charitable Foundation, the McLeod Family Foundation, and numerous individual donors including Eva and Nagib Antonios, Jerry Castillo, Beth and Gregg Coccari, Harold Jackson and T Santora, Vicki Mathieu, Ilene Resnick-Weiss and Daniel Weiss, Roll Giving, and Farrel and Lori Stevins.

We wish to acknowledge our colleagues at the museums on the tour including Jonathan Fairbanks, Beth McLaughlin, Michael McMillan, Casandra Ortiz, Joseph Cronin, and Titilayo Ngwenya at the Fuller Craft Museum; Suzanne Iskin, Sasha Ali, Holly Jerger, and Lynn LaManna at the Craft and Folk Art Museum, Los Angeles; Lial Jones, Scott Shields, John Caswell, Kristina Gilmore, Maria Robinson, and David Separovich at the Crocker Art Museum; and Todd Herman, Brian Lang, and Thom Hall at the Arkansas Arts Center.

Our research on the twentieth-century enamels field has been aided by numerous individuals including Lisa Seguin Cantini, Steve Casagranda, Oliver Drerup, Mel Druin, Jeannine Falino, Dave Hampton, Jean Hasselschwert, Bartley Jeffery, Mary MacNaughton, Tom Madden, Shirley Rabe Masinter, Julie McMaster, Jane Port, Marbeth Schon, Judy Stone, Susan Willoughby, and John Zeitner. We are especially grateful to Jessica Shaykett, librarian at the American Craft Council, for her kind assistance throughout this project.

We want to acknowledge a number of individuals who helped us with the technical and logistical preparations for the tour. They include Kathleen Brzezinski, Kevin Dosch, Paul Gordon, Andrea Grayson, Ron Jones, Jim Kovacich, Jairo Ramirez, Brant Ritter, Lou Uhler, Donna Williams, and at Capital Art and Frames, Amos Friedman.

We are further indebted to Julia Henshaw for her sensitive editing of this book and to Ron Shore of Shore Design for his superb publication design. We are also grateful to Charles Grench and his colleagues at the University of North Carolina Press for managing the myriad details associated with the book's distribution.

We especially want to thank the artists who have so generously shared their time, insight, and the beauty of their work with us as we pursued our research on the past history and future of this glorious field.

Finally, we want to thank our family and friends who have supported and encouraged our passion for this field for many years. It is to them we dedicate this exhibition and its accompanying publication.

Bernard N. Jazzar and Harold B. Nelson
Enamel Arts Foundation, Los Angeles

# Foreword

ENAMELING, THE ART OF FUSING GLASS TO METAL through a high temperature firing process, gained widespread popularity in the United States in the second half of the twentieth century. With its foundations in long-standing cultural traditions and practices, enameling today has emerged as a vibrant form of contemporary art.

We first became fascinated with enamels about twenty years ago when we started noticing these remarkable visually alluring pieces—plates, plaques, bowls, and enticing sculptural forms—on our regular visits to antique shows and consignment shops. We were struck by the beauty and layered depth of these stunning, colorful objects. Out of our own sense of curiosity—and drawing on our training as curators and art historians—we wanted to know more about who made these works, where they came from, and the circumstances under which they were admired, collected, and exhibited. As we began to seek answers to our many questions, we discovered that there was very little information published on the subject. Undaunted, we continued our detective work. Whenever we learned that a museum had enamels in its collection, we made arrangements to travel to that city—from New York and Cleveland to Wichita and San Diego. On these trips, we visited fellow curators and, with their encouragement and support, we researched, measured, photographed, and documented their enamel collections. We also met collectors as well as respected enamelists and their families from whom we learned about the process of enameling and about the history of the field. Over time we built an extensive archive on twentieth-century enamels which has become the basis for our research and subsequent publications.

We discovered through the course of our explorations that Cleveland was a major center for enameling in the post-World War II period and that enamels were shown along side ceramics in both the Ceramics National at the Syracuse Museum of Fine Arts and the Scripps Invitational in California. We learned that enamels were a mainstay of the annual Decorative Arts and Ceramics Exhibition at the Wichita Art Association from 1946 until the early 1970s. And we found that major institutions such at the Metropolitan Museum of Art, the Smithsonian American Art Museum, and the Museum of Fine Arts, Boston, along with the Cleveland Museum of Art, had actively exhibited and collected enamels in earlier years and had marvelous examples tucked away in their storage vaults.

Most importantly we met many contemporary artists working with enamel in a wide variety of forms and formats, keeping traditions alive and finding new expressive potential in this extraordinary medium.

While all this was happening, we began to form what has become the largest and most significant collection of American enamels in the United States. In 2007 we established the Enamel Arts Foundation as a non-profit organization to preserve this collection and to make it more accessible to the public through exhibitions, loans, and partnerships. We also wanted to further document the rich, but under-recognized, history of enameling in this country and to acknowledge and record the stories of some of its early leaders. Over the past eight years, in an effort to assure that this art form will be available to future generations, we have donated many of the finest pieces in our personal collection to the foundation. Happily, as more collectors, artists, and enamel enthusiasts learned of our goals, they too have given significant works of art to the foundation to complement our holdings. Their generous contributions are acknowledged throughout this book.

The foundation's overarching goal is to promote awareness, understanding, and appreciation of enameling as a vibrant form of modern art through its collection, exhibitions, and educational programs. In addition to building a strong and representative collection of modern and contemporary enamels, we have developed a content-rich website which serves as a significant educational resource for students, scholars, artists, and the public in general (www.enamelarts.org); sponsored artists, lectures, and seminars; organized exhibitions and related publications; and loaned work to museum exhibitions throughout the country. We are proud that *Little Dreams in Glass and Metal* is the first major touring exhibition organized under the auspices of the Enamel Arts Foundation and we are pleased to document it with this publication.

With one hundred and twenty-two works, ranging in date from 1920 to the present, made by more than ninety artists, *Little Dreams* reflects the remarkable diversity of modern and contemporary enameling in the United States. It also represents the wide variety of forms and formats artists have chosen to explore using this highly versatile medium. More than half of the artists included in *Little Dreams* are women; at least twenty-eight studied or taught in Cleveland; fourteen were born abroad and came to this country in the 1930s to escape Nazi persecution and the impending war in Europe; many studied under the GI Bill after serving in the armed forces during World War II. While sixteen were based in California, others lived in disparate regions of the country from New England to the Pacific Northwest; many were accomplished in other media but chose enameling as their preferred vehicle; eight couples worked collaboratively; and many used enamel as but one tool in their multi-media compositions. The artists' themes are similarly diverse, ranging from traditional still lifes, genre scenes, and religious subjects to abstractions and powerfully evocative explorations of nature, culture, and memory. This impressive array of makers and their equally wide-ranging subjects reflect the dynamic state of enameling in this country in the last half of the twentieth century and the first decades of the twenty-first.

We are pleased to share the works featured here with the public and we hope that this exhibition and book will serve to increase awareness and enjoyment of this immensely exciting field.

Bernard N. Jazzar and Harold B. Nelson
Enamel Arts Foundation, Los Angeles

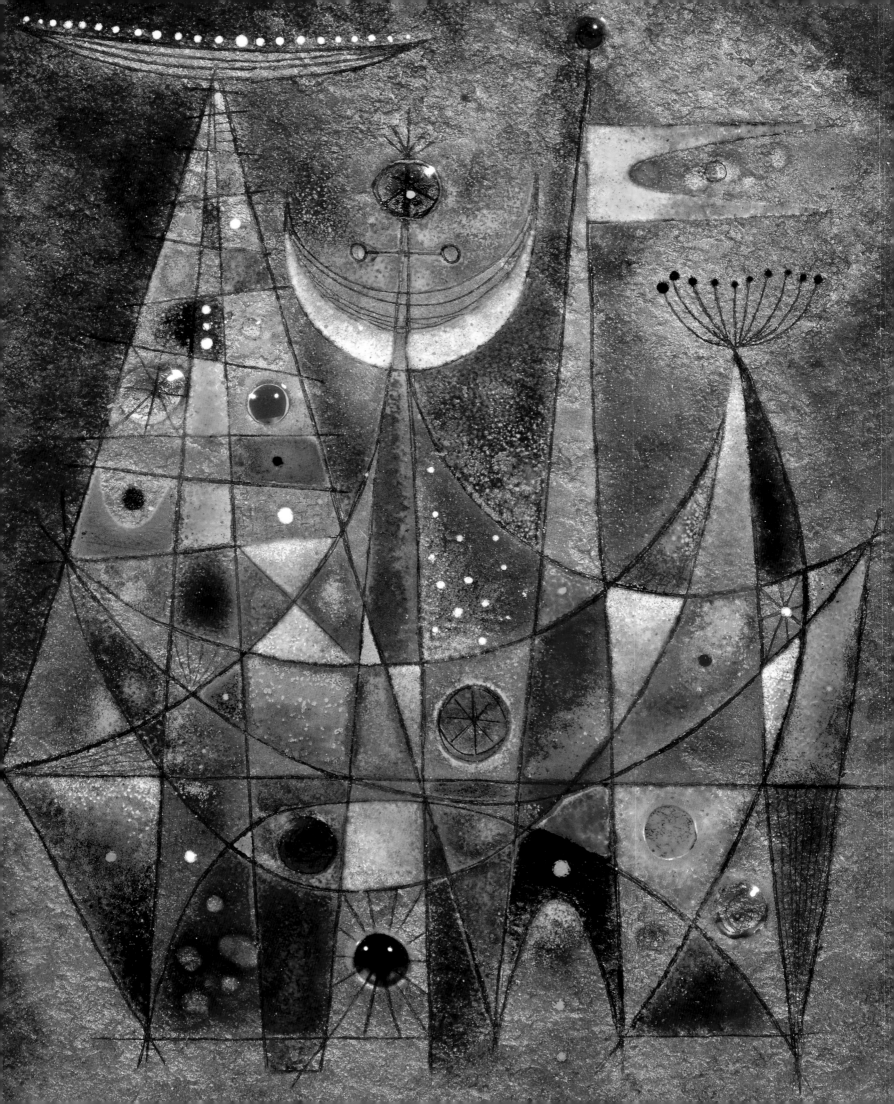

# Little Dreams in Glass and Metal

## ENAMELING IN AMERICA, 1920 TO THE PRESENT

n Christmas Day in 1956 the German-born émigré Karl Drerup wrote a letter from his home in rural New Hampshire to Mr. and Mrs. Richard Smith in Schenectady, New York. His brief note was a reply to a holiday card he had received from the Smiths telling him how delighted they were to be the proud owners of one of his extraordinary enamel plaques. In response to their compliments, Drerup wrote, "It is most gratifying to know that you like my work enough to own it. Over the years so many pieces have left my workbench. I often wonder where they have gone. The more do I appreciate knowing when someone can derive joy from the long hours I spend in making these *little dreams out of glass and metal.*"

Drerup's poignant note touches on several issues of relevance to the mid-twentieth-century enameling field as well as to post-World War II craft in general. As Drerup mentions in his self-effacing remarks, there is something indisputably "dream-like," something undeniably exquisite about enamels. This may have to do with the small, jewel-like size of most early twentieth-century work (although size will change dramatically over time) or it may be the result of the kiln-firing process that magically transforms ground glass into exuberant, brilliant color and lush visual imagery. It may also be a factor of the visual overlapping that occurs when a skilled maker places transparent glass on opaque surfaces to reveal layered images and veils of color lying deep within the body of the enamel. Or it may simply have to do with the nature of the subject matter that many mid-twentieth-century enamelists chose to portray in their compositions.

As Drerup also suggests, for most practitioners of his time, enameling was an isolated and painstakingly laborious activity—something artists spent long hours doing in the confines of their studio. Unlike ceramists or glass-blowers who often share kilns and other equipment with their colleagues, enameling is a relatively solitary activity as both the application of the enamel and the firing can be done in a small, low-fire kiln in the artist's own workspace.

Further, with the development of a market for craft in the postwar period and the proliferation of shops, galleries, and exhibitions from which work was sold, makers became somewhat disengaged from their clients to the extent that as Drerup mused, "I often wonder where they have gone." To makers for whom that human connection was vital, its absence was deeply felt.

Finally, and perhaps most importantly, for many artists, making objects by hand offered a means of carrying venerable traditions forward and of asserting the unique presence of the individual over the ubiquity of machine-made goods. Craft provided a way to express humanist values and a means to connect with another individual through an object lovingly produced by one's own efforts.

*Little Dreams in Glass and Metal* surveys enameling in the United States from 1920 to the present through one hundred twenty-two objects from the Enamel Arts Foundation's permanent collection. Produced by more than ninety artists from all regions of the country, the works featured represent a wide variety of formats—including jewelry, three-dimensional objects, sculpture, and wall-mounted plaques—and a broad array of styles and approaches to the medium. While some artists such as Kenneth F. Bates, John Paul Miller,

and Mary Kretsinger exploit the preciousness of enamel produced at an intimate scale, others such as Fred Ball defy expectations by using non-traditional methods to produce work of a surprisingly monumental size. Also while Kathe Berl, Harold B. Helwig, and Ruth Raemisch create complex visual narratives, others such as Paul Hultberg, June Schwarcz, and Oppi Untracht explore enamel's expressive potential in abstract forms and compositions. As with any medium, much of the work produced during the period of this survey reflects prevailing styles, tastes, and themes from the overarching influence of Cubism seen in the mid-century compositions of Harold Hasselschwert, Zella Eckels Marggraf, and Jackson and Ellamarie Woolley to the gestural energy of Abstract Expressionism seen in the work of Joseph Buzzelli, Paul Hultberg, Richard Loving, and the personal and social explorations of contemporary artists Jessica Calderwood, Mary Chuduk, and Thom Hall.

Naturally, over the course of time the unique voices and visions of artists who have made exceptional contributions to the field emerge. Together the selection featured in *Little Dreams* provides a well-rounded introduction to enameling in America and a meaningful context within which the work of individual makers might be seen and better appreciated.

## The Early Years: Sources and Influences

Artists in the United States first began to explore enameling as an independent form of creative practice between the late 1920s and early 1940s. Throughout this seminal period in American art, artists in disparate regions of the country from coastal New England to the heartland of the Midwest investigated the medium's rich expressive potential while utilizing a variety of techniques, forms, materials, and formats. During these early years in the field's development, three traditions influenced artists working in enamel: the turn-of-the-century Arts and Crafts tradition, particularly the work of the Boston school; the sophisticated abstractions of Viennese modernism; and the rich pictorial tradition of the French Limoges school. Over time, however, the impact of these three sources of influence diminished as enamelists began to discover their own independent voices and to bring new vitality to this versatile medium.

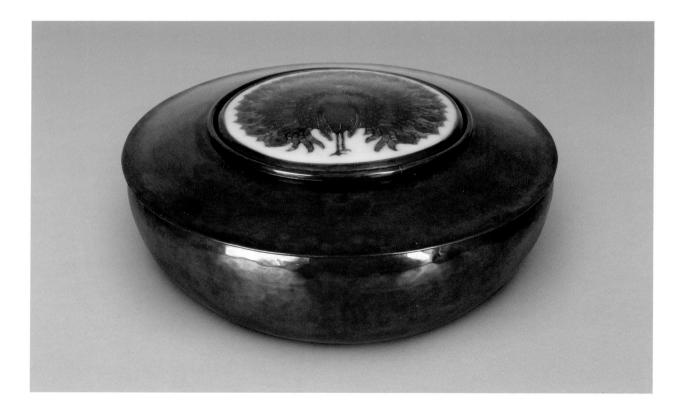

Fig. 1. *Lidded Bowl with Peacock Plaque*, c. 1920

to the medium. However, aware of the work of such pioneering innovators as Paul Cézanne, Pablo Picasso, Georges Braque, and especially Paul Klee, Drerup developed a style influenced by these progressive artists and their provocative new work. In addition to working within the Limoges tradition, Drerup continued to follow time-honored practices such as grinding his own enamels using a mortar and pestle. (Fig. 4) While extending these traditions and practices he formulated a remarkably modern and uniquely twentieth-century body of work.

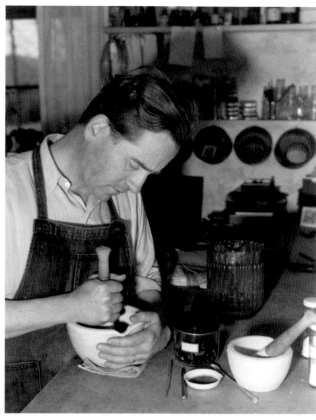

Fig. 4

The exceptional nature of both Raemisch's and Drerup's work, in its combination of tradition and innovation, was recognized from a fairly early date. As *New York Times* critic Walter Rendell Storey wrote in a review of a 1940 exhibition at the Society of Designer-Craftsmen: "Some of the best enamel work in the country may be seen in this display, notably a group of small plates and bowls by Karl Drerup and small plaques by Ruth Raemisch. Their rich coloring reminds one of antique examples yet their decorative motifs are expressed with the freedom of modern art."

Over time, these three prevailing traditions gave way to more innovative and idiosyncratic approaches to the medium as enameling evolved from its decorative foundations to emerge as a field of primary interest to numerous artists throughout the country.

## The Cleveland School

To a great extent, the story of modern enameling in this country begins in Cleveland, Ohio. In the late 1920s, 1930s, and early 1940s, several important forces combined to make Cleveland, the seventh largest city in the nation, the preeminent center of enameling in mid-twentieth-century America. Among the individuals and institutions supporting the enameling field during this rich period of growth was Kenneth Bates, the so-called 'Dean of American Enamelists,' who came from Boston and taught design and enameling from the late 1920s to the mid-1970s at the Cleveland School of Art (now the Cleveland Institute of Art). The exhibitions and acquisitions program at the Cleveland Museum of Art sustained the field during this critical period of growth. Another important factor in the city was the Ferro Enamel Corporation, a manufacturer of enamel components for use in domestic, industrial, and architectural settings. The company's president Robert A. Weaver provided artists such as Edward Winter access to its industrial kilns, enabling them to fire large-scale enamel-on-steel panels that would forever alter the nature of enameling and set a new standard for the field.

### KENNETH BATES

A recent graduate of the Massachusetts School of Art in Boston where he had studied painting and art education, Kenneth Bates (Fig. 5) was hired by the Cleveland School of Art in 1927 to teach a rigorous lineup of classes in watercolor, design, jewelry, drawing, and perspective. While Bates's own education in

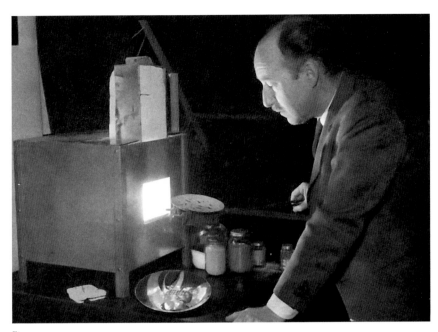

Fig. 5

Boston included a brief exposure to the work of Laurin Hovey Martin (1875–1939), one of the leading enamelists in this country in the first quarter of the twentieth century, his first year of teaching did not draw upon this area of his expertise. However, a year off in 1928 to study in Europe, followed by another trip to France in 1931, solidified Bates's commitment to enameling and assured his ultimate preeminence in the field.

Kenneth Bates's earliest work from the late 1920s was decorative and firmly grounded in the Boston Arts and Crafts tradition in which he had been trained. However, upon his return from France in 1932, he began to explore religious themes, presenting Christian subjects such as the Crucifixion, Deposition, and Lamentation in a modern Cubist-influenced style. In the late 1930s Bates began to combine his passion for nature and gardening with his interest in enameling, creating vibrantly colorful plates, plaques, brooches, and three-dimensional objects that depict a wide variety of plants and animals. He continued to investigate traditional techniques that had been forgotten or neglected and used them to explore subjects that were more relevant to his personal interests: the flowers in his garden, a portrait of his favorite cat, a complex composition interpreting Mussorgsky's musical interpretation of an argument in a village market, and more abstract subjects such as debris washed up on the beach of his lakeshore home in Euclid, Ohio. Throughout his long and immensely productive career, his work was meticulously crafted and exquisitely finished as it adhered to the principles of his early training in the Arts and Crafts tradition.

Kenneth Bates was also a skilled teacher who inspired countless students in his classroom and his workshops. Through his work at the Cleveland School of Art, he influenced several generations of American enamelists. Among his students who went on to become leaders of the field are Charles Bartley Jeffery, Mary Ellen McDermott, John Puskas, Norman Magden, James "Mel" Someroski, and William Harper.

A talented writer, Bates also authored two of the twentieth century's most influential books on enameling. His first, *Enameling: Principles and Practice*, was published in 1951. Prior to this publication, there was little available in English on the subject. While he began with a brief essay on the history of enameling in Europe and Asia, Bates focused the majority of his text on various enameling techniques. Profusely illustrated with images of his own work as well as that of the most prominent artists working in the field, the book had a lasting impact on enameling as it introduced countless artists across the nation to the beauty and range of the medium. It would lead to the publication of several other how-to books by various professionals, including in 1967 a second volume by Bates titled *The Enamelist*.

Kenneth Bates exhibited his work extensively throughout his life. He first entered the Cleveland Museum of Art's May Show in 1927 and continued to exhibit there and throughout the country for more than sixty-five years. In an age where most reproductions in books and magazines were in black and white, his work had a significant influence on the artists and viewers who saw it at these shows and were impressed with its richness and exuberance. He continued to create and exhibit his work until shortly before his death in 1994.

Fig. 5. Kenneth Bates firing an enamel plate in a small kiln, c. 1955. Photograph courtesy of the American Craft Council.

The artist Edward Winter (Fig. 6) was among Kenneth Bates's most influential colleagues in Cleveland as well as one of his most cantankerous and formidable rivals. While Winter taught at the Cleveland School of Art for only one semester, his impact on the enamels field was wide-ranging and profound. After graduating from the school in 1931, Winter traveled to Austria to study enameling with Josef Hoffmann and ceramics with Michael Powolny, two of the leading figures in the contemporary Viennese design movement. His experience in Vienna solidified his commitment to modern design and the medium of enameling. He returned to Cleveland in 1932 and exhibited his first works in enamel at the Cleveland Museum of Art's May Show in 1933. In that same year he showed his work in the *Second Annual Robineau Memorial Ceramic Exhibition* (later known as the *National Ceramic Exhibition*) at the Syracuse Museum of Fine Arts and won awards in both shows. Not content to work on a small scale, Winter began a partnership in the mid-1930s with the Ferro Enamel Corporation that would alter the nature of enameling in this country. Because of his friendship with Robert Weaver, the company's president, Winter was allowed to use Ferro's industrial kilns, after hours, to fire his large mural-scale enamel panels. Winter radically transformed a medium traditionally associated with small scale and intimate format to unprecedented levels of size and grandeur.

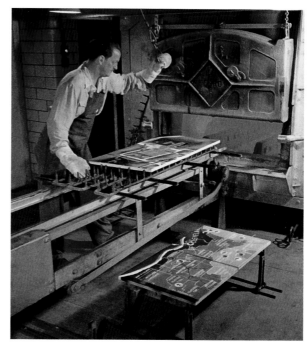

Fig. 6

He was also able to experiment freely, fusing enamel onto a wide variety of metal surfaces, including copper, steel, and aluminum. By the early 1940s, in addition to making a number of large pieces, Winter had produced several lines of enameled copper bowls, ash trays, vases, cigarette boxes, and other household items which were sold in high-end department stores throughout the country. However, he continued to create unique pieces that were destined solely for exhibition. These works challenged the perceived notion of the field and displayed his technical abilities while showcasing his artistic experimentation. He used images of these works to illustrate the books he wrote on the subject of enameling: *Enamel Art on Metals* in 1958, *Enameling for Beginners* in 1962, and *Enamel Painting Techniques* in 1970. All three were well received and solidified Winter's reputation as an expert and an important leader in the enameling field.

The educational tradition begun in Cleveland in the late 1920s in the work of Mildred Watkins, Kenneth Bates, and Edward Winter and advanced at mid-century by John Paul Miller and Mary Ellen McDermott continues today with the leadership of Gretchen Goss. Their work was complemented by that of Mel Somerowski at nearby Kent State and that of Harold Hasselschwert and later Andrew Kuebeck at Bowling Green. Combined, these educators along with several others and their institutions have made northern Ohio one of the foremost regions for enamels education in the late twentieth century and early twenty-first.

## Advancing the Field

Between the early 1930s and the late 1960s, a small group of institutions scattered across the country from New York to California provided critical assistance to the burgeoning enamels field by organizing a series of widely respected and highly influential annual and biennial exhibitions. Enameling, at the time considered a sub-category of ceramics perhaps because of its related kiln-firing process, was regularly featured in these

shows. These exhibitions were of importance to the history of modern enameling in this country because they offered a national showcase for innovative developments while providing institutional support and prestige to this newly developing field. Additionally, with prize money provided by industry, including the Ferro Enamel Corporation and IBM, these institutions were able to acquire pieces that financially aided the artists and enriched the institutions' collections.

## THE MAY SHOW

From its inception in 1919 to its final presentation seventy-four years later, the Cleveland Museum of Art's *Annual Exhibition of Work by Cleveland Artists and Craftsmen*, known simply as the May Show, served as a tangible expression of the museum's commitment to local artists in all media, from painting and sculpture to ceramics, fiber, metals, and enamels. The May Show was a juried exhibition and, between 1919 and 1961, any artist or craftsman living or born in Ohio's Cuyahoga County could submit work for consideration. After 1961 the exhibition was open to artists living in the thirteen counties in northeastern Ohio that originally formed the Western Reserve. Judges over the years included such nationally prominent artists as George Bellows, Edward Hopper, Georgia O'Keefe, and Ansel Adams. Works selected for the exhibition were displayed in the museum's galleries and offered for sale. Enamels were a regular feature of the May Show, as artists such as Kenneth Bates, Edward Winter, Mildred Watkins, Charles Bartley Jeffery, Doris Hall, and countless others were given the opportunity to share their most current work with the public. One particular individual who played a crucial role in the presentation of enamels was William M. Milliken, first as a museum curator (1919–1930) and then as director (1930–1958). Under his supervision, enamels were introduced to the May Show in 1926 and became a regular feature in 1932. Over the years, through purchase awards associated with this exhibition, Milliken acquired a substantial collection of enamels for the museum, supporting local artists while lending prestige to this burgeoning field. Many of the artists featured here were first shown in Cleveland's May Show. In some cases they are represented by the specific work shown in this annual exhibition. Among these are Kenneth Bates's *Memories of Youth* which was exhibited in the Thirty-sixth Annual May Show in 1954 and Fern Cole's *City at Night*, included in the Forty-ninth Annual May Show in 1967. Other examples are noted in the artists' biographies.

## THE CERAMIC NATIONAL

Like Cleveland's May Show, the *National Ceramic Exhibition*, also known as the Ceramic National, launched by the Syracuse Museum of Fine Arts in 1932, was a juried exhibition. At the time, enamels were shown with ceramics as the exhibition celebrated new developments in both fields within a national rather than a regional context. Begun as a memorial tribute to the innovative ceramist Adelaide Alsop Robineau (1869–1929) and presented annually through 1953 and biennially thereafter, the Ceramic National was overseen for many years by the museum's director Anna Wetherell Olmsted. For each exhibition a different panel of jurors was chosen to select work. The exhibition quickly became one of the most prestigious venues in which new work by ceramists and enamelists might be seen. Because the show was regularly reviewed in all the major art journals and because the Ceramic National often toured to other institutions throughout the country, it played a highly important role in advancing ceramics and enameling to a national arena and increasing public awareness of the medium as a legitimate form of artistic practice. Among the enamelists featured in the Ceramic National over the years were Kenneth Bates, Karl Drerup, Doris Hall, Mizi Otten, Ruth Raemisch, Harold Tishler, Edward Winter, and others. In some cases, they are represented here by the specific works featured in the Ceramic National. Edward Winter, whose *Resurrection* of 1951 was exhibited under the title *Metamorphosis* in the 1958 Ceramic International, is one such example. Others are noted in the artists' biographies.

In 1946 the Wichita Art Association (now the Wichita Center for the Arts), under the leadership of Maude Schollenberger, began a series of annual juried exhibitions that celebrated contemporary developments in decorative art and design. The goal of this annual *Decorative Arts and Ceramics Exhibition*, popularly known as the Wichita, was "to encourage craftsmen artists in the creation of unique and esthetically gratifying objects that show fine workmanship and thus to advance the standards of all design." Jurors from throughout the country were invited to Kansas to select finalists for the show and award purchase prizes. Among these jurors were some of the leading figures in the postwar craft field including Kenneth Bates (enamels), John Paul Miller (jewelry), Bernard Leach (ceramics), and Antonio Prieto (ceramics). As with the May Show and the Ceramic National, the Wichita was a source of great pride to its local community as well as to the participating artists. Not only did the show bring awareness of the crafts field to the middle of the country, it also encouraged the development of studio craft courses at both the community center and university levels. Unfortunately, for a variety of reasons—including the financial challenges and logistical complexities of gathering more than a thousand works for preliminary review and subsequent exhibition—the Wichita came to an end in 1976. However, during its thirty years, the exhibition served as an influential platform, supporting the work of such emerging leaders in the field as Virgil Cantini, Joseph Trippetti, Jade Snow Wong, Ellamarie and Jackson Woolley, and many others.

## SCRIPPS COLLEGE AND THE SCRIPPS ANNUAL

Teachers and students at Scripps College, a private college for women in Claremont, California, first encountered modern enameling through an exhibition of the work of Karl Drerup presented at the school in the early 1940s. They were intrigued but also curious about the process. As Jean Ames, a design instructor at the college, later stated: "We saw an exhibition of Karl Drerup's work at Scripps College in 1941 which gave us a big tug. While the materials, kilns, and methods were then unknown in California, the enamels we longed to make glowed brightly in our minds throughout the war years. When Arthur [Jean Ames's husband] returned home from war service, our fascination for enamel took real direction." In 1947 Jean and Arthur Ames, along with another husband and wife artistic team, Ellamarie and Jackson Woolley, and several of their friends and colleagues, participated in a pivotal enameling workshop at Scripps given by the innovative ceramics instructor Richard Petterson. A step-by-step "how-to" demonstration, that single workshop provided the tools artists needed to embark upon a career in enameling. Remarkably, the workshop also provided the inspiration that led to the development of a dynamic enameling movement in Southern California. While the Ameses remained in Claremont—Jean taught at Scripps and Arthur taught at the Otis College of Art and Design in Los Angeles—the Woolleys returned to their home in San Diego after his studies at the Claremont Graduate School. Together the four artists became the leaders of the burgeoning Southern California enamels movement in the years immediately following World War II. They were later joined by Kay Whitcomb, a transplant from New England, who, besides creating innovative work, helped organize and run the enamels guild in San Diego and encouraged artists to participate in national and international exhibitions. Over time other Californians began to work with enamel. They included Elizabeth Madley, Zella Eckels Marggraf, James Parker, Barney Reid, Curtis Tann, and JoAnn Tanzer who vitalized San Diego State Univerity's enamels program, and Phyllis Wallen. David Freda and Marianne Hunter, among many others, have made Southern California a major center for enamels in the late twentieth century. They were joined in the Bay Area by Fred Uhl Ball, Franz Bergmann, Colette, Molli Juin, Win Ng, June Schwarcz, Judy Stone, and Jade Snow Wong, positioning the state of California as the second most significant region—after Ohio—for enameling in the United States.

In addition to its role in advancing enamels education, Scripps College regularly featured enamels in its exhibitions, especially in its celebrated series the *Scripps Annual*. Scripps presented its first invitational ceramic exhibition in 1945. Selected by William Manker, director of the ceramics program, the inaugural exhibition featured work by many of the leading ceramists in California. Through the course of the 1950s and early 1960s, the Scripps exhibition, known after 1947 as the Scripps Annual or the Scripps Invitational, became the most significant showcase for contemporary ceramics in the western United States. From its inception, enamels were a regular feature of the exhibition. Among the enamelists who were included in the Scripps Annual over the years were Arthur and Jean Ames, Virgil Cantini, Harold Hasselschwert, Richard Loving, Joseph Trippetti, Phyllis Wallen, and Ellamarie and Jackson Woolley. Distinguished from the other shows by its invitational format, the Scripps Annual has, since its inception, been juried by artists with dual educational and curatorial interests. While enameling played a relatively small role in these exhibitions, the Scripps Annual provided a highly visible platform for the field and broadened awareness of this area of artistic activity in the western United States.

## A New National Arena

### ENAMELS

Between the late 1950s and the early 1970s, two major exhibitions brought national attention to the enamels field and solidified enameling as a legitimate creative practice. In 1959 the Museum of Contemporary Crafts in New York (now the Museum of Arts and Design) opened *Enamels*, the largest exhibition of enamels ever presented in this country (Fig. 7). Filling the museum's three-year-old galleries, this expansive show featured more than three hundred ninety-one objects. Wishing, perhaps, to further validate contemporary work through association with traditional forms, the organizers of *Enamels* presented the

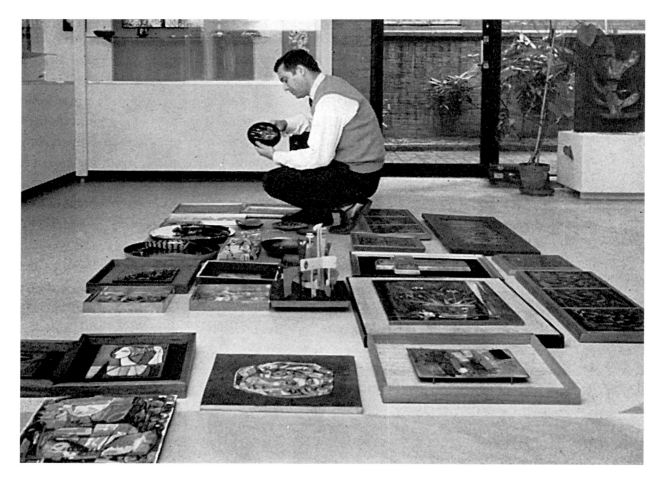

Fig. 7. Assistant Director Robert A. Laurer arranging artwork for *Enamels* at the Museum of Contemporary Crafts, 1959. Jean Ames's *The Garden* can be seen in the lower left. Photograph courtesy of the American Craft Council.

work of contemporary artists within the context of earlier periods of enameling history. Consistent with its mission, the museum featured many more contemporary than traditional pieces in the exhibition: sixty objects in its "Historic Enamels" section and three hundred thirty-one contemporary works. As a tribute to three of the early pioneers in the modern enameling field, the organizers of *Enamels* presented small one-person surveys within the heart of the exhibition. This section, entitled "Three Americans in Retrospect" featured Kenneth Bates, represented by thirty works; Karl Drerup, also represented by thirty works; and Edward Winter, represented by sixteen works. The exhibition's contemporary section contained a wide-ranging selection of American enamelists working in disparate regions of the country. As a testimony to the growing interest in the field, these works were by more than seventy-two artists who had chosen enameling as their principal interest. At the exhibition's opening reception, many of the artists met one another for the

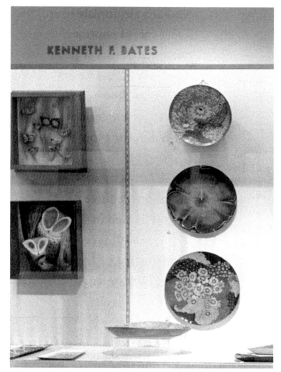

Fig. 8

first time. Thirty-four of the artists featured in *Little Dreams* were also included in this groundbreaking exhibition. Among them were Jean and Arthur Ames, Franz Bergmann, Virgil Cantini, Fern Cole, Doris Hall, Paul Hultberg, Charles Bartley Jeffery, Richard Loving, Elizabeth Madley, Mary Ellen McDermott, John Paul Miller, Win Ng, Peter Ostuni, James Peck, Miriam Peck, John Puskas, Barney Reid, Lisel Salzer, June Schwarcz, Margaret Seeler, Dorothy Sturm, Joseph Trippetti, Jade Snow Wong, Helen Worrall, Ellamarie and Jackson Woolley, and others. *Little Dreams* includes two pieces that were featured in the show: Jean Ames's *The Garden* of 1956 (Fig. 7) and Kenneth Bates's *Mid Summer* of 1958 (Fig. 8).

After its initial opening in New York, the exhibition traveled in condensed form to several other institutions, further increasing the field's visibility and firmly establishing enameling as a significant form of contemporary art. Response to the show was enthusiastic as critics, using terms such as "stunning" and "impressive," touted the exhibition's success and praised individual artists in it. This 1959 exhibition was of historic significance and important in bringing cohesion to a group of artists-craftsmen widely dispersed throughout the country.

## OBJECTS: USA

In the late 1960s *Objects: USA*, an exhibition and publication of great importance to the history of craft in this country, was organized by the art dealer Lee Nordness with the assistance of Paul Smith, the director of the Museum of Contemporary Crafts. The show was presented at the Smithsonian Institution's National Collection of Fine Arts (now the Smithsonian American Art Museum) in the fall of 1969. *Objects: USA* comprised more than three hundred pieces by sixty-seven American artists with work by many of the leading figures in all fields of contemporary craft. The exhibition featured a broad array of artists including pieces by eight enamelists: Arthur Ames, Kenneth Bates, Harold B. Helwig, Paul Hultberg, Vivian Koos, J. Ormond Sanderson, June Schwarcz, and Ellamarie Woolley. After its initial presentation in Washington, where it received an enthusiastic critical response, *Objects: USA* traveled throughout the country and was shown in Belgium, England, France, Germany, Italy, Scotland, Spain, Sweden, and Switzerland. The exhibition and its substantial catalogue exerted a profound influence on craft in this country in the 1970s. Through its popular success and broad visibility, *Objects: USA* raised the field's profile to new levels and helped validate the

Fig. 8. Display of work in the 1959 exhibition *Enamels*; the installation included Kenneth Bates's *Mid Summer* as seen above in the upper left. Photograph courtesy of the American Craft Council.

crafts as a legitimate form of artistic practice. *Objects: USA* was of enormous importance to enameling in America in that it positioned the field as a central voice in discussions of contemporary craft. Notably, enameling appeared as the first section in the catalogue reflecting the new central role enamels played in the evolving critical discourse.

### EXPANDING TRADITION

In the fertile three decades between 1940 and 1970, artists trained in diverse disciplines explored a rich variety of subjects and themes, while employing a broad range of traditional enameling techniques. Some artists featured in *Little Dreams*, such as Margarete Seeler, Mary Kretsinger, Maggie Howe, and Norman Magden, used silver or gold wires in

Fig. 9

their compositions, investing the cloisonné technique with new expressive potency. While Seeler's powerfully moving *Crucifix* and Magden's richly embellished *Plaque* (*Three Kings*) mine traditional religious themes and subjects, Kretsinger's *Double-sided Ring* and Howe's playful *Le Jazz Hot* are more generalized and abstract. During this same period other artists explored a more painterly approach to enameling, creating dynamic gestural expressions using a Limoges painted enamel technique. While the lithe figure in Molli Juin's *Box with Female Nude* is exquisitely detailed, the eclectic array of figures in Kathe Berl's *Man in Paradise* are more broadly rendered and gestural. This same loosely executed painterly quality may be seen in Doris Hall's *Fish*, Mel Someroski's *Madonna and Child*, Curtis Tann's *Plaque* (*The King*), and to a greater extent in Richard Loving's panel depicting highly abstract figures. These artists all used opaque and transparent enamels, sifting or troweling finely ground glass onto a metal surface and then firing, creating a narrative composition in enamel that emulated the loose, gestural qualities of paint on canvas. Also during these same years, artists like Kenneth Bates, Herman Casagranda, Fern Cole, and Helen Trivigno used another time-honored technique, imbedding *paillons*, pieces of gold or silver foil, in their enamels to further enrich the visual opulence of their compositions. While the whimsical butterflies in Bates's *Mid Summer* differ greatly from Helen Trivigno's autumnal forest scene, the luminous cityscape in Fern Cole's *City at Night*, and the pure abstraction of Herman Casagranda's untitled composition, the artists' use of shimmering, reflective foil enlivens the surface and adds a sparkling brilliance to all four compositions.

## Breaking Free: Innovations in Form and Content

While some artists chose to create work using traditional approaches, others broke free of such constraints and began to explore enamel's rich expressive potential using innovative techniques and provocative new formats. New York artist and educator Oppi Untracht's 1957 book *Enameling on Metal* laid the groundwork for artistic experimentation devoting a whole chapter to "Techniques to Produce the Unique." Among the most audacious methods discussed was the use of firescale as an intentional design element. Firescale, which most enamelists considered a technical "flaw," is the dark layer formed as a result of the exposure of bare metal to high heat in the firing process. Traditionally this deposit was viewed as an undesirable element and was removed before the next application could proceed. Using images of his own work and that of Paul Hultberg, Untracht's publication illustrated the powerful visual and expressive potential of firescale in abstract work. Hultberg would become one of the main champions of this experimental approach starting in the 1950s.

Fig. 9. Paul Hultberg, *Lepidopteral Pyrotecnics*, 1965 (detail)

## PAUL HULTBERG

Trained as a painter and a muralist, Paul Hultberg produced powerfully gestural compositions in enamel at a scale not typically associated with the medium. He studied art in California before moving to Mexico City to work with the renowned muralist José Gutierrez. After returning to this country, he taught painting and drawing at the Brooklyn Museum Art School where he first experimented with enamels. In 1956 he joined an artists' cooperative in Stony Point, New York, and began to pursue a highly experimental approach. Interested in producing enamels at a large scale, but constrained by the size of commercially produced kilns, he developed a unique firing method using gas torches on a cart that moved on tracks from one end of a large panel to the other, producing heat at a sufficiently high level to fuse his powdered enamel color onto the metal surface. He also used unorthodox methods of applying enamel color to metal, including dripping liquid enamels onto the surface of a hot panel to create compelling images of dynamic, explosive color. In the early 1960s Hultberg was hailed as an innovator in the field and his work was favorably compared by critics to that of Abstract Expressionist painters such as Jackson Pollock and Franz Kline.

## FRED UHL BALL

Another artist who would take the medium to new levels of innovation and unorthodox practice was the Californian Fred Uhl Ball. In a short span of twenty-six years, beginning from age fourteen and continuing until his untimely death in 1985 at the age of forty, Fred Ball rose to prominence in the field of enameling. Along with his wide-ranging body of work, Ball left behind a legacy of experiment and innovation that changed the way young enamelists approached the medium. His legacy also includes the publicly commissioned monumental enamel murals he created for his beloved city of Sacramento.

In 1958 he was bored with traditional approaches and began to experiment with new techniques and forms. Inventiveness was to characterize his work throughout his career. Early on he began to experiment with test tiles, composing torch-fired enamels on copper foil, assembling these into collage-like panels. Not restricting himself to the powdered form of enamel sifted onto a metal surface, he used enamel in liquid form and at times added clay to create unusual finishes. He dipped metal into liquid enamel, painted with it, dripped it, and squirted it onto a hot surface and watched it explode. He also fired white enamel to varying degrees of heat to produce a broad range of hues. The burnt areas of firescale became an integral part of his work. He also used natural elements such as cobwebs and leaves, coating them with liquid enamel, and applied them to the work before firing. A fine writer and dedicated educator, Ball published *Experimental Techniques in Enameling* in 1972. This was the first technical book devoted to such an unconventional approach to enameling and it had a major impact on a generation of emerging enamelists eager to explore novel approaches to the medium.

Fig. 10

Fig. 10. Fred Uhl Ball, *Untitled*, 1982 (detail)

23

# Looking Forward While Honoring the Past

Since the early 1970s artists in unprecedented numbers have been drawn to enameling. Well-grounded in the traditions of the field, they have exploded preconceptions and broken down boundaries as they explore exciting new technical and conceptual territory. While some have focused on the unique properties of the medium, others have pursued elaborate strategies to convey richly layered narrative content using enamel as but one tool in a multi-faceted technical arsenal. During this period, institutional support for enameling has increased significantly as numerous museums, university galleries, community centers, and guilds across the country have begun to recognize some of the leading figures in the field through one-person shows and retrospectives, while also chronicling the history of modern enameling through expansive group exhibitions and publications. Similarly, organizations such as the Enamelist Society, the W.W. Carpenter Enamel Foundation, and the Enamel Arts Foundation have emerged with the goal of promoting awareness of enameling to broader public audiences while also encouraging cohesiveness within the community of makers, educators, collectors, and enthusiasts.

## INDIVIDUAL EXHIBITIONS

In 1987 just two years after Fred Ball's untimely death, the Crocker Art Museum, in conjunction with the Creative Arts League of Sacramento, organized a memorial exhibition *Fred Uhl Ball Retrospective* providing well-deserved recognition for the extraordinary accomplishments of this talented artist. With fifty-nine pieces ranging from 1969 to 1985, it surveyed the artist's work offering an opportunity to celebrate his achievements in the community he so dearly loved. The exhibition, in combination with his 1972 publication *Experimental Techniques in Enameling*, served to solidify Fred Ball's international reputation and encourage a generation of artists to explore innovative approaches to the medium. Ball's next retrospective didn't take place until twenty-two years later. Organized by the Enamel Arts Foundation, *Fred Ball Enamels* was presented in 2009 at the Museum of Craft and Design in San Francisco, enabling a new generation to acquaint themselves with this ingenious enamelist, while reminding other artists of his impact on their work.

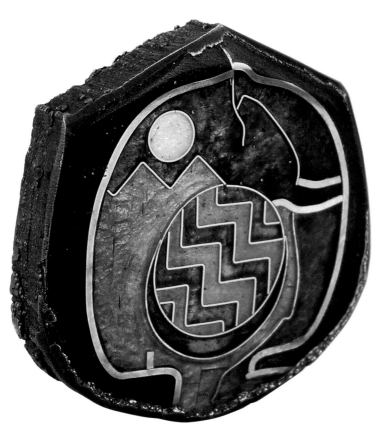

Thomas Manhart in 1989 organized an exhibition for the Orlando Museum of Art exploring the rich, multifaceted career of William Harper (Fig. 11). *William Harper: Artist as Alchemist* included 105 examples of the artist's work made between 1971 and 1989. In his catalogue essay, Manhart emphasized the layered content of Harper's work and traced the development of his jewelry over the period of three decades. After its presentation in Florida, the exhibition traveled to four museums in Europe and four in the United States. Critically well received, it solidified Harper's reputation as one of the leading figures in the contemporary enamels field.

In 1998 the San Francisco Craft and Folk Art Museum celebrated June Schwarcz's contributions to the enamels field in *June Schwarcz: Forty Years/Forty Pieces* (Fig. 12). Selected by the museum's curator Carole Austin, the exhibition provided a retrospective survey of the artist's achievement over the period of four decades. In addition

Fig. 11. William Harper, *Paperweight*, 1975–76

Fig. 12

to an insightful introductory essay by Austin, the catalogue included a moving tribute to Schwarcz by William Harper. He remarked on how seeing Schwarcz's work at a show in New York when he was a student at the Cleveland Institute of Art "changed his life forever" and solidified his commitment to enameling. After its presentation in San Francisco, *June Schwarcz: Forty Years/Forty Pieces* was also shown at the Museum of Arts and Design and the Honolulu Academy of Arts. Since that time Schwarcz has been featured in many other solo exhibitions including presentations at the Palo Alto Art Center (2003 and 2006), the Fresno Art Museum (2008), the Mingei International Museum, San Diego (2009), and the Craft and Folk Art Museum, Los Angeles (2011), as well as a 2012 two-person exhibition with the photographer John Chiara when she was ninety-four years old, at the Richmond Art Center in Richmond, California.

Recent one-person exhibitions include those for Jade Snow Wong (The Chinese Historical Society of America, San Francisco, 2002); Harlan Butt (The Metal Museum, Memphis, Tennessee, 2002); Marilyn Druin (The Newark Museum, New Jersey, 2004); Win Ng (The Chinese Historical Society of America, San Francisco, 2005); Jamie Bennett (Fuller Craft Museum, Brockton, Massachusetts, 2008); and Harold Balazs (Northwest Museum of Arts and Culture, Spokane, 2010). While focusing on the work of specific individuals, these exhibitions, many of which traveled to other museums throughout the country, have helped raise the profile of enameling and increase awareness of the medium. The accompanying catalogues have begun to chronicle the history of the field through insightful essays on individual artists' work. Additionally, the Metal Museum in Memphis, through an on-going series of programs called Tributaries, has featured the work of both seasoned leaders in the field and emerging talents. Although the focus of this series is on metal, several enamelists have been featured including Jessica Calderwood, Sarah Perkins, and Marlene True.

### GROUP EXHIBITIONS

Over the past three decades, numerous exhibitions have been organized to celebrate the art of enameling while showcasing newly emerging talent. Reflecting the field's appeal to broader, increasingly diverse, and more widely dispersed audiences, most were sponsored by university galleries and community art museums. In addition, guild-organized exhibitions exploring regional, national, and even international developments have enriched the mix. Four of these exhibitions stand out for their originality, their inventiveness, and their breath of impact.

In 1985 Enamel Guild West, a San Diego-based organization for enamelists, originated *Enamels International 1985* and presented it at the Long Beach Museum of Art in Long Beach, California. Selected by Fred Uhl Ball and Harold B. Helwig, along with their German colleague Kurt Neun, the exhibition featured the work of fifty-eight American artists presented along side that of sixty-two of their peers from Europe, Asia, Israel, Canada, Australia, New Zealand, and Central and South America. The exhibition was especially significant in that it was one of the first presented in this country to consider contemporary American enamels within a broad international context. Among the artists featured were Harlan Butt, Colette, Linda Darty,

Fig. 12. June Schwarcz, *Central Asia II #567*, 1970 (detail)

25

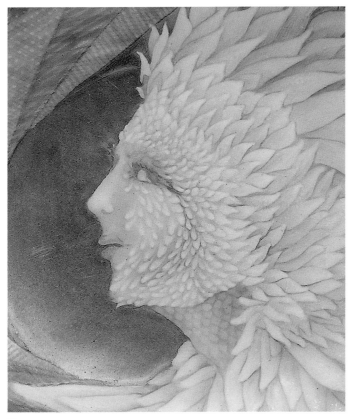

Fig. 13

Gretchen Goss, Belle and Roger Kuhn, Antonia Schwed, Jean Tudor, Phyllis Wallen, and Helen Worrall.

In 1987 Harold B. Helwig selected seventy-two enamels for an exhibition organized by Thompson Enamel, the major supplier of enameling materials to artists, in cooperation with the Taft Museum in Cincinnati, Ohio (Fig. 13). The exhibition *Masterworks/Enamel/87* featured work in a wide variety of formats by twenty-four artists from the United States and Canada. As Helwig wrote in the accompanying brochure, the exhibition's presentation was unusual because it featured work by many of the leaders in the contemporary enamels field in a gallery immediately adjacent to the Taft's extraordinary collection of sixteenth-century Limoges enamels. With this juxtaposition, the public could explore rich parallels and relationships between traditional and contemporary forms of enamel. Its presentation in such an august setting contributed prestige to the contemporary artists featured.

In 1988 the Gallery Association of New York State, a non-profit agency circulating exhibitions to regional centers throughout the state, engaged Lloyd Herman, founding director of the Smithsonian Institution's Renwick Gallery, to organize an exhibition *Color and Image: Recent American Enamels*. The exhibition which was shown at institutions in Oswego, Huntington, and Glens Falls, New York; Tempe, Arizona; and Towson, Maryland, provided a thoughtful survey of contemporary enameling in this country as it presented work by several seasoned leaders in the field beside that of younger and emerging artists. Among the twenty-seven artists included in the show were Harold Balazs, Jamie Bennett, Harlan Butt, Colette, Gretchen Goss, William Harper, and June Schwarcz.

Reflecting continued interest in international presentations, the Art Gallery at Kent State University in Ohio organized in 1994 *Contemporary American, Canadian, and European Enamelists*. It was selected by artist and Emeritus Professor Mel Someroski and featured work by sixty-two artists. Among the Americans included were Harold Balazs, Kenneth Bates, Harlan Butt, Marilyn Druin, Gretchen Goss, William Harper, Harold B. Helwig, James Malenda, Mary Ellen McDermott, John Puskas, June Schwarcz, and Jean Tudor. The exhibition traveled to Waterloo, Ontario, where it was shown at the Canadian Clay and Glass Gallery.

Regional guilds also played a significant role, providing a place for enamelists to teach and learn as well as an exhibition venue. The nearly two-dozen major guilds spread across the country are important centers that keep enameling relevant to a broad range of makers. It is, however, through their exhibitions that they have had their widest impact. Of these, two are noted here. In 2002 the Northern California Enamel Guild organized the *Sixth International Juried Exhibition* at the Richmond Art Center in Richmond, California. This exhibition included fifty-two artists from the United States, Argentina, Australia, Germany, Japan, Switzerland, the United Kingdom, and the Republic of Georgia. Juried by Colette, Susan Elizabeth Wood, and Jean Tudor, it offered an updated perspective on developments in enameling within a broad international context.

Fig. 13. Harold B. Helwig, *Man of Sorrows*, 1987 (detail)

Similarly ambitious, in 2012 the Enamel Guild/North East organized an exhibition for the Cape Cod Museum of Art in Dennis, Massachusetts, to celebrate the guild's twentieth anniversary. Selected by Linda Darty, the exhibition included work by twenty-eight artists divided into three categories: objects, jewelry, and panels. Among the artists were Michael and Maureen Banner, June Jasen, Averill Shepps, and Katharine Wood. As with the Northern California Enamel Guild exhibition, presenting this exhibition at the Cape Cod Museum of Art added to the show's prestige and broadened the public's exposure to important new work in the enamels field. In addition to appealing to younger artists, these guild-sponsored exhibitions continued to attract more mature enamelists because their work was shown in these regional museums where it could be seen and enjoyed by the general public.

Finally, in 2007 the Long Beach Museum of Art organized *Painting with Fire: Masters of Enameling in America, 1930–1980*. The first major museum exhibition to survey the enameling field in more than forty years, *Painting with Fire* presented the work of fifteen influential artists, exploring their contributions to enameling during the fifty year period through twelve to fifteen examples each. The exhibition was a critical and popular success, well attended and reviewed by national and international art journals. More importantly, however, the catalogue accompanying the exhibition provided the first scholarly survey of the history of enameling in the United States.

## New Voices/New Visions

During the past three decades enameling in the United States has been characterized by an unprecedented pluralism, a rich mix of artistic voices and visions. While some artists have continued to experiment with the medium, formulating new approaches and processes, others have been engaged by issues of content, using enamel as a means to explore such subjects as personal identity, humankind's relationship to nature, and spirituality, along with numerous other themes.

Artists in *Little Dreams* such as Jamie Bennett, Marilyn Druin, David Freda, William Harper, Melissa Huff, Marianne Hunter, and John Iversen have produced enamel jewelry of astounding beauty and power, while Harlan Butt, Linda Darty, Jill Baker Gower, Jan Harrell, James Malenda, Sarah Perkins, and Marlene True

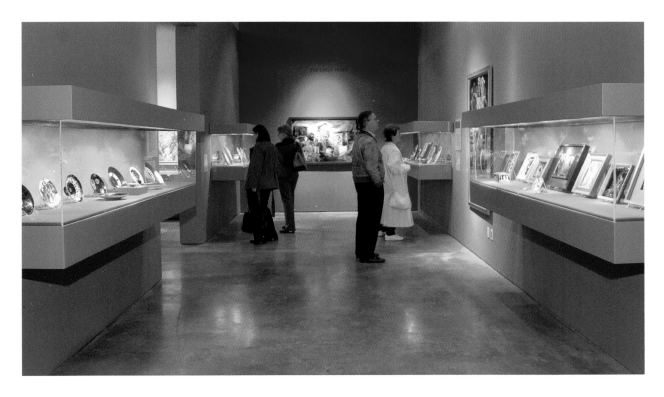

Fig. 14. Display of work in the 2007 exhibition *Painting with Fire: Masters of Enameling in America, 1930–1980* at the Long Beach Museum of Art. Photograph courtesy of the Long Beach Museum of Art.

have created three-dimensional objects that resonate with layered meaning and depth. Some, such as Helen Elliott and Esteban Perez, have exploited a fundamentally abstract vocabulary in their two-dimensional wall pieces, while others such as Emily Bute, Gretchen Goss, Sarah Perkins, Averill Shepps, and Judy Stone have explored personal narrative and issues such as our relationship to nature. Similarly, questions of personal and cultural identity may be seen in work by Jessica Calderwood, Mary Chuduk, Colette, Thom Hall, Andrew Kuebeck, and Jean Tudor. These distinct voices and visions combine to make the present moment one of the most stimulatingly diverse periods in the history of the enamels field.

## EMERGING LEADERS

Over the past thirty years, several talented artists from different regions of the country have emerged to new leadership roles within the enameling community. Like many of their predecessors, these artists are committed educators who have divided their time equally between their own independent studio practice and teaching duties at colleges and universities, as well as classes and workshops at art centers such as Arrowmont School of Arts and Crafts in Gatlinburg, Tennessee, and Penland School of Crafts in Penland, North Carolina. Inventive visionaries, they have taken enameling to a new place in the twenty-first century as they continue to explore the medium's capabilities in a wide range of forms and formats. While there are many who made important artistic and educational contributions, six of them are featured in *Little Dreams*. Viewed collectively, the work of Jamie Bennett, Harlan Butt, Linda Darty, Sarah Perkins, Gretchen Goss, and Jessica Calderwood has had a far-reaching impact on the field.

The eldest of these artists, Jamie Bennett produces enamel jewelry that is both raw and elegantly refined, such as his *Chadour #18* of 2002. Defying the notion of preciousness often associated with enameled objects, he has created a body of work that is richly colored, loosely gestural, and poetically evocative. Trained in metals under Kurt Matzdorf and Robert Ebendorf and in enameling under William Harper and Harold B. Helwig, Bennett was Professor of Art in the metals program at the State University of New York at New Paltz where he taught from 1985 until his retirement in 2014.

Another eminent leader in the field, Harlan Butt has taught at the University of North Texas in Denton since 1976; he is now Regents Professor of Studio Arts. In a body of work he calls the "Earth Beneath Our

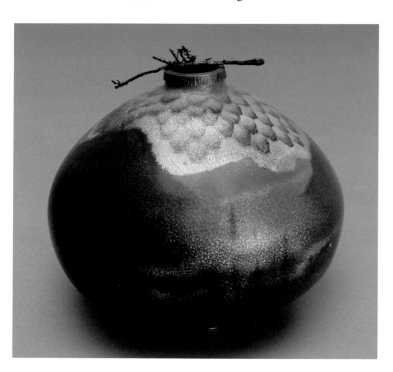

Feet" and other related series, he has created superbly wrought three-dimensional objects in metal and enamel that explore our relationship to nature in its closely observed detail. His work combines fine cloisonné enamel executed in a palette inspired by nature with sculpted flora and fauna rendered in finely crafted silver. Influenced by Japanese philosophy and aesthetics, as seen in *Manjusri I* of 1998, he often embosses haiku poetry of his own invention in the silver to add further layers of meaning to his work.

Combining her expertise as a metalsmith with the coloristic instincts of an enamelist, Linda Darty is a prominent leader in the contemporary enamels field. In her multifaceted body of work, which includes functional, ornamental, and wearable forms, she has created resonant objects in glass and metal that allude to family, nature, and memory. Her use of rich,

Fig. 15. Harlan Butt, *San Juan Horizon #1*, 2009

layered reference may be seen in *Garden Candlestick* of 1999. As professor of metalwork and enameling at the School of Art and Design, East Carolina University in Greenville, North Carolina, she has introduced a new generation of students to enameling. Sought out as both a juror and lecturer, she published in 2004 *The Art of Enameling*, a book that elucidates numerous enameling techniques while incorporating important historical information on the field. Her book has become one of the most significant publications on enameling technique currently in print.

Sarah Perkins's elegant three-dimensional enamel and metal vessels and jewelry may be seen as a late twentieth-century heir to the "precious object" tradition advanced by Louis Comfort Tiffany, René Lalique, and Carl Fabergé. Her highly inventive sculptures with their allusions to nature, the body, and ritual celebration reflect her skills as a metalsmith combined with her coloristic interests as an enamelist. Her work, some of which refers to natural forms like *Caterpillar Stylus* of 1998 and some of which is completely abstract, is both sensuous and richly evocative. Perkins is Professor of Art and has taught at Missouri State University in Springfield since 1994.

A respect for nature, its awe-inspiring expanses and most minute details, characterizes the work of Gretchen Goss. In her poetically layered plaques and panels, she depicts diverse subjects from nature—a field in her native Ohio, treetops viewed from varying vantage points, or light reflecting on the surface of water—with a sense of becalmed awe and reverence. A greatly admired educator, she has taught enameling at the Cleveland Institute of Art since 1989 and is Professor and Chair of the Material Culture Environment.

The youngest of the artists who have emerged to leadership roles, Jessica Calderwood is intrigued by human traits and passions—our most ennobling virtues as well as our most regrettable shortcomings. In a rich body of work produced over the past ten years, she explores those stolen moments in time when everyday people pursue their private passions thinking that no one is looking as in *Smoking Boy* of 2005, as well as man's or more aptly, woman's relationship to nature. Working in the Limoges technique, she has produced a body of work in a wide variety of formats from brooches, plaques, and panels, to three-dimensional objects and room-size installations in which enamel is but one tool in her diverse array of technical strategies. After studying with Gretchen Goss at the Cleveland Institute of Art, since 2008 Calderwood has taught enameling at the University of Wisconsin-Oshkosh, where she is Associate Professor of Art.

## Supporting the Field

Over the past thirty years, numerous publications have shed new light on the field, its past and present. Eleven of the artists included here have written noteworthy books on techniques and the history of enamels. At the same time, several organizations have been created to support the field and broaden awareness of the medium.

### PUBLICATIONS

A wide variety of books on enameling provide both technical instruction for students and insight into the work and practices of contemporary enamelists. Expanding upon the early how-to publications by authors such as Kenneth Bates, Edward Winter, and Oppi Untracht, and somewhat later William Harper and Fred Ball, these books have nurtured and encouraged an ever-expanding interest in the field. Among them are Glenice L. Matthews, *Enamels, Enameling, Enamelists* (1984); Margarete Seeler's posthumously-published *Enamel Medium for Fine Art* of 1997 (an expansion upon her 1969 publication on the cloisonné technique *The Art of Enameling*); Lilyan Bachrach's *Enameling with Professionals* (2002) followed by her *Contemporary Enameling: Art and Techniques* (2006); Karen L. Cohen's *The Art of Fine Enameling* (2002); and Linda Darty's *The Art of Enameling: Techniques, Projects, Inspiration* (2004). Complementing these were four publications that surveyed the history of the enamels field: Erika Speel's *Dictionary of Enameling: History and*

*Techniques* (1998); followed by her magisterial *Painted Enamels: An Illustrated Survey, 1500–1920* (2008); Sarah Perkins's *500 Enameled Objects* (2009); as well as *Painting with Fire: Masters of Enameling in America, 1930–1980* (2006).

## ORGANIZATIONS

Over the past thirty years several non-profit organizations have been formed with a shared goal of promoting enameling to wider and more diverse audiences. While one of them has focused on building a strong and representative collection of modern and contemporary enamels, two provide technical support and training to artists as core components of their mission.

Since its founding in 1986, the Enamelist Society, based in Atlanta, has provided invaluable support to artists—beginners and seasoned professionals, alike—through its meetings and workshops as well as its biennial juried exhibitions. For almost thirty years, the society's conferences, scheduled in various locations around the country, have provided teaching opportunities for professionals and learning opportunities for enamelists through workshops and demonstrations on all aspects of the medium. These biennial conferences also provide a rare opportunity for enamelists to meet one another and to share ideas, fostering a sense of community within the geographically widespread enamels field. The juried exhibitions accompanying these conferences provide opportunities for artists to have their work seen by their peers and for the public to enjoy the newest work in the enamels field. Since 1986 the Society has also promoted enameling to larger international audiences through a quarterly newsletter providing information about training and workshops, profiles of leading figures in the field, and other news of interest to the enameling community.

The W.W. Carpenter Enamel Foundation, established in 2004, supports the field through enamel workshops held at the corporate headquarters of Thompson Enamel. Founded by Woodrow Carpenter, the Carpenter Foundation has a large and diverse collection of historic and contemporary enamels that it shows in a small museum adjacent to the corporate offices. The foundation provides invaluable technical and educational support to the enameling community. The Carpenter Foundation also publishes *Glass on Metal*. Launched in 1982, this magazine includes descriptions of materials and techniques while at the same time publishing feature articles on prominent artists and on the history of enameling in the United States, Europe, and Asia.

The most recent of the three non-profit organizations, the Los Angeles based Enamel Arts Foundation was created in 2007 with a goal of promoting awareness and appreciation of modern and contemporary enamels through its collection, exhibitions, and educational programs. Considered a "museum without walls," the foundation has a collection of more than one thousand enamels ranging in date from the early twentieth century to the present. It regularly lends objects from its collection to museums throughout the country for exhibitions and special programs. Its website provides valuable information about artists and their work and the foundation regularly develops exhibitions from its collection that circulate to museums. It has also commissioned work by artists, encouraging them to explore new territory and it has provided financial support to educational programming that advances awareness and appreciation of the enamels field.

## Looking to the Future

As a result of exhibitions, publications, and dedicated organizations, all based on the fine work of contemporary enamelists themselves, the field has gained greater visibility than ever before, prompting what several critics have referred to as an "enameling renaissance." However, unlike its "sister" fields ceramics, glass, and wood, there has never existed for enameling a substantial support community or promotional structure such as that provided by galleries, collecting communities, and museums. Remarkably, many of the leaders in the field are not currently represented by commercial galleries and there are no galleries devoted to enamels as there are for glass, ceramics, and studio jewelry. As a result, there is little awareness of the diversity of work produced in enamel over the past fifty years. Until recently, few people knew of the history of the field and its importance to our understanding of the development of craft in this country in the twentieth century.

However, as we approach the third decade of the twenty-first century, artists continue to explore the beauty, vibrant color, and layered depth of this venerable medium. In many cases they have begun to exploit its expressive potential and to use enamel as but one tool in a multifaceted artistic arsenal. As they continue to investigate a multitude of issues, ideas, and techniques, they have greatly expanded the traditional boundaries of what the artist Karl Drerup lovingly referred to as these "little dreams in glass and metal."

It is our hope that artists will continue to explore this remarkable medium and that over time audiences will become more fully acquainted with its storied history, its richly diverse present, and its immensely promising future.

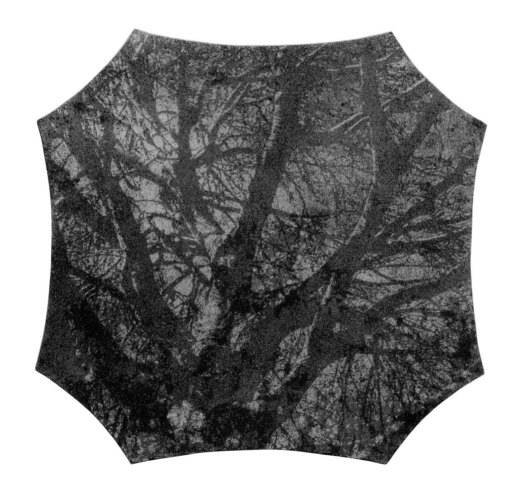

Fig. 16. Gretchen Goss, *Five Saves*, 2009 (detail)

31

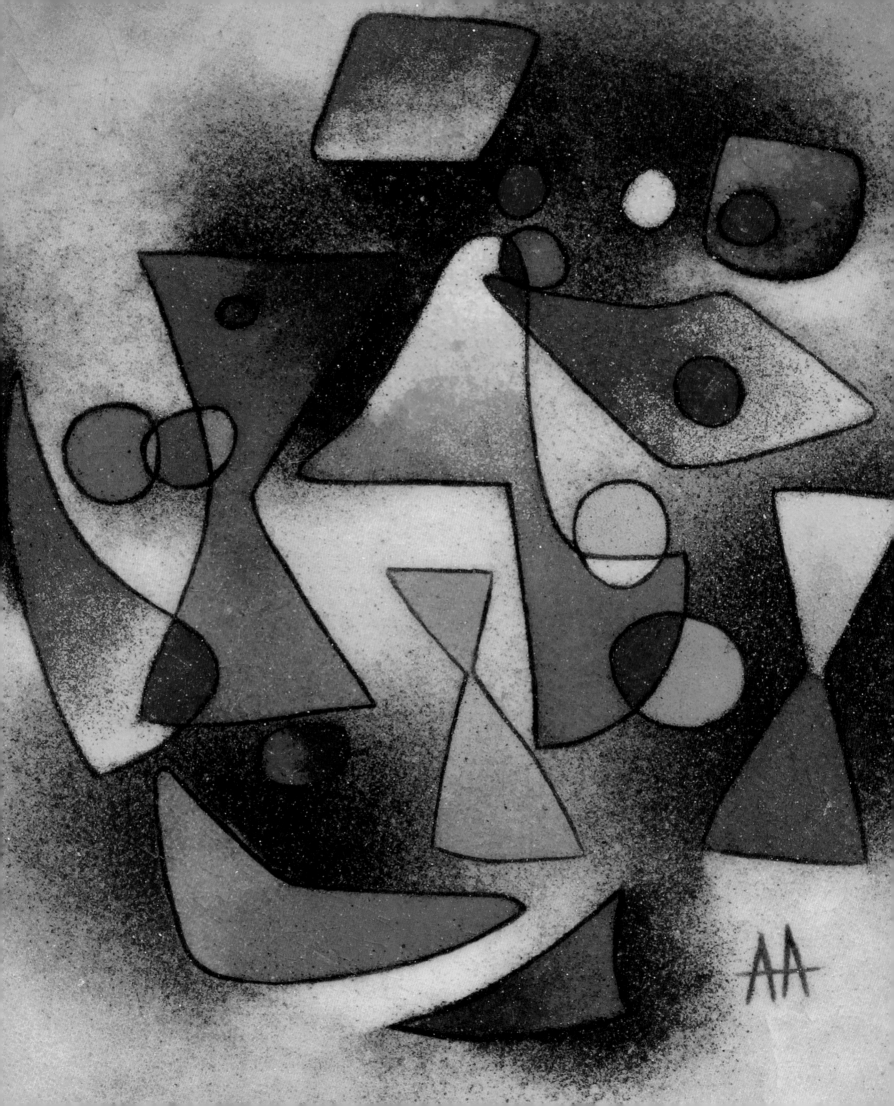

# Arthur Ames

## 1906–1975

The Claremont, California, based artists Arthur Ames and Jean Goodwin Ames were among the foremost leaders in the mid-twentieth-century American enameling movement. Trained in a wide variety of disciplines, the Ameses produced paintings, sculpture, prints, ceramics, tapestries, mosaics, and mural decorations—both individually and in collaboration—throughout their long and productive careers. For both artists, however, enameling was the preferred medium.

Arthur Ames was born in Tamaroa, Illinois. After his father's death in 1907, he moved to Ontario, California, where his mother supported the family by working as a seamstress. He studied with Ray Boynton and Jock Schneier at the California School of Fine Arts in San Francisco (now the San Francisco Art Institute). In the 1930s and early 1940s, Arthur and Jean Ames produced numerous mural decorations throughout California. They were married in 1940. Arthur taught design at the Los Angeles County Art Institute (now the Otis College of Art and Design) from 1954 until his retirement in 1971 and Jean taught design at Scripps College and the Claremont Graduate School from 1940 to 1969.

The Ameses' fascination with enameling began in 1941 when they saw an exhibition of Karl Drerup's work at Scripps College. They began enameling in earnest in 1948 after attending a brief workshop at Scripps led by the ceramist Richard Petterson. Through trial and error and by reading the few technical books available at the time, they taught themselves to enamel and quickly became nationally recognized leaders in the field.

Influenced in part by the Cubist paintings of Pablo Picasso and the boldly patterned compositions of Georges Rouault, Arthur Ames's earliest enamels of the late 1940s and early 1950s are figurative and often include overlapping images of people and objects viewed from disparate vantage points. Over time, however, he was increasingly interested in abstraction and his enamel panels and plaques became more formal, spare, and abstract. Nevertheless, vibrant color and lucid design continue to characterize his work of the 1950s and early 1960s.

*Waiting* represents an important transition in the artist's career. While the work includes figurative references, as five women wait expectantly behind doors and windows, the figures are each highly abstract and seem contained within the architecture and structural grid of the composition. The work anticipates the artist's increasing interest in abstraction. A circular plate with similar imagery was shown in the Sixteenth Ceramic National at the Syracuse Museum of Fine Arts in 1951 and acquired for the museum's collection.

*Assemblage*, made about 1955, is a fine example of Arthur Ames's more abstract work. Its overlapping forms seem to dance in and out of space as the geometry of those forms is softened and rendered more organic, echoing the circular shape of the plate. Ames's skills as a designer are evident in this intimately scaled abstract composition.

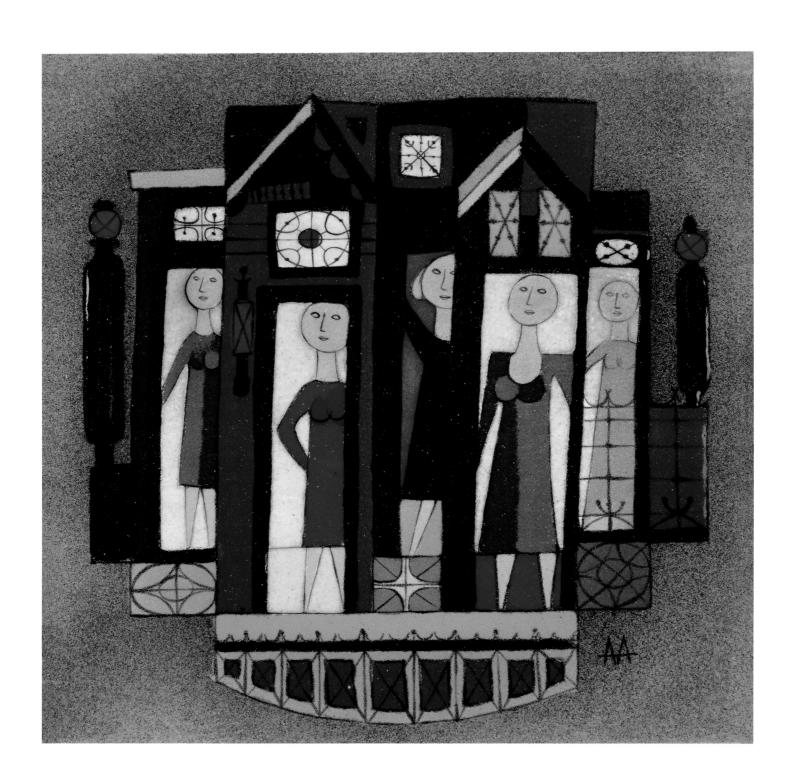

*Waiting*
1952
Enamel on copper
7³/₄ x 7³/₄ in.
19.7 x 19.7 cm
Signed on the lower right: *AA*
Signed on the reverse:
*Waiting Arthur Ames 1952*

34

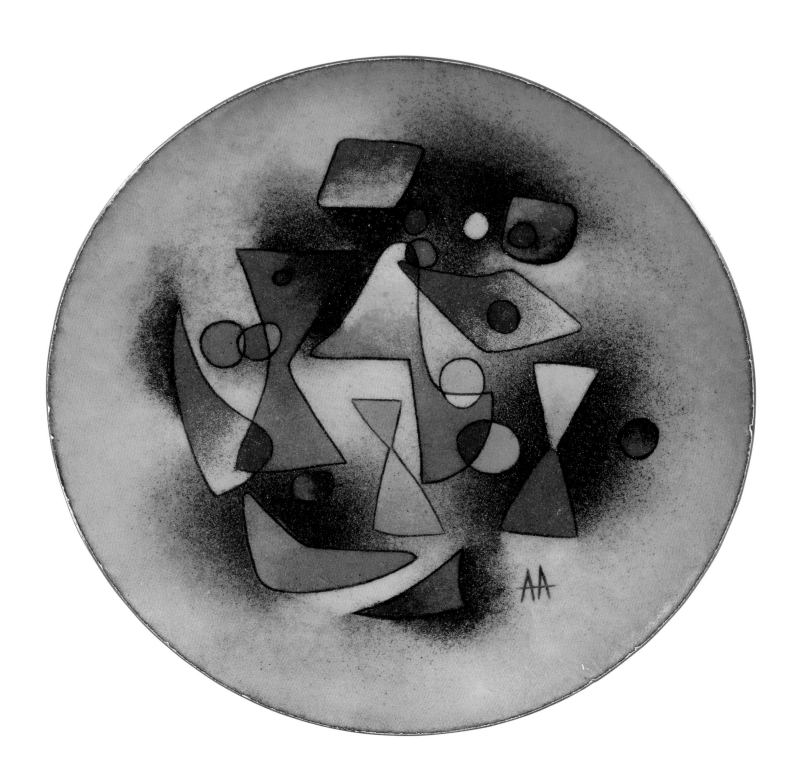

*Assemblage*
c. 1955
Enamel on copper
$\frac{1}{2}$ x 6$\frac{1}{2}$ x 6$\frac{1}{2}$ in.
1.3 x 16.5 x 16.5 cm
Signed on the lower right: *AA*
Signed on the reverse:
*Assemblage Ames*

# Jean Goodwin Ames
## 1903–1986

Evoking the world of her idyllic childhood in rural California, Jean Ames's work is filled with animals and fanciful beings—angels, dryads, water sprites, and pixies—idealized characters that exist at the very wellspring of her imagination. Although fundamentally a modernist, Ames admitted that her primary interest was in these whimsical subjects rather than in abstract compositions and designs. "My orbit seems full of angels and lovely sprites, all mingling with enchanted birds and beasts. Although I see these images within their abstract design, they are more of a motivation and possibly more important to me than the abstract elements in which I interpret them."

Born in Santa Ana, California, Jean Goodwin Ames studied at Pomona College from 1921 to 1923 and received her diploma at the Art School of the Art Institute of Chicago in 1926. She later studied at the University of California, Los Angeles, and at the University of Southern California, where she earned an MFA in 1937. She married Arthur Ames in 1940. An inspiring teacher, Jean Ames taught at Scripps College and the Claremont Graduate School from 1940 to 1962 and was chair of the art department from 1962 to 1969. In 1969 the Claremont Graduate School honored her lifelong commitment to teaching by awarding her the title Professor Emerita.

Jean Ames's interest in enameling began when she and Arthur saw an exhibition of Karl Drerup's work at Scripps College in 1941. By studying his plates, plaques, and bowls, she developed a pictorial, Limoges-style technique as enameling became her preferred medium after about 1948. The lustrous panel *Angel in Adoration* is part of an imaginative series completed in the early 1950s portraying angels, solitary and in groups, engaged in various activities from performing on musical instruments to prayer. In each, a vividly colored background adds brilliance and a preternaturally magical presence to the central figure.

In *The Garden*, comprising six separately fired, irregularly shaped enamel panels, Ames finds exceptional beauty in the world of nature amidst plants, flowers, and birds. Here the artist may be recalling her youth or simply looking out into her garden through her own fertile imagination. This vibrant work was featured in the seminal 1959 exhibition at the Museum of Contemporary Crafts and is considered one of the artist's most significant and complex compositions.

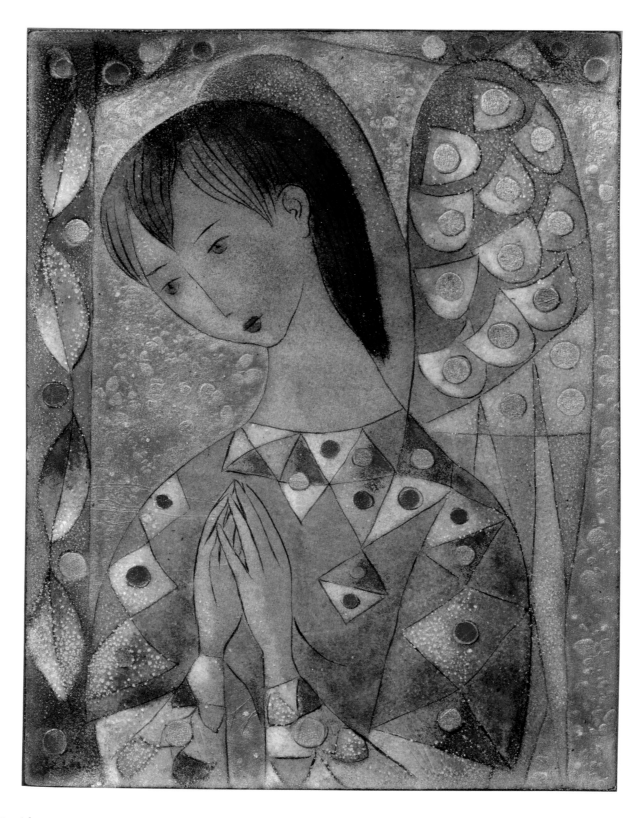

*Angel in Adoration*
c. 1952
Enamel on copper
10 x 8 in.
25.4 x 20.3 cm
Signed on the lower left: *Jean*
Signed on the reverse:
*Angel in Adoration Jean Ames*
*Claremont Calif.*

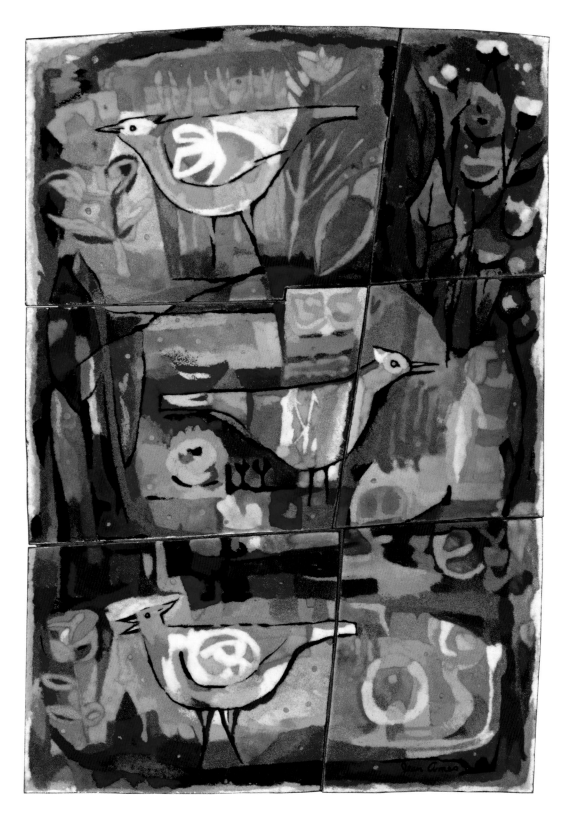

*The Garden*
1956
Enamel on copper
20¹/₂ x 13¹/₄ in.
52.1 x 33.7 cm
Signed on the lower right: *Jean Ames*
Various paper labels on the reverse
indicating the title and date

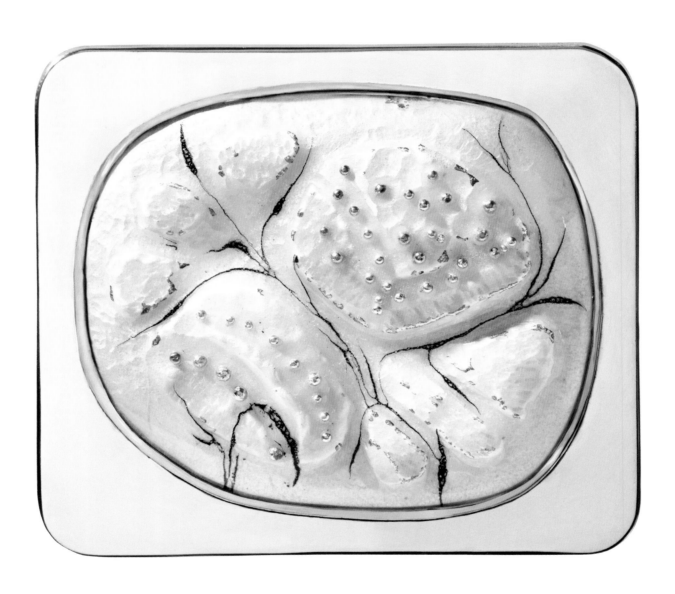

# Lilyan Bachrach
## Born 1917

*Brooch*
c. 1980
Enamel on fine silver, 24K gold
granulation, 18K gold bezel,
and sterling silver
2$\frac{1}{2}$ x 2$\frac{3}{4}$ x $\frac{1}{2}$ in.
6.4 x 7 x 1.3 cm
Signed on the reverse: *Bachrach*
Partial gift of the artist courtesy
of Marbeth Schon

In a career spanning five decades, Lilyan Bachrach has produced a wide-ranging body of work that includes jewelry, functional vessels, decorative plaques, switch plates, mezuzahs, and other religious and ceremonial objects. A superb craftsman, she is equally well versed in abstraction and representation, the cloisonné technique, and overglaze painting. The lush floral images she portrays on her decorative plates are perfectly suited to the forms on which they are rendered and her enamel jewelry is invariably bold, inventive, and visually rich.

Lilyan Bachrach was born in New Haven, Connecticut. In 1921, when she was four, her family moved to Lowell, Massachusetts, where her parents opened a curtain and drapery manufacturing business and, over time, several retail shops. Through her parents Bachrach learned to appreciate fine fabrics and she developed a lifelong commitment to quality workmanship. After producing several textile designs for the family business, Bachrach enrolled in 1934 as a student at Boston University, where she studied to become an interior designer and met her future husband, a student at Tuft's Medical School. She and Sam Bachrach were married in 1938. While her husband served in the military during World War II, she raised their growing family and, after the war, helped manage Sam's expanding medical practice.

In the early 1950s she enrolled in a metals class at the Worcester Center for Crafts where, in 1955, she was introduced to enameling. While she found some of the initial classes technically limiting, she eventually participated with seven other women in an informal enameling workshop called the "Lenox Enamelers." As she later stated, "I fell in love with enamels because of the infinite range of colors and their tactile quality." About this same time, she enrolled in a workshop in Boston under the direction of the Cleveland-trained artist Doris Hall. While the class met for only six weeks, the experience had a profound influence on her development. As Bachrach later observed, she found Hall's loose, painterly approach to enameling refreshing and highly compatible with her own. She subsequently studied cloisonné technique at the Worcester Center for Crafts with Joseph Trippetti and, over the years, participated in workshops led by a wide variety of artists including Kenneth Bates, Fiammetta Hsieh, Charles Bartley Jeffery, Mary Kretsinger, and others. In the late 1960s, Bachrach resumed formal studies at the Worcester Art Museum School where she was awarded a BFA in 1969 at the age of fifty-two.

In addition to producing an accomplished body of work, Bachrach also wrote and edited two important books on enameling. *Enameling with Professionals* was published in 2002 and *Contemporary Enameling: Arts and Techniques* in 2006. A testament to the work of friends and colleagues, Bachrach's publications are comprised of brief essays on enameling by artists working in diverse styles and formats. Her books offer unique insights into both form and process.

This versatile piece of jewelry can be worn either as a brooch or as a pendant. While its design is fundamentally abstract, the dark lines across the enameled surface suggest branches of a tree against a spare wintery landscape. The piece is further enlivened by the gold and silver granulation dotting the undulating repousséd surface of the enamel and by the gold bezel that attaches the enamel to its sterling silver mount.

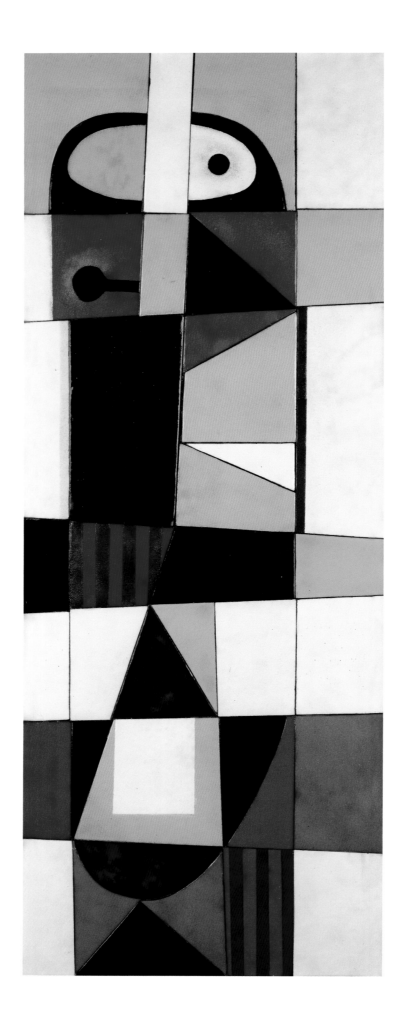

# Harold Balazs
## Born 1928

*The Eye*
1952
Enamel on copper
36 x 13³/₄ in.
91.4 x 34.9 cm
Signed on the lower center: *Balazs 52*
Inscribed on the reverse: *The Eye*
Purchased with funds contributed by the
Windgate Charitable Foundation

For more than sixty years the immensely talented artist Harold Balazs, the so-called "Bernini of Spokane, Washington" reflecting his numerous commissions for public sculpture in the eastern region of that state, has pursued his interest in a variety of subjects with an extraordinary level of craftsmanship and unbridled imagination. Since the early 1950s he has created a wide range of objects from beautifully designed and intimately scaled enamel jewelry to large metal sculpture. His work is grounded in his love of the figure and nature as well as his interest in pure abstraction.

Born in Westlake, Ohio, Harold Balazs took Saturday morning art classes at the Cleveland Museum of Art as a child. Balazs remembers being particularly impressed with two enamel panels by Edward Winter "in the stairway to art classes in the Cleveland art museum where I studied from 1938 to 1941." Balazs realized at this early age that "I wanted to do that some day—enamel!"

He went on to study painting and drawing at the Art School of the Art Institute of Chicago and received a BFA from Washington State University in 1951. There the Czech-born artist George Laisner introduced him to the spare, geometric work of Bauhaus masters György Kepes and László Moholy-Nagy. Laisner also rekindled Balazs's early passion "by exposing us to enameling."

After graduating, Balazs supported himself and his family in Spokane by "freelancing at any and all things," including "making lots of enamel jewelry, bracelets, cufflinks, earrings, bowls, and ashtrays." However, in the early 1950s, he also began to collaborate with several local architects, creating doors, decorative panels, light fixtures, and furniture for churches and synagogues, schools, libraries, and businesses. Among his most celebrated works are large-scale sculptures that adorn various parks throughout the Pacific Northwest. After the early foray into jewelry and other functional forms, his work in enamel began to focus almost exclusively on wall panels. His subjects varied greatly, ranging from still lifes to complete abstractions, often with humorous content. His work is recognizable for its vividly colored and boldly graphic imagery.

In 2010 Harold Balazs's contributions to the field were celebrated in a major retrospective exhibition organized by the Northwest Museum of Arts and Culture in Spokane and in a monograph published by the University of Washington Press. His work is in the collections of the Northwest Museum of Arts and Culture; the Jundt Art Museum, Gonzaga University, Spokane; the Missoula Art Museum, Montana; and others.

The figurative subject of this early large multi-part panel, comprising more than thirty brilliantly colored, individually enameled copper tiles, is identifiable only through the presence of the oddly staring eye in the central top panel. A key, used to tighten the strings on a violin, cello, or bass, appears below and to the left of the eye, suggesting that the elusive figure is playing a stringed musical instrument. In its brilliantly contrasting colors and its near-complete abstraction, *The Eye* represents a fine example of the artist's dual interests in abstraction and the figure.

# Fred Uhl Ball

## 1945–1985

*Bowl*
1968
Enamel on copper
1⁷/₈ x 11¹/₂ x 11¹/₂ in.
4.8 x 29.2 x 29.2 cm
Signed on the reverse:
*Fred Ball 1968*

Fred Uhl Ball's remarkable compositions using unorthodox enameling techniques are highly regarded by generations of enamelists. An inspiring teacher and supportive colleague, Ball helped fellow artists push the boundaries of their medium through the workshops he offered as well as through his widely influential 1972 publication *Experimental Techniques in Enameling*.

Ball was born in Oakland, California. His father F. Carlton Ball (1911–1992) was a prominent and well-regarded ceramist, author, and educator and his mother Kathryn Uhl Ball (1910–2000) was an accomplished illustrator and enamelist. From an early age, he studied enameling with her and by the time he was twelve, he demonstrated enameling technique at the California State Fair in Sacramento. After participating in Chapman College's "World Campus Afloat" program from 1966 to 1969, he returned to Sacramento where he received his BA and MA from the California State University.

Although he was well grounded in traditional technique, Ball's approach to enameling was audaciously experimental. He applied enamel to metal employing highly unorthodox processes and used both kiln and torch firing techniques to produce boldly provocative new work. During the course of his relatively brief life he created numerous large-scale compositions for public spaces and businesses in and around the Sacramento area. He is best known for the mural he created between 1977 and 1979 on the side of a parking garage in downtown Sacramento. Comprised of more than 1,488 twelve-inch square enamel on copper tiles, all individually fired, this monumental six by sixty-two foot composition entitled *The Way Home* is a tribute to the city of Sacramento and to the delta region the artist loved. Sadly, he died in 1985 from injuries resulting from a mugging in the street behind his studio. While his life was cut short, his influence continues in the work of a generation of artists who were inspired by his experimental approach to enameling and his commitment to the medium's expressive potential.

In his lively yet somber enamel on copper bowl, made in 1968, Ball created a highly gestural design by splashing, dripping, and spraying liquid enamel onto a spun copper form and then encasing it in a rich layer of transparent enamel. With its glistening surface, this bowl is among the largest vessels Ball made in the late 1960s.

Beginning about 1971, Ball produced a series of envelopes made from thin sheets of copper that he enameled in a variety of colors and textures. These envelopes, variously configured— open, closed, torn, or sealed—were often presented as gifts to friends, acquaintances, and loved ones. Art critic and friend Victoria Dalkey aptly described these pieces as "fire-tongued tales of passion...discrete whispers full of delicate nuance. Like Emily Dickinson's poems, they are his letters to the world."

This envelope was made for Ball's student and friend Donna Buchwald. In 1980 he was scheduled to offer an enameling workshop in Florida. When he became ill and couldn't teach it himself, Ball sent a colleague in his place with an envelope to give to each of the participants who had signed up for the workshop: his way of apologizing for his absence. The spirit of generosity embodied in this gesture was typical of Fred Ball's attitude toward life. As Dalkey described, something of that spirit is embedded in every object Ball produced.

*Envelope*
1980
Enamel on copper
3³/₄ x 6¹/₂ in.
9.5 x 16.5 cm
Signed on the reverse:
*Fred Ball 1980*
Gift of Donna Buchwald

*Untitled*
1982
Enamel on copper
72 x 48 in.
182.9 x 121.9 cm
Signed on the reverse:
*Fred Uhl Ball 1982*
Partial gift in memory of
Margaret Merrick Scheffelin

Ball's untitled composition of 1982, a collage comprising myriad fragments of enameled copper, underscores the artist's interest in producing visually dazzling work in the final three years of his life. In its brilliant gold color, its richly varied patterns and textures, and its large scale, this piece is among the most extravagantly luminous panels the artist ever created. It was made using a variety of shapes cut from copper sheets whose surfaces were etched, embossed, or engraved in abstract patterns and then enameled using various methods, some conventional, some experimental. Ball then arranged the pieces in a coherent composition and adhered the individual elements to a wooden substrate. One of only two known works produced at this scale, Fred Uhl Ball's untitled composition is a tour de force in enamel collage.

## Michael Banner
Born 1939

## Maureen Banner
Born 1946

*Container: Pitcher Plant*
2003
Sterling silver, enamel, and fine silver
3⅝ x 4 x 3 in.
9.1 x 10.2 x 7.6 cm
Signed on the bottom: *Banner 03*
*Handwrought Sterling*

Nature, the movement of grasses in the wind, ripples on water, the arcing curves of the human body, or the abstract flow of a melodic line all serve as inspiration for Michael and Maureen Banner's highly inventive designs in silver and enamel. Their exquisitely wrought forms are the result of a close creative partnership between an exceptionally talented silversmith and his equally gifted wife. While their work is conceived and developed collaboratively, through an intuitive back-and-forth design process, Michael typically forms the silver and Maureen provides a counterpoint to the cool lucidity of the silver with richly colored enamel and subtle naturalistic detail.

Michael Banner was born in Kalamazoo, Michigan, and, while largely self-taught, he studied metals briefly with Frederick Miller at the Cleveland Institute of Art and enameling there with John Paul Miller and Kenneth Bates. Maureen, the daughter of a potter, was born in Chicago, and trained as a ceramist and painter. She studied at several institutions in the Midwest including Northern Illinois University. She also studied sculpture with Nelli Bar Wieghardt at the Art School of the Art Institute of Chicago. She is the colorist in the family. However, many of the forms the Banners produce emerge from her years of experience exploring the organic, malleable properties of clay.

The Banners have been collaborating since they were married in 1968. In the early years of their partnership, they were best known for the fine jewelry they produced and sold at high-end craft shows throughout the country including the American Craft Council and Smithsonian Craft Shows.

However, since about 1980 they have been producing hollowware forms, including multi-part tea and coffee services with inventive organic shapes and gracefully attenuated handles. For these sets, Maureen frequently produces enamel lids that add vibrant color to their spare, modernist design.

As they begin to develop the idea for a new piece—a process which usually emerges somewhat organically from a previous work—Maureen creates a preliminary sketch. They then use this conceptual rendering as a point of departure, refining the design as their ideas develop. Once they settle on a form, Michael cuts Bristol board into the desired shapes to use as a three-dimensional model. He subsequently cuts the silver using the Bristol board as a pattern as he shapes and assembles the piece. Maureen then develops a design for the enamel lid and finishes it in rich enamel color. The Banners are both drawn to curvilinear forms and when creating sets, they tend to pair objects in evocative, complementary relationships.

In the lid they created for this dramatically shaped silver box, the Banners' shared interest in sculptural form and vibrant enamel color are equally balanced. In addition to describing the outline of the pitcher plant, the curving lines on the lid serve as a formal counterpoint to the arcing shape of the box. Rather than using silver to contain cells of color, as is the case with most cloisonné enamel, Maureen uses her hand-cut shapes as a form of abstract drawing while silver lines flow through cool enamel color like ripples on the surface of still water. While small in scale, this lidded box is an exquisite example of the work of this extraordinary couple.

The Banners' work is in the collection of the Renwick Gallery of the Smithsonian American Art Museum; the Museum of Fine Arts, Boston; the Currier Museum of Art, Manchester, New Hampshire; and the Fuller Craft Museum, Brockton, Massachusetts.

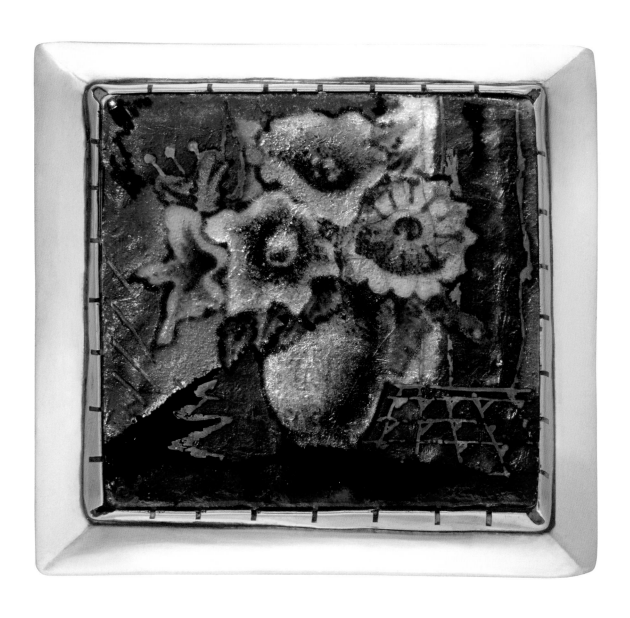

# Kenneth F. Bates

1904–1994

*Brooch*
1947
Enamel on copper, sterling silver
2 x 1³/₄ x ³/₈ in.
5.1 x 4.5 x 1 cm
Signed on the reverse:
*K F Bates '47*

Described in a 1967 issue of *Ceramics Monthly* as the 'Dean of American Enamelists,' Kenneth Bates was a highly imaginative artist, a prolific writer, a skilled teacher, and an indomitable champion of enameling. He was born in North Scituate, Massachusetts, a small coastal town south of Boston. From 1922 to 1926 he studied painting at the Massachusetts School of Art in Boston where he was awarded his BS in 1926. In 1924 he was briefly introduced to enameling through Laurin Hovey Martin, one of the leading enamelists in this country in the first quarter of the twentieth century. Bates's early experience with Martin—as well as his exposure, through his studies in Boston, to Arts and Crafts philosophies—informed his work and his artistic beliefs throughout the remainder of his life. In 1927 Bates was invited by the Cleveland School of Art to teach design. He remained at that institution, influencing several generations of Cleveland-based artists, until his retirement in 1968. He exhibited his work throughout the country, but especially at the Cleveland Museum of Art's May Show until he died in 1994.

Bates was an extraordinarily versatile artist with extensive knowledge of enameling technique, from cloisonné to plique-à-jour. While he explored a variety of subjects and themes in his work, he is best known for his plates, plaques, and vessels, decorated with images from nature, including plants, flowers, leaves, butterflies, and birds. He was fundamentally a colorist whose palette featured a wide range of brilliant hues, often presented in startling and vibrant juxtapositions, and he frequently incorporated *paillons*, small pieces of gold or silver foil, into his work to give it even greater visual appeal.

Educator, mentor, leader, writer, and spokesperson for the field, Kenneth Bates had an immeasurable impact on enameling in this country in the early years of its development. His work, and particularly his book *Enameling: Principles and Practice* published in 1951 and illustrated with his own work as well as that of the most prominent artists, influenced an entire generation of enamelists, and his dedication to technical exploration opened the field to new designs, materials, and inventive approaches to this venerable medium.

This brooch, dated 1947, is typical of Bates's early work. A diminutive painting in enamel, it depicts an expansive, rich, and colorful interior with a vase of flowers presented on a table. Lines in gold enamel form a receding grid pattern, lending spatial depth to the composition. The plaque is placed in a sterling silver setting of the artist's own devising, creating an intimate, wearable small painting.

Color also predominates in Bates's circular plaque *Memories of Youth* of 1953. Humorous in content, the composition is Cubist in its structure, with broken planes reassembled to give a sense of fractured and layered space. In this work Bates was undoubtedly reflecting on his childhood. Raised on a farm, Bates left home in his teens to pursue his dream of becoming an artist. In this image as he leaves the farm of his youth dressed in stylish clothes, he carries a brightly colored exotic bird in his arms, an emblem, perhaps, of his aspirations for the future. As he departs, two brooding hens and several large eggs are humorous symbols of the rural world he left behind.

*Mid Summer*, which was shown in the influential 1959 exhibition *Enamels* at the Museum of Contemporary Crafts, is among Bates's most boldly experimental pieces. Comprising ten separately enameled elements, attached to metal stems and arranged at different heights, the composition presents an array of vividly patterned butterflies hovering above a loosely rendered field of grass. In this work, Bates created a richly complex construction and a moving homage to the quiet beauty of the natural world of his garden.

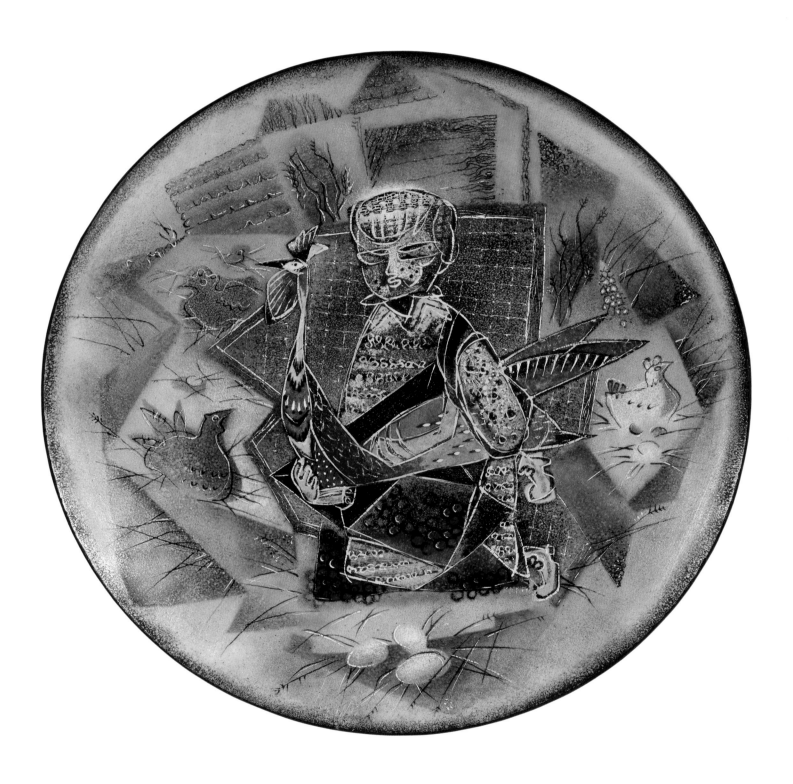

*Memories of Youth*
1953
Enamel on copper
1¼ x 11½ x 11½ in.
3.2 x 29.2 x 29.2 cm
Signed on the reverse:
*K F Bates '53*

*Mid Summer*
1958
Enamel on copper
Overall:
14 x 12 in. x 3¼ in.
35.6 x 30.5 x 8.3 cm
Signed on the lower right: *K Bates*
Paper label on the reverse indicating the title

# Jamie Bennett
## Born 1948

*Chadour #18*
2002
Enamel on copper, gold
2⅛ x 2⅛ x ⅝ in.
5.4 x 5.4 x 1.6 cm
Purchased with funds contributed by the
Windgate Charitable Foundation

With the color sensibilities of an abstract painter and the formal and structural interests of a sculptor, Bennett has created a body of work that is at once powerfully raw and elegantly refined. His abiding love of color and his embrace of rich decorative patterns are apparent throughout his work. Something of an iconoclast, Bennett has created both wearable and non-wearable forms—including jewelry, sculpture, drawings, and paintings—that defy the notion of preciousness so often associated with contemporary studio jewelry and enamels. Having produced a rich diversity of work over a career spanning more than forty years, he was honored in 2008 with a major retrospective that began its tour at the Fuller Craft Museum, Brockton, Massachusetts, and traveled to several other venues throughout the country.

The son of a designer for a prominent dress manufacturer in New York, Jamie Bennett was raised in an artistically rich environment. He left New York in 1966 to study business administration at the University of Georgia where he was awarded a BBA in 1970. However, in his senior year he took several classes that sparked his interest in art and led him in an entirely unexpected direction. He went on to receive his MFA at the State University of New York at New Paltz in 1974, where he studied with the master silversmith Kurt Matzdorf and an emerging leader in the metals field Robert Ebendorf. Bennett was introduced to enameling by Matzdorf and became more deeply interested in the medium after reading Margarete Seeler's important book on enameling technique. To learn more, he enrolled in a workshop at the Penland School of Crafts in North Carolina with the innovative young artist William Harper, and subsequently with the influential Harold B. Helwig. After teaching at several universities in the Midwest and New England, Bennett returned to the State University of New York at New Paltz where he taught from 1985 until his retirement in 2014.

Bennett's earliest work in enamel, produced in the late 1970s, is highly structured and rather subdued in color. In the early 1980s he introduced brilliant color and inventive new shapes to his enamel jewelry. While his style became increasingly loose and painterly through the 1980s, his enamels were usually framed within clearly delineated silver bezels. Starting about 1988 with his "Priori" series, Bennett abandoned the enclosure of the bezel and began to use an electroforming process to make highly sculptural copper shapes he then enameled on all sides. These raw, twig-like forms, enameled fully in the round, broke radically from tradition and forged a new identity for contemporary jewelry. Over the past ten years he has returned to using the bezel as a form of framing device. However, the dynamic power and evocative poetry unleashed in his "Priori" series continue to appear as fundamental characteristics of his work.

Throughout Bennett's work there are frequent references to nature. Rather than describing its elements in copious detail, he is interested in how the forms of nature—plants, leaves, berries, seed pods, and flowers—have been interpreted by various cultures around the world, from the figurative imagery seen in Persian miniatures to the abstract patterns of Islamic ceramics, mosaics, and textiles.

*Chadour #18* is part of a series of work that alludes to the cloaks worn by women in Islamic countries. Bennett first visited Istanbul in 1999 and was intrigued by the brilliantly colored veils he saw. In its configuration with five circular shapes radiating out from a large central orb and its use of gold, *Chadour #18* is also reminiscent of traditional forms of jewelry from the ancient Near East. However, the rich color and painterly application of the enamel are distinctly and inventively contemporary.

# Franz W. Bergmann
## 1898–1977

*The Master Magician*
c. 1955
Enamel on copper
³/₄ x 6¹/₂ x 6¹/₂ in.
1.9 x 16.5 x 16.5 cm
Signed on the reverse:
*The Master Magician F Bergmann*

Franz Walter Bergmann was born in Austria and raised in Vienna in the waning years of the Austro-Hungarian Empire. After serving in the Austrian army during the First World War, Bergmann enrolled in the National Academy of Art in Vienna where he embarked on a seven-year course of study focusing on figure painting and portraiture. He graduated in 1925. Although academically trained, Bergmann brought elements of a more avant-garde style to his work including the brilliant palette and simplified pictorial structure of German Expressionist painting and an interest in myth, folklore, and popular forms of entertainment that was influenced by what he had seen in early twentieth-century Viennese painting, sculpture, and design.

He left Vienna in 1925 to tour Europe, traveling in early 1926 to the United States. After living in New York and Chicago, Bergmann decided to move to San Francisco in 1929. Once there, Frank Bergman, as he was then known, exhibited his work at several prominent galleries and was awarded prestigious commissions including murals for the Sir Francis Drake Hotel that are still in place. By the end of the decade, Bergmann was considered one of the most significant modernist painters working in Northern California. During this period he also illustrated children's books, including *This Way to the Circus* in 1938. In the early 1940s he taught at various institutions in the Bay Area, including the California School of Fine Arts. After the war he decided to devote his artistic output solely to jewelry, ceramics, and enamels. While his jewelry was abstract, his ceramics and enamels were, like his paintings and murals, figurative.

In 1952 he was involved in a serious car accident that left him with two broken legs. Because of his limited mobility, he began to focus exclusively on enameling and his work soon became very popular. In addition to direct private sales, he also sold his work through Gump's, San Francisco's leading retailer of home furnishings and high-end specialty goods. By 1959 he was considered one of the foremost figures in the contemporary enamels field and his work was included in the exhibition *Enamels* at the Museum of Contemporary Crafts.

His early work as a children's book illustrator led him to explore similarly fanciful themes and subjects in his colorful enamel plates and vessels. In addition to depicting children and their various activities and playthings, he illustrated episodes from a variety of novels, plays, and operas. Throughout his work in enamel, his images are rooted in the modernist style for which he had become famous in the late 1920s. Inspired by Cubism and Surrealism, his subjects are always rendered in flat planes, superimposed on each other, resulting in a complex, layered arrangement. His preferred method of enameling was the painterly Limoges technique which he used for the central subject of each work while he executed the background following the most basic approach, sifting enamel powder onto the metal surface. At times, he also explored the cloisonné technique, using copper wire instead of the more traditional silver. Bergmann always signed and titled his work.

In this plate titled *The Master Magician*, Bergmann presents a fanciful depiction of a performer. His clothing, including his hat, coat, and sleeves, are exaggerated to suggest the multitude of items concealed within. His assistant is partially seen in a box floating in the center of the composition, her "disappearance" an indispensable part of the magician's act. All these elements are typical of the whimsical yet thought-provoking work Bergmann produced throughout the mid-1950s.

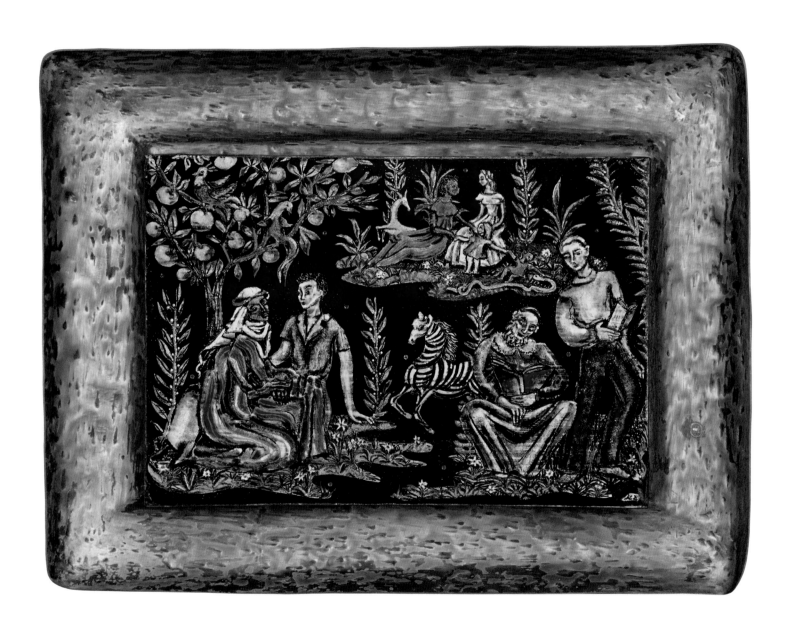

# Kathe Berl
## 1908–1994

*Man in Paradise*
1948
Enamel on copper, brass
Plaque:
6¹⁄₂ x 9¹⁄₈ in.
16.5 x 23.2 cm
Overall:
10¹⁄₈ x 12⁵⁄₈ x 1 in.
25.7 x 32 x 2.5 cm
Signed in the lower right: *KB*
Various labels on the reverse
indicating title and provenance
Gift of the Pen and Brush, Inc.

A boldly experimental artist and a dedicated educator, Kathe Berl described her passion for her medium in *Glass on Metal*, "The art of enameling is ancient yet eternally new . . . so versatile and open to development. . . . Each piece I do is a stepping stone to the next and fulfillment will never come. I want enamel to express every idea I am feeling . . . whether tongue-in-cheek or in a serious vein. To play it like an instrument. I love my instrument."

Born in Vienna, Berl began art classes in 1917 at a school run by Franz Cižek, an early proponent of art education for children. During her studies she was exposed to a wide variety of art and craft disciplines from painting and carving to embroidery, illustration, and metalwork. She later attended Vienna's acclaimed Kunstgewerbeschule. First exposed to enameling after she graduated, Berl felt an immediate attraction to the medium, a passion that never wavered throughout the course of her long and productive career. She moved to New York in 1939 and gained her first national recognition when two of her enamels were accepted into the 1948 Syracuse Ceramic National. She was to participate in this prestigious exhibition in 1949, 1951, 1952, 1954, 1956, 1958, and 1970. She also exhibited in the Decorative Arts and Ceramics Exhibition in Wichita in 1952.

In her earliest work, Berl used the painterly Limoges technique. However, after exploring other traditional formats such as grisaille and plique-à-jour, she began to adopt a highly experimental approach to enameling, taking her work to new and unusual levels of inventiveness. In the early 1960s Berl began to incorporate enamels in her three-dimensional forms. Embedding plique-à-jour enamels into her work, she lit her sculptures from behind or from within the structure, to produce an effect reminiscent of stained-glass windows. This new body of work quickly gained prominence and was featured in an exhibition organized in 1965 by the Artist-Craftsmen of New York for the National Design Center. Her desire to make transparent enamel sculpture on a monumental scale drove her research and experimentation well into the 1970s. Enamelist Katharine Wood described Berl in the June 1995 issue of *Glass on Metal*, "She was a risk taker, finding ways to be innovative, unconcerned whether it was 'commercial' enough. Her imagination was without limits and she was unafraid to try the 'impossible.'"

Berl was also committed to sharing her knowledge about the field and became a prominent writer and educator. In 1950 she and Mizi Otten co-authored a manual on enameling technique entitled *The Art of Enameling; or, Enameling Can Be Fun*, one of the earliest how-to books on the subject to appear in this country. In 1958 she began a regular column on enameling techniques for *Ceramics Monthly* and in 1962 she contributed to the book *Crafts for the Aging*, published by the American Craft Council. Finally, in 1988, just six years before her death, she became a contributing writer to *Glass on Metal*.

*Man in Paradise*, one of the two pieces by Berl that were featured in the Thirteenth Ceramic National in 1948, is an exceptional example of her work in the painterly Limoges style. In this buoyant composition, individuals of widely differing ethnicities, religions and ages— blacks and whites, Arabs and Jews, young and old, alike—join together in a sun-infused landscape in which family, literature, and learning seem to be the ties that interconnect all humankind. It is all the more remarkable that this image of a peaceful, harmonious world was created three years after the end of World War II by an artist who came to the United States to escape the ravages of war-torn Europe and Nazi persecution. This work, presented in a brass frame made by Berl, is a remarkable testimony to the artist's indomitable spirit of optimism and joy.

# Emily Bute
## Born 1984

*To Regenerate: Salamander*
2007
Enamel on copper
³/₄ x 10 x 10 in.
1.9 x 25.4 x 25.4 cm
Signed on the reverse:
*Emily Bute 07*

Born in Cleveland, Emily Bute attended the Cleveland Institute of Art where she studied enameling, jewelry, metalsmithing, and visual culture. Upon receiving her BFA in 2007, she moved to Brooklyn where she lives and creates handcrafted jewelry, drawing inspiration from Bauhaus designs and modern science.

In 2007 Bute created a series of work in which she explored the practical, moral, and ethical issues generated by scientific investigations into the possibility of improving and prolonging human life. For this provocative series Bute created five enamel on copper plates, each of which memorializes a creature used in scientific experiments. The animals she depicted all possess unique abilities and were being studied by researchers in an effort to apply their discoveries to improving the human condition. Through the work Bute gives voice to complex, layered observations regarding our attitudes towards life and death, beauty and decay, and remembrance.

Using a traditional cloisonné technique with lustrous silver *paillons*, Bute places each deceased creature in the center of the composition against a white background that is intentionally mottled. Inspired by Victorian mourning portraits, Bute surrounds the animal with a floral wreath using it not only as a framing device, but also as a symbol of life, victory, and immortality. The lush wreath of blue, pink, and white flowers is a tribute to those creatures—some fearsome, some awe-inspiring—who, through their death aided scientific research and helped advance medical technology. The complex set of emotions the artist feels towards these experiments is suggested in the ring of black leaves and vines around the border of the platter, rendered in stark and rather menacing silhouette. She seems to suggest that this research embodies, at once, humanity's hope for regenerative abilities and our hubris in longing to attain a god-like status.

Bute wrote, "This body of work is a representation of my desire to fuse the decorative and the destructive, the beautiful and the sublime. I work with a set of strong contrasts to make the grotesque attractive through use of precious materials including enamel and fine metals. The studied mouse, regenerating salamander, and cycles of insect-driven decomposition are all fair game in my attempt to find beauty and worth in creatures often associated with feelings of disgust. I hope that in simply viewing the pieces one can find the feeling of reverence I have for these creatures." Bute further described *To Regenerate: Salamander*, "The prime example of offering hope for human limb regeneration is memorialized in my platter *To Regenerate: Salamander*. The salamander has been studied for its remarkable ability to grow back its own severed limbs."

# Harlan W. Butt

Born 1950

*Manjusri #1*
1998
Enamel on copper, silver
4³/₄ x 5³/₄ x 5¹/₄ in.
12.1 x 14.6 x 13.3 cm

A leader in both the contemporary metals and enameling fields, Harlan Butt produces superbly crafted, intimately scaled vessels in copper, silver, enamel, and brass. While rooted in utilitarian form, his work with its richly layered metaphors rises to the level of fine metal sculpture. For more than thirty years, Butt has investigated mankind's relationship to nature—or, in his words, "the earth beneath our feet"—as he explores the spiritual implications of simple natural things.

Born in Princeton, New Jersey, Harlan Butt studied metalsmithing at the Tyler School of Art in Philadelphia where he received his BFA in 1972. He continued his work with metals at Southern Illinois University where he was awarded his MFA in 1974. A committed educator, Butt has taught at the University of North Texas in Denton since 1976.

In both form and content, Harlan Butt's work has been profoundly influenced by Japanese philosophy and aesthetics. His interest in nature, simplicity, asymmetry, and indeed, in enamel itself, emerges from his exploration of Asian cultural traditions. Butt is also a poet and the traditional Japanese haiku, a highly succinct form of expression, is his preferred genre. Occasionally words or fragments of words appear on his vessels, lending rich layers of meaning to his work.

His work is in numerous museum collections including the Victoria and Albert Museum, London; the Museum of Arts and Design; the Museum of Fine Arts, Boston; and the Renwick Gallery, Smithsonian American Art Museum, Washington, D.C.

Butt described his abiding interest in nature, "I have used the tops of my vessels as a stage to spotlight a scene from nature. In the series entitled 'Earth Beneath Our Feet,' I have tried to describe a landscape that exists, not as a view of the distance or as a window of observation opening out to a panoramic horizon, but as the place on which we stand. The viewer is part of the landscape not apart from it. Within these vignettes I have described scenes in nature: a snake sneaking up behind a frog, a butterfly alighting upon some elk scat. The scene often tries to describe both the beauty and the disturbing character of nature or the simultaneous delicacy and crudeness of nature from a human perspective."

In discussing his pair of *Manjusri* vessels—of which this piece is one—Harlan Butt said, "I made the two in 1998. The year before I had modeled and cast in bronze a statue of *Manjusri* for the Albuquerque Zen Center. But the enamel pieces are only abstractly related to the religious mythological figure. Manjusri is the bodhisattva of wisdom. He is often depicted with a sword that symbolizes cutting through ignorance. The puzzle-piece-like pattern I used on *Manjusri #1* was supposed to indicate the complexity and interconnectedness which is both incredibly beautiful and distracting from our true nature. Of course, this is an attempt to put a literal explanation on something that was more intuitive than logical." This extraordinary piece is one of the artist's most sophisticated and most highly abstract compositions.

64

# J. Anthony Buzzelli
## 1907–1982

*Three Clowns*
1960
Enamel on copper
10 x 8⅜ in.
25.4 x 21.3 cm
Signed in the lower center: *JABU*
Signed on the reverse:
*Joseph A. Buzzelli "Three Clowns"*

Like many of his colleagues in the enamels field, J. Anthony Buzzelli was a multifaceted artist who produced work in a wide variety of media including paintings, watercolors, drawings, and ceramics as well as enamels. Often signing his work *JABU*, a shortened version of his full name, he was critically acclaimed for his experimental work in enamel.

The son of Italian immigrants, James Anthony Buzzelli was born in Old Forge, Pennsylvania. After his father died in a coal mining accident, Buzzelli, the oldest of eight siblings, worked in the mines to support his family. In 1927 he moved to New York and enrolled in classes at the Art Students League. He subsequently studied at the University of Southern California, Columbia University, and in Paris at the Ecole des Beaux Arts and the Académie de la Grande Chaumière. His earliest work which depicts downtrodden laborers and moments from daily life of the urban poor reflects both his own origins and the influence of Social Realism then popular in this country. After traveling to France in the late 1940s, his palette became more colorful and his subjects more joyous and celebratory. Over time, his work in all media—painting, watercolor, and enamels—became increasingly abstract.

An emerging leader in the enamels field in the late 1940s, Buzzelli was included in the Ceramic National in Syracuse in 1948. His work was subsequently featured in the influential 1959 exhibition *Enamels* at the Museum of Contemporary Crafts and in the *Imperial Exhibition 1961*. This high-profile exhibition was organized to promote the launch of the Chrysler car company's new 'Imperial' line and it was presented at their flagship showroom in midtown Manhattan.

In 1960, when his work was exhibited at the Vera Luzuk Gallery in Cold Spring Harbor, New York, Buzzelli was described in an article in *Craft Horizons* as, "a pioneer in the enamels field." According to the review, the work he showed ranged from small two- and three-inch ashtrays to ten-foot long architectural panels. In discussing his enamel on steel mural decorations, the artist stated, "I have been trying to achieve the durability and quality attained by the Chinese enamelists and I think I have done it. No fine art today is so well suited in terms of permanence for outdoor architectural installation."

With its energetic strokes of vivid color against a light ground, *Three Clowns* is boldly gestural and as powerfully expressive as the Abstract Expressionist paintings that inspired it. In this work, out of a cacophony of improvisational marks, the faces of three clown figures emerge to give further definition to the overall composition. The opaque colors describing the faces and costumes lie beneath a layer of raised, clear transparent enamel that has been dripped onto the surface lending the composition a richly layered depth.

# Jessica Calderwood
## Born 1978

Jessica Calderwood's best-known early works typically depict commonplace events and activities—a woman eating a strawberry or a girl fondling a string of pearls. However, in these arresting compositions something always seems odd, something is amiss or slightly askew. These offbeat notes lend an element of the surreal to her imagery. The artist's ability to discern strangeness in the commonplace, the truth hidden behind a layer of artifice, lends her work its mystery and its power. The subject of quotidian vice is especially compelling to the artist. In a series of works entitled "Mother's Little Helper," a woman takes a pill—probably a sedative—to help her deal with her day-to-day challenges. While the title prompts a somewhat humorous response, the depiction also captures a compelling moment of quiet desperation.

Born in Cleveland, Calderwood received her BFA from the Cleveland Institute of Art where she studied enameling with Gretchen Goss. She subsequently received her MFA in metals from Arizona State University in 2005. Calderwood's work, including her jewelry, panels, sculpture, and installations, reflects her interest in the human body and in capturing those moments in time when our strengths and frailties are most fully exposed. She has also expanded the expressive potential of enameling by using the medium as but one tool among many in her exploration of provocative subjects and highly inventive forms. Calderwood is a multifaceted artist for whom draftsmanship is fundamental and in many of her compositions, the grisaille elements closely resemble finely rendered drawings.

Calderwood described her interests in the following terms: "Sexuality, gender, human relationships and issues surrounding the body are subjects that often permeate my work. Some of my drawings and forms are very literal interpretations, while others are more abstracted and ambiguous. My drawings often reference images from the media and popular culture to convey my ideas. My most recent pieces are psychological portraits addressing the idea of personal obsession and consumption in contemporary culture."

In Calderwood's *Smoking Boy*, a child, with a determined, defiant look on his face, puffs on a cigarette. Referencing Early Renaissance portraits in which sitters are often placed against a rich, gold background, the artist juxtaposes the innocence of the boy with the audacity of illicit smoking. In works such as this, Calderwood deftly captures those stolen moments in time when everyday people pursue their little vices, thinking that no one is looking. This particular event is further memorialized through Calderwood's use of gold foil to render the moment all the more iconic.

*Overgrown*, a brooch Calderwood made in 2013, is part of the ever-expanding flower series she began in 2010. About that time, the artist's interest shifted from other people's passions and vices to issues that were more personal to her as a woman, a wife, and a mother. For these pieces, Calderwood drew on similarities between the life cycles of plants and those of humans. Further research into flowers and their use throughout history as symbols of the feminine led her to draw upon the various meanings and apply them to her work. In this piece a woman's head is nearly completely covered with an overgrown array of plants leaving visible only the lower part of the face, primarily the lips and the chin. Rather than being rendered anonymous as in many of Calderwood's other recent works, this figure is still in control as she retains the all-important power of speech.

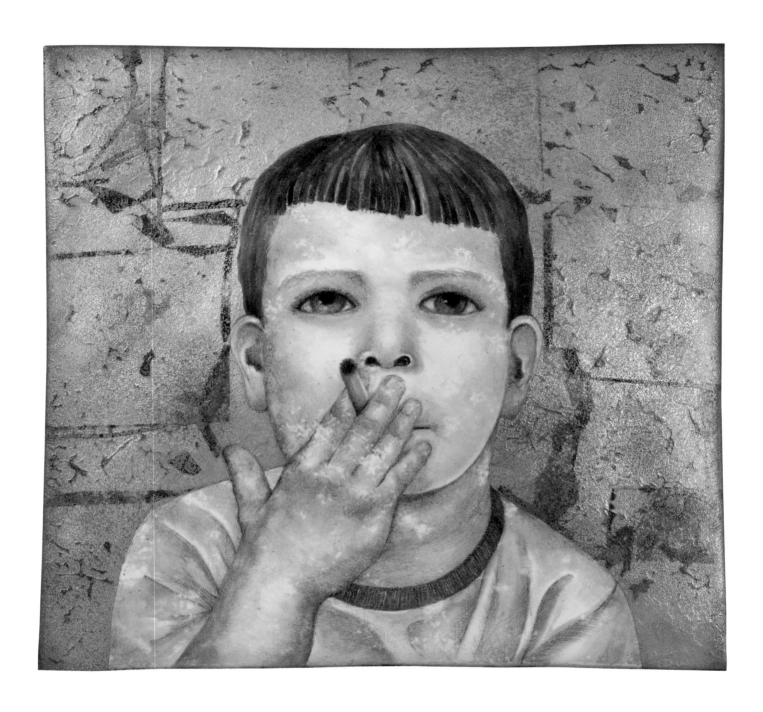

*Smoking Boy*
2005
Enamel on copper
12 x 12 x 1 in.
30.5 x 30.5 x 2.5 cm

*Overgrown*
2013
Enamel, copper, ceramic decals, sterling
silver, stainless steel, and pearls
3 x 2¹/₂ x ¹/₂ in.
7.6 x 6.4 x 1.3 cm
Signed on the reverse: *JC 2013*

# Virgil D. Cantini

1919–2009

*Opus*
1971
Enamel on steel
31 x 24 in.
78.7 x 61 cm
Signed on the lower left:
*Cantini 1971*

Best known for the brilliantly colored, abstract murals he created for public spaces in and around Pittsburgh, Pennsylvania, Virgil Cantini was among the leading figures in the mid-twentieth-century American enamels movement. Born in Italy, he moved with his family to the United States in 1930, settling in Weirton, West Virginia, a coal-mining town west of Pittsburgh. Cantini attended the Carnegie Institute of Technology (now Carnegie Mellon University) on a football scholarship and was awarded his BFA in 1946. There his mentor, the silversmith Frederick Claytor, introduced him to enamels and the medium soon became his preferred form of expression. He went on to earn his MFA from the University of Pittsburgh in 1948, and began teaching there in 1952. He remained at the university in roles of increasing responsibility through his retirement in 1999.

Cantini's enamels gained national exposure in 1948 when a work entitled *Masquerade* was juried into the Thirteenth National Ceramic Exhibition at the Syracuse Museum of Fine Arts. Starting in 1949, he also participated several times in the Wichita Art Association's Decorative Arts and Ceramics Exhibition. In 1951 Wichita purchased *Saint Francis*, one of his panels, for its collection. In 1950 the Department of Fine Arts at the University of Pittsburgh organized a groundbreaking exhibition entitled *History of Enamels: VII–XX Century*. Cantini was represented in the show by nine works. In 1952 an interview with the artist conducted by Dorothy Sterling appeared in the nationally influential periodical *American Artist*. This was followed by another mark of distinction in 1953 when he was named one of the "Hundred Leaders of Tomorrow" in a *Time* magazine poll. By 1959 he was considered one of the most significant contemporary enamelists and his work was featured in the exhibition *Enamels* at the Museum of Contemporary Crafts.

Cantini's style changed dramatically during the course of his long and productive career. His early work was predominantly figurative, well suited to his interest in religious themes and subjects. Based on this work, he was awarded numerous commissions by churches throughout the greater Pittsburgh area. However, during the 1950s and 1960s, Cantini's style evolved. His figures, still an important part of his work, became increasingly abstract as his palette became bolder and more energized.

In the early 1970s he abandoned the figure and narrative subjects altogether as he developed a greater interest in pure non-descriptive color and abstract form. Steel, rather than copper, panels became more prevalent and his colors became increasingly vibrant as his application ranged from loose and gestural to hard line and flat. In a publication titled *Virgil Cantini Enamels* published around 1974 by the Art Education Department of the University of Pittsburgh, forty-six works all labeled *Opus* created between 1970 and 1973 were illustrated. Cantini chose this title to designate this new body of work, probably alluding to the Latin term used by composers to refer to the sequence of their musical compositions. Inspired simultaneously by music, space exploration, and formal abstraction, Cantini's enamel on steel panels are among his most progressive compositions. Later in life, he gave specific titles to his works.

In *Opus* of 1971 Cantini created a formal dialogue between a complex array of radiating lines, overlapping planes, geometric forms, and the random splashes of color scattered across a brilliant enamel surface. In this work two oval shapes, one in white and the other in black, dominate the composition. These soft organic forms provide a dramatic contrast to the linear angularity of the composition. As the darker oval may be read as a shadow of the white, they also lend a sense of spatial recession and depth to the composition. This richly dynamic enamel-on-steel panel represents one of the finest works in Cantini's "Opus" series.

# Herman Casagranda
1917–2011

*Untitled*
1983
Enamel on copper
8¹⁄₈ x 24¹⁄₂ in.
20.6 x 62.2 cm
Signed on the lower right:
*HA Casagranda 1983*

Herman Casagranda was born in Ouray, a small mining town nestled in the mountains of southwestern Colorado. As a child, he moved with his family to Denver where he graduated from East High School. Following three years of service in the Navy during World War II, he attended the University of Denver, graduating in 1949. He later earned an MFA in fine arts from the same university. Casagranda taught in the Denver public school system for thirty-one years, offering courses in drawing, painting, enameling, sculpture, and art history. He retired from teaching in 1982.

Listed as a woodworker in Denver's 1937 city directory, Casagranda trained in a variety of disciplines before settling on enamel as his preferred medium. Something of a romantic, he built a chalet for his family in Frisco, Colorado, which he decorated in a medieval style with many of his hand-crafted pieces including shields, chandeliers, coats of arms, and a life-size knight. He spent many hours there doing fine woodwork.

Largely self-taught as an enamelist, he produced a wide variety of work including abstractions, floral images, and plaques depicting birds, fish, and religious themes, along with his favorite subjects: medieval court jesters, knights, kings, and unicorns. He also received ecclesiastical commissions from churches and synagogues throughout the Denver area, including twelve panels depicting the twelve tribes of Israel for the Hebrew Educational Alliance, a crucifixion for Our Savior Lutheran Church, and a Torah breast plate for Temple Emmanuel.

Casagranda's work was shown in several important exhibits including the 1948 National Ceramic Exhibition at the Syracuse Museum of Fine Arts and the Decorative Arts and Ceramics Exhibition at the Wichita Art Association in 1959, as well as exhibitions at the Joslin Art Museum, Omaha, Nebraska; the Denver Jewish Community Center; the Rocky Mountain Liturgical Arts Association; and the Denver Art Museum.

Casagranda discussed his interest in enameling in the following words:

> The art of enameling is of great interest to me because it affords me the opportunity to express many of my ideas or feelings towards things in this world which fascinate me. The range of my work runs from the realistic to the very abstract. All of my work is done in the 'as I go along manner.' I have no real definite or precise ideas in mind as to how I am going to handle or treat my subject. As I work along things like color, forms, etc., tend to lead my way to the final statement. I work and am guided by the commands of my conscience and innermost feelings directly with the medium. This is the simplest manner in which I can explain how I derive my art work.

In its vibrant color, augmented by brilliant *paillons*, this three-panel abstraction is one of Casgranda's most dazzling compositions. Against a rich red background, there is an interplay of geometric forms and amorphous shapes mixed with silver and gold foil, some precisely cut, others appearing to be randomly shredded, interspersed with raised beads of glass. Produced relatively late in the artist's life, it exemplifies his philosophy of working with the material in a random, spontaneous manner that expresses his personal sentiments and ideas. According to his son, this work was one of the artist's favorites and he kept it for his own personal collection throughout his life.

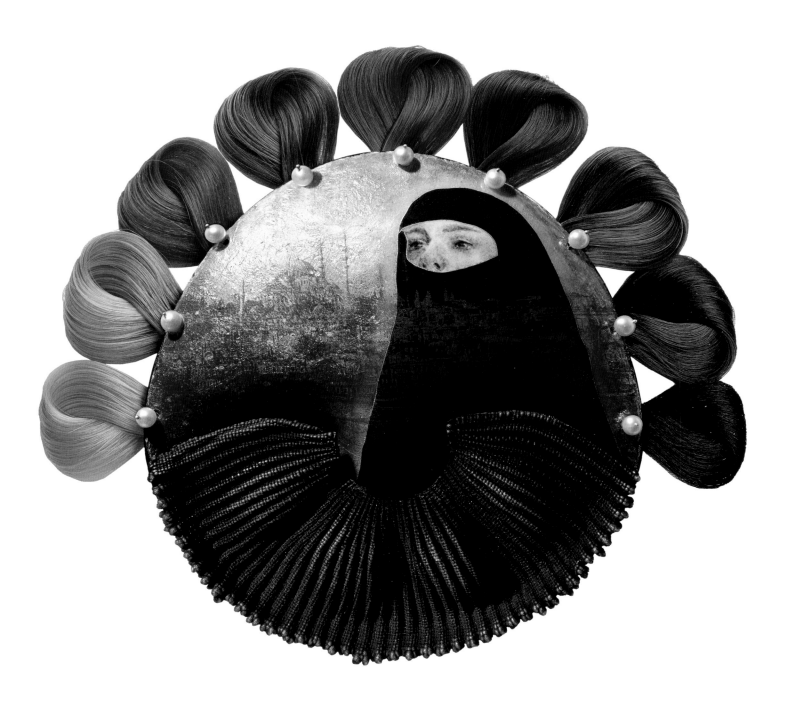

# Mary Chuduk
Born 1955

*Veiled*
2009
Enamel on copper,
electroformed copper,
hair, and pearls
7 x 7½ x 1 in.
17.8 x 19.1 x 2.5 cm

In her richly layered sculptural narratives, Mary Chuduk explores such compelling issues as gender, ethnicity, religion, and the ways in which cultural bias shapes identity and our perception of one another. Like several of her contemporaries, Chuduk uses enamel as just one tool in a multifaceted technical arsenal to achieve beautiful and powerfully thought-provoking work.

Born in Chicago, Mary Chuduk received her BFA from Illinois State University in Normal. She was subsequently awarded an MFA at Northern Illinois University where she studied metals with Lee Peck. She continued her studies at the University of Grenoble and pursued post-graduate work in metals at Arizona State University where she studied with David Pimental.

Chuduk's work tends to defy categorization as she continuously experiments with a variety of materials and forms. Over the years, she has mined traditional techniques such as *camaïeu* to create compelling narratives in enamel. In other work, she manipulates copper to fashion unusual shapes on which she draws her images and then enamels them. At one point in her career, she studied the art of Chinese brush making with Jensheng Li, a master of traditional Yixing technique. She then adapted this technique, using hair from her children, her pets, and variety of other sources, in sculptural constructions that combine diverse materials with enamel to create an emotionally charged and personal body of work. In 2003 she began to use copper mesh, hand forming it into bowls, containers, and teapots that she then enameled. The forms she created were influenced by the various cultures she had explored during her international travels. As she stated, "I am following the thread of rich similarities within seemingly disparate human experiences from Eastern Europe and the mid-East, regardless of the strife and warring that plague these areas."

Chuduk has been included in exhibitions in the United States, Korea, Switzerland, Japan, India, Russia, Spain, and Canada. Her work is in numerous collections in this country including the Wichita Center for the Arts and the Mesa Arts Center in Mesa, Arizona. A highly regarded educator, she published in 2008 *Enamel Technique and Experiments*. Mary Chuduk has also taught enameling workshops throughout the United States and in Canada, Australia, Japan, Turkey, and the Republic of Georgia.

In *Veiled* Chuduk presents the quarter-length image of a woman dressed in a black *hijab* (veil) with the city of Istanbul and Hagia Sophia in the distance. This commanding image is surrounded in the upper half by twisted locks of human hair each terminating with a pearl. Arranged from blonde to black, it encompasses the variety of hair colors concealed under the hijab worn by the women who live in Istanbul and it reflects the rich cultural diversity of the city itself. An electroformed bronze element that resembles the lower section of a veil is placed in the foreground below the cityscape.

In discussing the body of work of which *Veiled* is a central part, Chuduk stated, "My recent work is informed by the plight of women... As I continue to read and research, I become more and more aware of the gross misunderstandings that continue to fester worldwide, especially those concerning women of various countries in the Middle East. The goal of my new metalwork is to inform, educate, and galvanize my viewers to see the wide variety of differences between many countries in relation to the powerful meanings of the veil. The visual statements in my work seek to open my viewer's eyes by providing a direct, emotional connection with the plight of covered women from a variety of countries. I see the images in my metalwork challenging the notion of what a woman can and cannot wear, and what it means to wear it in an increasingly complex global society."

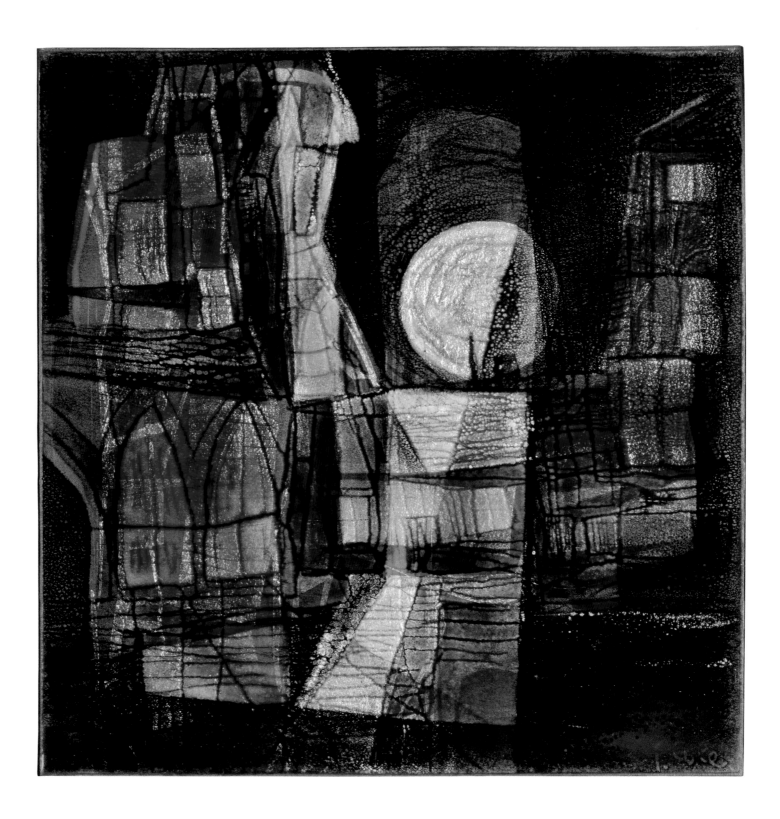

# Fern Cole
1917–1979

*City at Night*
1967
Enamel on copper
13¼ x 12¼ in.
33.7 x 31.1 cm
Signed on the lower right:
*F Cole*
Signed on the reverse:
*City at Night Fern Cole*

Born in Dwight, Kansas, Fern Cole studied painting at Bethany College, Lindsborg, Kansas, with Birger Sandzén, a Swedish-born émigré who specialized in landscapes painted in a vibrant Post-Impressionist style. In 1946 Cole moved with her husband to Akron, Ohio, where she gained prominence as an artist and educator at the Akron Art Institute (now the Akron Art Museum) and the nearby Revere Ohio School District. Multitalented and versatile, Cole worked throughout her career in a wide variety of media, including painting, ceramics, and enameling. Although she began her career as a painter, by the 1950s she was working primarily as an enamelist. Through her friendship with the artist Mary Ellen McDermott, she became acquainted with the Cleveland enameling community.

Cole received her first national exposure as an enamelist in 1954 at the Decorative Arts and Ceramics Exhibition in Wichita. The exhibition included two of her enamels, one of which won a purchase award and entered the Wichita Art Association's collection. She participated in the Wichita in 1956, 1957, 1960, and 1961, and two additional works from these shows were acquired by the association. Her first major work in enamel, *Mardi Gras*, was also juried into the Eighteenth Ceramic National in Syracuse in 1954. This complex and imaginative work, composed of nineteen individual enameled panels, evokes the color, excitement, and cacophony of the well-known festival in New Orleans. Her enamels were included in three more Ceramic Nationals in 1956, 1962, and 1964. *Mardi Gras* was shown again at the Wichita in 1956 as well as in the Ohio Ceramic and Sculpture Show at the Butler Institute of American Art in Youngstown, which purchased it for the collection. Cole submitted work on numerous occasions to the Butler exhibition, and two additional works were purchased, in 1957 and 1958. In 1962 she first presented her work at the May Show in Cleveland and continued to do so until the mid-1970s.

In 1956 Cole received a thirty-five-dollar prize for a work called *Faces*, submitted to the *Third Annual Kansas Designer Craftsman Show*, and in 1959 five of her works—two panels, two trays, and a bowl—were featured in the watershed exhibition *Enamels* at the Museum of Contemporary Crafts. In the first decade of her enamel production, her work, largely pictorial, was introspective in spite of its often-jubilant subject matter. By the mid-1960s her palette had grown more vibrant, and her subjects expanded to include still lifes. Her work gradually became more abstract, and by the late 1960s it had become highly stylized and nonobjective.

Fern Cole's increasing interest in abstraction is evident in *City at Night* of 1967. The glowing presence of abstract buildings seen against the dark night sky, as well as the outlines of windows, doors, and pointed arches, suggest the quiet poetry of the nocturnal urban landscape. Seen through layers of rich transparent color, the silver *paillons* accentuate the mystery of the nighttime setting. Cole included a full moon in her landscape—a foil disc glowing brightly above the city—to lend further drama to her luminous composition. *City at Night* was included in the Cleveland Museum of Art's Forty-ninth Annual May Show where it was awarded the Special Jury Mention.

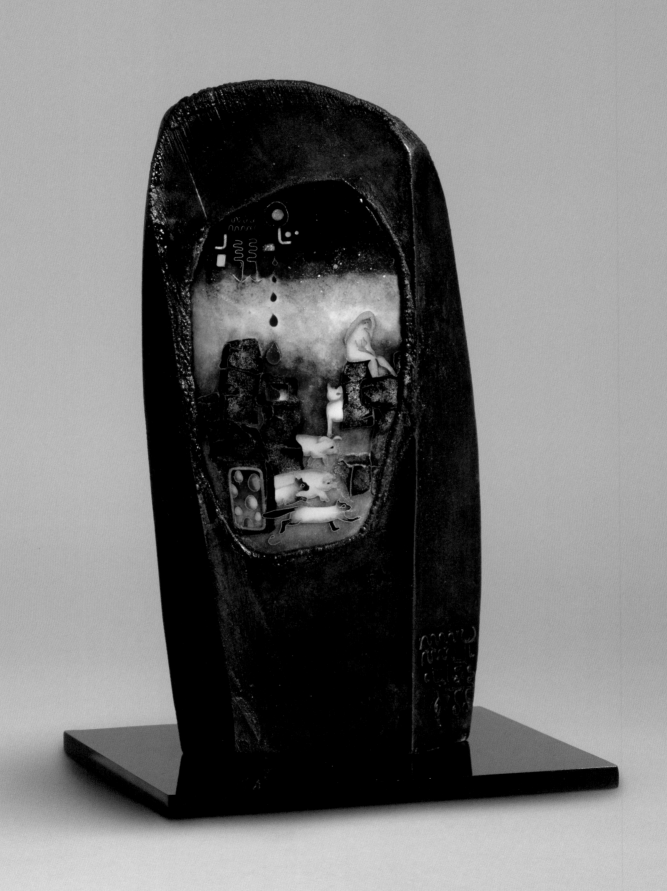

# Colette

Born 1937

*Stele 22: Woman with Familiars*
1979
Enamel on copper,
electroformed copper,
acrylic
6³/₄ x 3¹/₄ x 1¹/₄ in.
17.2 x 8.3 x 3.2 cm
Signed in the lower left: *C*

An exceptionally versatile artist, Colette has over the past forty years produced a richly varied body of work. Utilizing a wide range of techniques, materials, and formats—including enamel on fine silver, oil and alkyd on canvas, and metal and wood sculpture—Colette has created a series of evocative narratives that tend to suggest more than they describe. Since the late 1980s her cloisonné abstractions, which she calls ideograms and pictograms, have become increasingly spare, while still alluding to complex issues and themes but using radically simplified signs and symbols.

Born in Oakland, California, Colette has been exploring the cloisonné enameling technique since the early 1970s. Self taught as an enamelist, she received her California State teaching credentials in 1977. In 1978 she was awarded the jury's Prix d'Honneur at the *Fourth International Enamels Biennial* in Limoges, France, and from 1986 to 1990 she served as a trustee on the American Craft Council. Colette's work has been featured in numerous exhibitions and she is represented in the collections of the Oakland Museum of California; Philadelphia Museum of Art; Museum of Arts and Design; Smithsonian American Art Museum; the Royal Ontario Museum; and the Museum of Fine Arts, Boston.

Colette has stated, "I am not a jeweler but a maker of objects...I want my pieces to look like fragments out of history, my own personal history... My designs are full of half-buried symbols, veiled elements, like dreams. The mystery within each piece is very close to the mystery we all find in our lives: in fact, we are a mystery to ourselves."

Colette's great affinity for animals informs every aspect of her work and gives shape to her spiritual vision. Images of animals—particularly cats, ravens, and wolves—recur throughout her work. Similarly, calligraphic symbols often emerge, suggesting words and meanings in some elusive archaic language known only to the artist. Colette combines these mysterious signs and symbols in an effort to lead the viewer or, in the case of her jewelry, the wearer to a deeper understanding of themselves and a richer experience of the world.

In the late 1970s in an effort to create a broader canvas for her complex narratives, Colette produced a series of enamel panels mounted on electroformed sculptures in the shape of ancient monoliths or steles. *Stele 22: Woman with Familiars* is part of that series. In several of these pieces, enigmatic marks appear, calligraphic symbols that refer to no particular language or signs. Colette describes her interest in the following terms, "The markings represent my emotional self, and yet to the wearer or viewer, they may appear to be only a decorative feature. It can be a challenge to decipher this code...the markings of the ideogram predate language. They are the symbols of ideas and events without name, a conscious and unconscious record of feeling."

Colette also portrays complex dream-inspired narratives in the enamel panels on these steles. In her hauntingly poetic work *Stele 22: Woman with Familiars*, blocks of stone have tumbled in disarray as droplets of blood fall from the heavens. Cats and pigs roam the decimated landscape, as a dejected female figure sits high atop the rubble, seemingly guarded by a stolid white cat. However, beyond the apocalyptic landscape, the scene opens to a sky filled with sparkling gold dust, offering an element of hope to an otherwise bleak prospect. Here Colette has combined hope and despair in a poetic counterbalance. In discussing a related body of work, Colette described her intentions, "I want to state in quite palpable terms the paradoxes we live with: exaltation and sorrow; tension and relief; rationality and passion; the physical and the transcendent."

# Linda Darty
## Born 1952

*Garden Candlestick*
1999
Sterling silver, fine silver,
and enamel
3½ x 2⅞ x 3⅜ in.
8.9 x 7.2 x 8.6 cm
Signed on the base:
*Linda Darty*

Equally adept at enameling and fine metalwork, Linda Darty has over the past twenty-five years created a richly evocative body of work informed by memory, celebration, and connection. She describes her interests in the following terms: "The imagery I choose to put on my vessels reflects cherished moments in my life—the times and people I want to remember and record. Some of the pieces are actually of drawings my young children created, but others are from images I created myself, like the Garden Candlesticks that are embellished with drawings taken from the rose bushes in my mother's garden."

Raised in a rural town in Florida, Darty first became interested in art while on a study abroad program in Italy during her sophomore year in college. In 1975 she received her BS from the University of Florida, Gainesville, with a focus on art education and ceramics. After teaching high school for several years, she took a job at the Penland School of Crafts in North Carolina where she was first exposed to enameling. Her teacher Harold B. Helwig became her mentor, introducing her to many of the leading figures in the field. During her time at Penland, she took almost every enamels course offered, including workshops with such luminaries as Martha Banyas, Jamie Bennett, James Malenda, and Mel Someroski. This broadened her experience and strengthened her resolve to pursue enameling as her preferred medium.

Wanting to further hone her metalworking skills, she enrolled in graduate school at East Carolina University in Greenville, North Carolina, where she was awarded her MFA in Metal Design in 1989. While still a graduate student, and under the direction of master silversmith John Satterfield, Darty established the university's first formal enamels program.

A frequent lecturer, Darty is an articulate champion of the enameling field. Her book *The Art of Enameling: Techniques, Projects, Inspiration*, which combines a detailed review of enameling techniques and practices with an informed discussion of artists' ideas and motivations, was published in 2004. Widely exhibited, Linda Darty's work is in the collections of the Victoria and Albert Museum, London; the Arkansas Arts Center, Little Rock; and the Museum of Arts and Design.

Darty has created a wide variety of pieces ranging from brooches to candlesticks and vessels. The underlying inspiration for her work is her love of flowers. The artist stated, "I received my first formal color and design lessons from my mother and when I learned to arrange flowers while a member of the Junior Garden Club." Darty compares her brooches to enameled garden badges that pay tribute to the efforts of the women of the Garden Club. Her floral candlesticks are also inspired by nature as they assume the shape of real and imagined blossoms enameled in brilliant and often unexpected colors.

Darty's vessels, which are among her most exceptional pieces, reflect her ability to create metalwork that is both structurally complex and inventively enameled. Among the various containers she has created are bowls, cups, and candlesticks. The subtle palette she uses on these hollowware forms distinguish this work from her more brightly enameled and descriptively detailed floral candlesticks. *Garden Candlestick* is a fine example of her hollowware vessels. This piece is particularly meaningful because the artist created it for her mother and it remained in her personal collection for much of her life. As in her other vessels and containers, Darty used cloisonné wire to draw images of flowers and leaves on the surface of her metal form. She especially loves the process of layering enamel to achieve subtle variations that evoke the coloristic variety of the actual plant. But she is also interested in functionality, metaphor, and memory. The artist wrote, "Though taken out of the context of utility, it is important to me that my vessels function, and could be lit with a candle, or raised in a toast to celebrate the memories that inspired them."

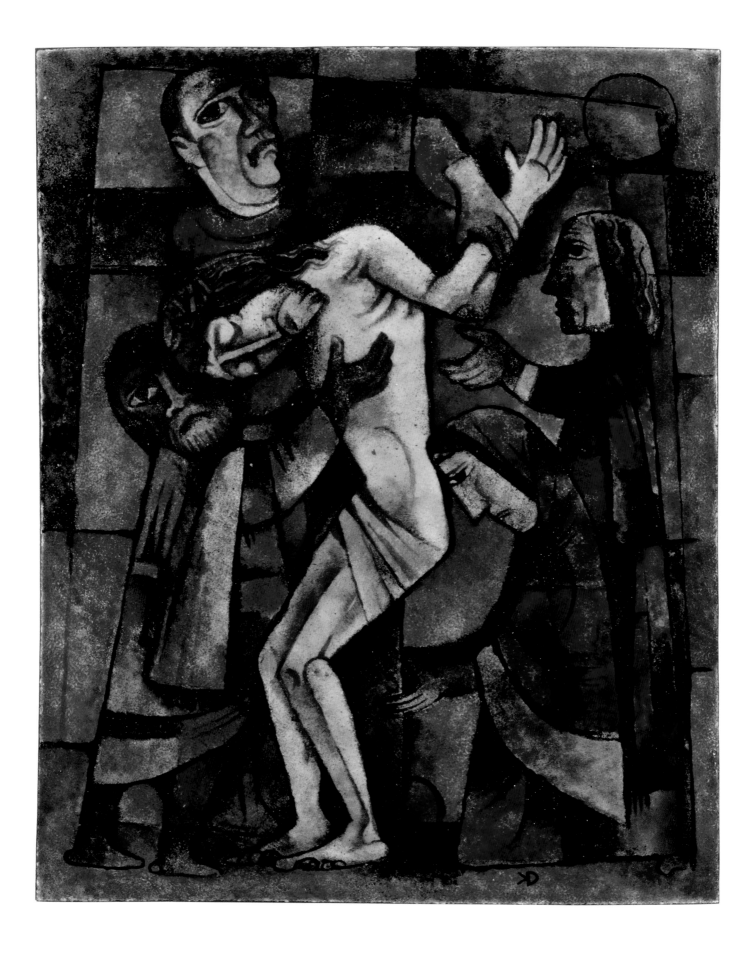

# Karl Drerup

1904–2000

*Plaque* (*Descent from the Cross*)
c. 1950
Enamel on copper
9 x 7 in.
22.9 x 17.8 cm
Signed on the lower right:
*KD* (the artist's mark)

Among the leading figures in the mid-twentieth-century enameling field, Karl Drerup is best known for his Limoges-style painted enamels that portray wooded landscapes filled with birds, bugs, and lizards, or images of farmers, sailors, and fishermen pursuing their humble daily chores. Drerup's love of nature is apparent in every detail of these intimate woodland scenes, just as his depictions of workers in natural settings reveal his profound respect for humanity. A deeply spiritual, widely read individual, Drerup also chose as his subjects religious themes, myths, and legends, or figures from the circus and the Italian commedia dell'arte. He produced these colorful, semi-abstract compositions in a style influenced by modern art in Europe, especially the paintings of Pablo Picasso and Georges Braque and the watercolors of Paul Klee.

Born in Boghorst, Westphalia, in the northwest region of Germany, Drerup studied painting in Munster and Berlin as well as at the Accademia di Belle Arti in Florence. In 1937, after living in the Canary Islands for several years, he moved to the United States with his wife Gertrude to escape impending war in Europe. It was after his arrival in this country that he took up enameling. While he pursued oil painting, drawing, and occasionally ceramics throughout his life, by the mid-1940s enameling had become his preferred form of expression. The Drerups first settled on Long Island where the artist found a job teaching at Adelphi University. However, in 1945, wanting to escape the congestion and hectic pace of New York, they moved to Thornton, New Hampshire, and made a home in a serene, wooded setting. Drerup's reverence for nature—his love of its intimate details as well as its awe-inspiring expanses—is apparent in virtually everything he created for the remainder of his long and productive life.

Drerup quickly rose to national prominence in the early 1940s. His enamels were featured in numerous exhibitions across the country as he emerged as one of the most influential artists working in the enamels field. The Metropolitan Museum of Art purchased a piece in 1940 and another in 1950 and in 1941 he was featured in a one-person exhibition that toured nationally. In 1959 Drerup's work was presented in depth in the exhibition *Enamels* at the Museum of Contemporary Crafts.

Disavowing the widespread movement toward pure abstraction in the mid-twentieth century, Drerup pursued a more pictorial approach. Describing himself as a "traditionalist" and an "irrepressible romantic," he stated, "Art without a subject is really not attractive to me...I can't help it; I have no excuses to make for my flight backwards instead of looking forward and taking all the cues. Part of my inner need, in a sense, is to tell a story."

His loosely rendered plaque of boatmen made in the mid-1940s reflects the time Drerup spent in the Canary Islands before moving to the United States. Much of the work he produced for the remainder of his career may be seen as an homage to the humble workers and salubrious environment he encountered during this golden period in his life. With its crudely drawn, stick-like figures and its profusion of abstract signs and symbols, this work reads like a painting on the walls of an ancient cave.

A powerful work, *Descent from the Cross* is among the most consciously primitive enamels Drerup made. Educated in a strict Catholic school run by Cistercian monks, Drerup developed a rather ambivalent attitude towards organized religion. Nonetheless, Christian imagery permeated his work throughout his career, including images of heroic saints, particularly Saint George (the dragon slayer) and Saint Hubert (who while hunting in the forest saw an image of the crucified Christ appear between the horns of a stag); the Nativity; and other scenes from the life of Christ. This intimate panel depicts Joseph of Arimathea and Nicodemus taking down the dead Christ from the cross while Mary and John

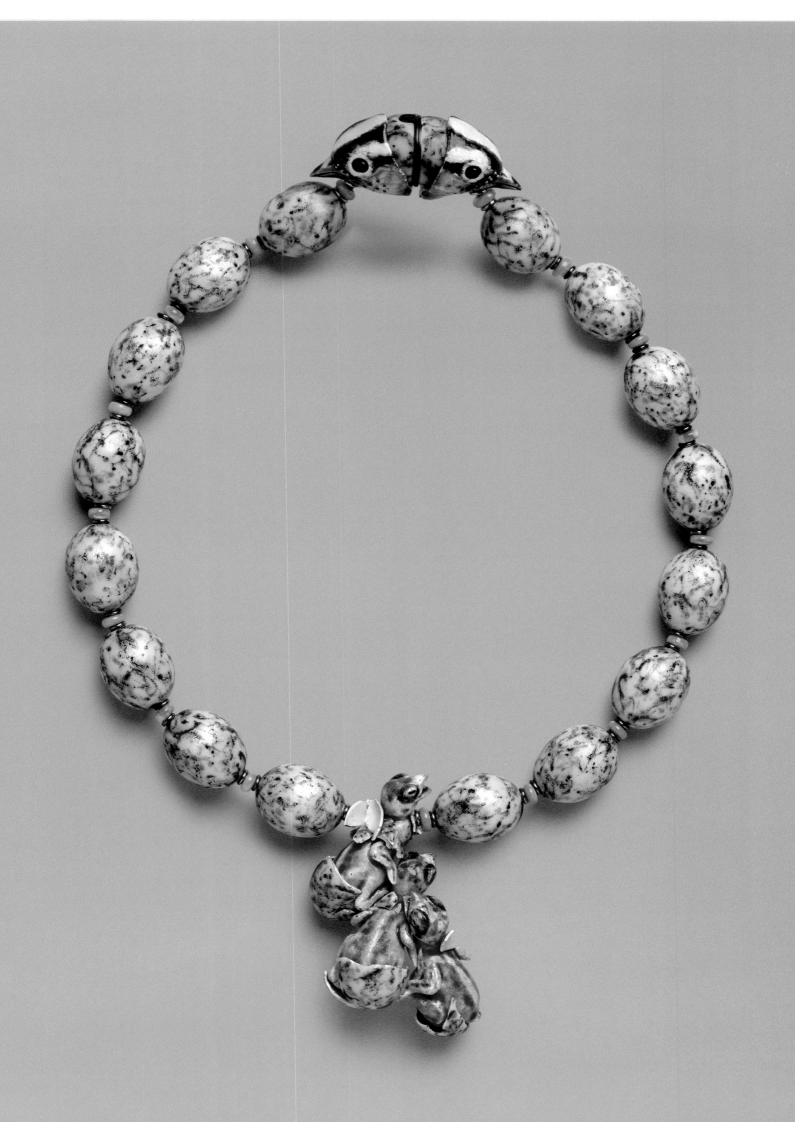

# David C. Freda
## Born 1953

*Study of Newborn White Crown
Sparrows, Eggs, and Adults*
2001
Fine silver, 24K and 18K yellow gold,
sterling silver, opals, and enamel
9 x 6¼ x 1¾ in.
22.9 x 15.9 x 4.5 cm
Signed on the clasp: *David C. Freda* ©
Purchased with funds contributed by the
Windgate Charitable Foundation

David Freda's fascination with the flora and fauna of the natural world is apparent in virtually everything he produces. From his early interest in wildlife illustration, falconry, and taxidermy to his current work depicting exotic plants and butterflies, he is curious about nature and finds poetic beauty even in its most arresting details. He is also a fastidious craftsman—a technical problem solver—who is highly dedicated to his craft. His mastery of the enameling medium combined with his knowledge of mold-making and hollow core casting techniques distinguish him as one of the leading figures in the contemporary metals field.

Freda was raised in Wisconsin where, as a child, he had easy access to nature in the woods, ponds, and streams surrounding his home. He developed an early interest in drawing and in his teens became an adept wildlife illustrator. After graduating from high school in 1974, he attended the University of Wisconsin-Whitewater where he studied painting, drawing, and ceramics. While there, he enrolled in a class with the silversmith Marcia Lewis that solidified his commitment to the metals field. After Lewis left Wisconsin for California, Freda studied with the silversmith Kelly Morris. Morris's interest in the sculpture and jewelry of Albert Paley exerted an important influence on the young artist's early work. After completing his studies in 1979, Freda traveled in Colorado and eventually headed east in 1980 to pursue graduate work in metals at the State University of New York at New Paltz where he studied with Bob Ebendorf and Kurt Matzdorf. Working there from 1980 to 1983, he began to produce forms that combined his interest in metals with his keen interest in nature. Further solidifying his commitment to enameling, Freda saw a René Lalique exhibition at the Cooper-Hewitt Museum in the mid-1990s that included Lalique's masterfully executed enameled jewelry. This rekindled Freda's interest in creating wearable forms that depict natural subjects and phenomena.

Freda gained prominence in 2002 when he won Rio Grande's Saul Bell Design Award for a necklace titled *Stag Beetles, Grubs, and Raspberries* executed in enamel on fine silver. Simultaneously attractive and startling, the necklace depicts the life cycle of a rather ferocious looking beetle along with the luscious food it devours. The award brought national attention to the innovative work Freda had been creating since the 1980s. It also led the artist to other explorations of life and death cycles in his necklaces and brooches.

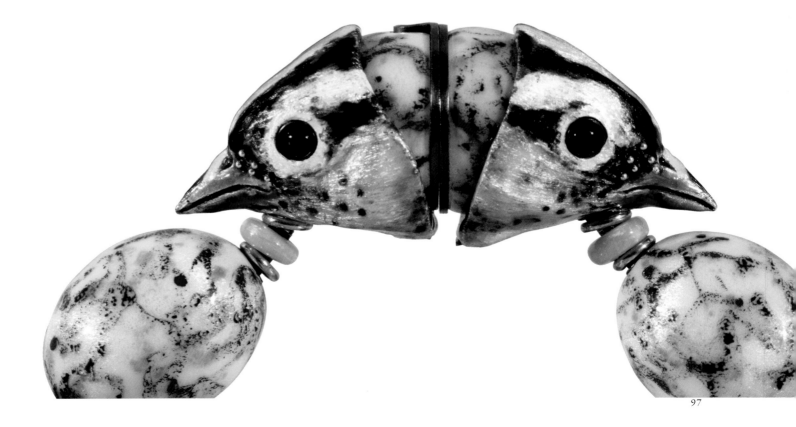

# Jill Baker Gower
## Born 1980

*Reflection #3*
2007
Enamel on copper, silicone rubber,
mirror, sterling silver, fine silver foil,
pewter, and ink
8½ x 5½ x 1¾ in.
21.6 x 14 x 4.5 cm
Signed on the reverse:
*Jill Baker Gower*

Jill Baker Gower was born in Winfield, Illinois, a small town west of Chicago. She received her BS with an emphasis on metals from the University of Wisconsin-Madison in 2003 and her MFA in metals and jewelry from Arizona State University in 2006. In Wisconsin she studied with the eminent metalsmith Fred Fenster and in Arizona she worked with David Pimental and Becky McDonah. She is currently an Associate Professor of Art, Metals/Jewelry and 3D Design, at Rowan University in Glassboro, New Jersey, where she has worked since 2007. Gower has led workshops at Arrowmont School of Arts and Crafts in Gatlinburg, Tennessee, and has been included in numerous exhibitions throughout the country. In 2009 she co-organized *Decorative Resurgence* at the Rowan University Art Gallery, an exhibition that surveyed contemporary artists' use of decorative forms to explore such issues as beauty, gender, identity, and class.

In her current work, which includes jewelry as well as sculpture, Gower combines precious and distinctly non-precious materials. Richly multi-dimensional, this work is informed by her interest in metalwork and jewelry from the Renaissance, Baroque, and Victorian periods. She is particularly fascinated by silver toiletry objects, lockets, containers, and cosmetic items. However, the historical references in her work are viewed through a contemporary lens—one in which she explores how the media, marketing, advertising, and packaging shape our understanding of beauty and our self-image. Her work subtly and humorously critiques the pursuit of beauty through constant body alteration as well as society's increasing obsession with material possessions.

In 2006 Gower began a series of work she calls "Reflections." Spanning a two-year period, the five pieces in this series explore such issues as beauty, vanity, luxury, and gender. In discussing her work, the artist has observed, "The female experience is a recurring theme in my work. The shapes and forms of my pieces come from disparate inspirations including the female form, faceted gems, historic jewelry and metalwork, and tools or implements for beautification or medical procedures."

Describing her interest in particular materials and her palette, she stated, "I choose to incorporate skin red and pink-toned colors in my work primarily to reference human flesh, cosmetics, the body, and blood. Materials such as skin-toned rubber and mirrors reference bodily transformation, self-examination, and vanity. Other materials like pearls, jewels, lustrous fabrics, feathers, enamel, hair, silver, and gold are chosen for their aesthetic qualities, emotional resonance, preciousness, and value associations. With these materials, formal considerations, and influences I create work that is both playful and beautiful and at times even absurd or humorous."

With its ornate, flesh-toned frame and its sleek, mirrored surface—further embellished with opulent decoration in colorful enamel and lacy silver foil—*Reflection #3* embodies many of the artist's concerns through its richly layered references and multiple cultural associations. In 2009 *Reflection #3* was included in *Surfacing*, the Enamelist Society's Twelfth Biennial International Juried Exhibition at the Oakland Gallery in Oakland, California.

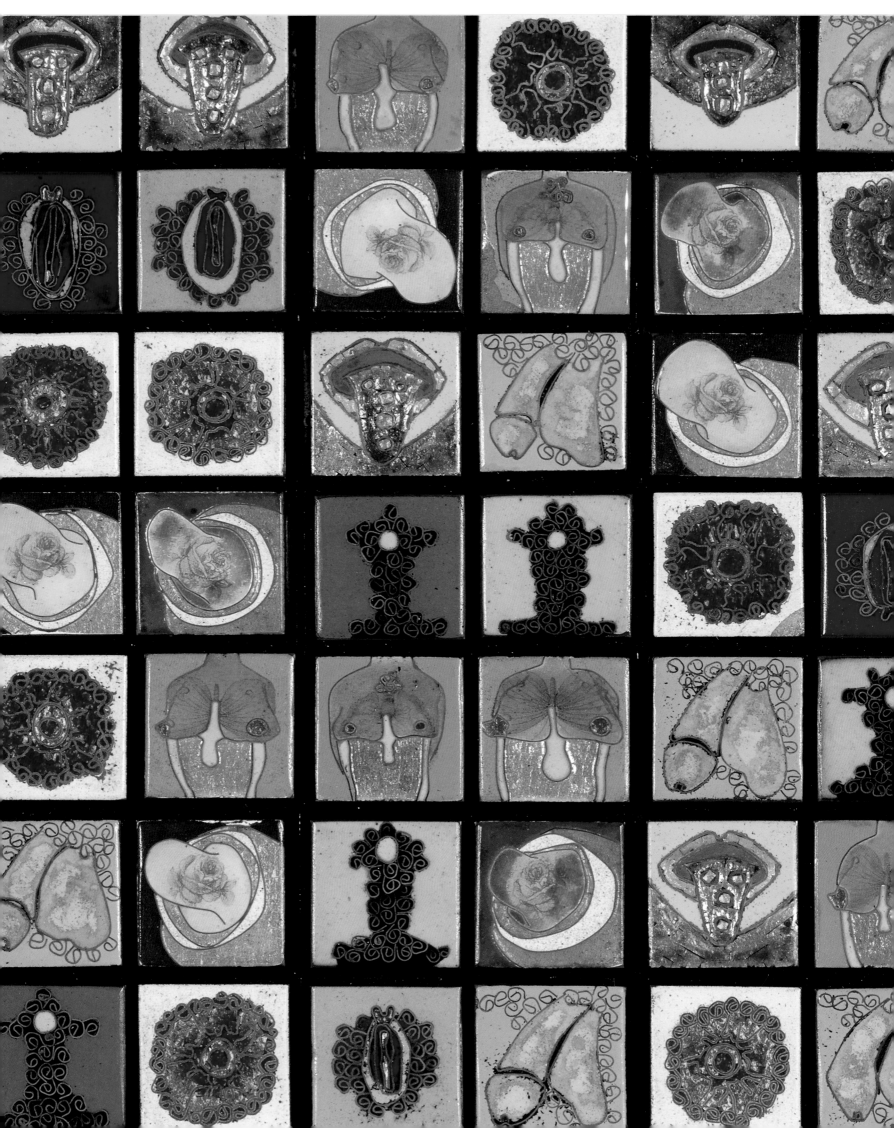

# William Harper
## Born 1944

*Dirty Dominoes #4*
1970
Enamel on copper, acrylic
1 x 9¼ x 8¼ in.
2.5 x 23.5 x 21 cm

With a unique vision, informed by a broad-ranging knowledge of art history and a keen understanding of human nature, William Harper has created a compelling and innovative body of work over the past forty years, one that exerted a profound influence on enameling in this country in the late twentieth century. Trained as a painter as well as an enamelist, he has produced a wide range of two- and three-dimensional forms, from chalices, rattles, and talismans to boxes, jewelry, paintings, and sculptural installations. An unrivaled master of the cloisonné technique, Harper creates multi-faceted objects that juxtapose his intricate enamel designs with gold, wood, and various other precious and, in some cases, distinctly nonprecious, materials. Rather than using cloisonné in the traditional way to contain cells of color, Harper employs silver and gold wires as a form of drawing, creating abstract linear rhythms in passages of rich enamel color. Throughout his work Harper establishes a provocative dialogue between opposing principles: the beautiful and the commonplace, the opulent and the mundane, the public and the intimately personal.

Born in Bucyrus, Ohio, a small town north of Columbus, he enrolled in 1962 in a five-year program offered jointly by Case Western Reserve University and the Cleveland Institute of Art. He was awarded his BS (1966) and MS (1967) degrees from Case Western Reserve with both advanced work in enameling and a certificate in teacher training. At the institute he studied with the enamelist Kenneth Bates, whose mastery of all forms of enameling and commitment to technical refinement had a lasting influence on Harper. However, he

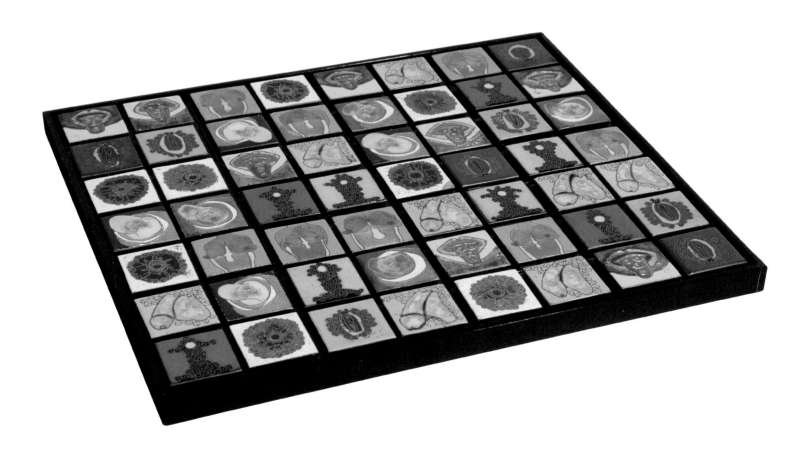

*Labyrinth*
1984
Gold, silver, cloisonné enamel
on copper, fine silver, amethyst,
tourmaline, pearl, and snail shell
3¾ x 1½ x ¾ in.
9.5 x 3.8 x 1.9 cm
Signed on the reverse:
*Labyrinth 1984 William Harper*
Gift of the McLeod Family Foundation

was also exposed to a freer, more spontaneous approach to enameling in classes offered by Mary Ellen McDermott. In 1966, while on vacation in New York, Harper first encountered the work of the enamelist June Schwarcz in an exhibition at the Museum of Contemporary Crafts. Schwarcz's highly unorthodox approach to object-making and enameling encouraged and reinforced Harper's own experiments in the medium.

In the early 1970s Harper produced a series of fetishistic rattles and amulets inspired by his study of diverse cultures and his particular interest in African art. Several years later he began to focus on jewelry, creating provocative new wearable forms that combine skillfully executed enamel, often stoned to diminish the shiny properties of the material, with fine gold and disparate non-traditional materials such as scarabs, baroque pearls, feathers, animal teeth, and bones. Endowing his pieces with rich narrative content, often of an autobiographical nature, Harper formulated a new direction for jewelry and influenced generations of artists working in the studio jewelry and enamels field in the late twentieth century.

A dedicated educator, Harper taught at Florida State University from 1973 to 1992. Harper published *Step-by-Step Enameling: a Complete Introduction to the Craft of Enameling* in 1973. His work has been widely exhibited, including a one-person exhibition in 1977 at the Renwick Gallery of the Smithsonian American Art Museum in Washington, D.C., and an internationally traveling retrospective in 1989. His work is in the collections of the Metropolitan Museum of Art, the Philadelphia Art Museum, and the Museum of Fine Arts, Boston, among many others in the United States and Europe.

*Dirty Dominoes #4* is part of the artist's "Freudian Toys Series" which he began in the early 1970s. In these works Harper placed acrylic blocks within a grid structure reminiscent of individual pieces on a gaming board. In an unusual riff on the standard board game, a cloisonné plaque, mounted on each block, depicts a lusty body part viewed in close proximity. These provocative images are rendered all the more playful through their brilliant color and joyous cartoon-like configuration. In this celebration of sexual freedom, Harper's "dominoes" are infinitely variable and can be arranged and reorganized according to the tastes and predilections of the players. *Dirty Dominoes #4* is among the most significant—and most boldly intimate—work in the series. Underscoring its importance, it was the only work from this series featured in Harper's 1977 exhibition at the Renwick Gallery.

In *Labyrinth* William Harper created a visually rich abstract composition that alludes to the maze built by Daedalus for King Midos of Crete to contain the half-man, half-bull figure of the Minotaur. Using a combination of precious and commonplace materials—gold, semi-precious stones, pearls, and the shell of a snail—Harper created a brooch that contains spiraling lines which, while seeming to lead inward—or outward—ultimately go nowhere at all. With the shield-like form of the enamel, the composition is divided into irregular quadrants, each separate and distinct from the other, suggesting impenetrable enigmas. On the back of the brooch, the artist has inscribed sharp lines in the metal, creating a drawing of the labyrinth to which the title refers.

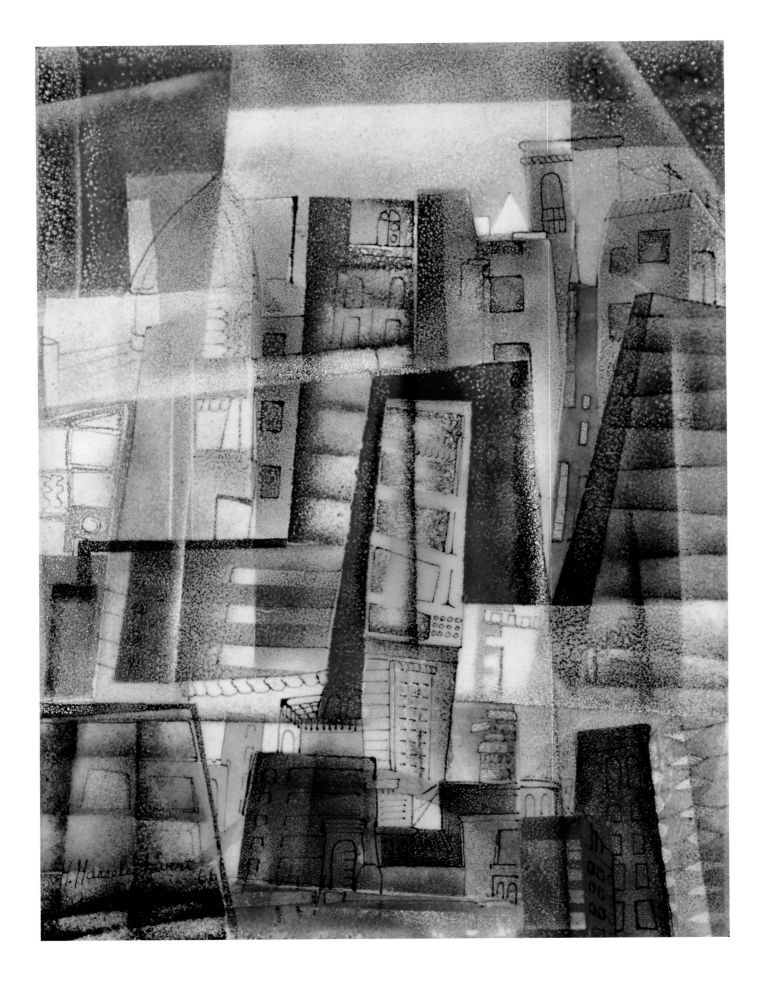

*Labyrinth*
1984
Gold, silver, cloisonné enamel
on copper, fine silver, amethyst,
tourmaline, pearl, and snail shell
3¾ x 1½ x ¾ in.
9.5 x 3.8 x 1.9 cm
Signed on the reverse:
*Labyrinth 1984 William Harper*
Gift of the McLeod Family Foundation

was also exposed to a freer, more spontaneous approach to enameling in classes offered by Mary Ellen McDermott. In 1966, while on vacation in New York, Harper first encountered the work of the enamelist June Schwarcz in an exhibition at the Museum of Contemporary Crafts. Schwarcz's highly unorthodox approach to object-making and enameling encouraged and reinforced Harper's own experiments in the medium.

In the early 1970s Harper produced a series of fetishistic rattles and amulets inspired by his study of diverse cultures and his particular interest in African art. Several years later he began to focus on jewelry, creating provocative new wearable forms that combine skillfully executed enamel, often stoned to diminish the shiny properties of the material, with fine gold and disparate non-traditional materials such as scarabs, baroque pearls, feathers, animal teeth, and bones. Endowing his pieces with rich narrative content, often of an autobiographical nature, Harper formulated a new direction for jewelry and influenced generations of artists working in the studio jewelry and enamels field in the late twentieth century.

A dedicated educator, Harper taught at Florida State University from 1973 to 1992. Harper published *Step-by-Step Enameling: a Complete Introduction to the Craft of Enameling* in 1973. His work has been widely exhibited, including a one-person exhibition in 1977 at the Renwick Gallery of the Smithsonian American Art Museum in Washington, D.C., and an internationally traveling retrospective in 1989. His work is in the collections of the Metropolitan Museum of Art, the Philadelphia Art Museum, and the Museum of Fine Arts, Boston, among many others in the United States and Europe.

*Dirty Dominoes #4* is part of the artist's "Freudian Toys Series" which he began in the early 1970s. In these works Harper placed acrylic blocks within a grid structure reminiscent of individual pieces on a gaming board. In an unusual riff on the standard board game, a cloisonné plaque, mounted on each block, depicts a lusty body part viewed in close proximity. These provocative images are rendered all the more playful through their brilliant color and joyous cartoon-like configuration. In this celebration of sexual freedom, Harper's "dominoes" are infinitely variable and can be arranged and reorganized according to the tastes and predilections of the players. *Dirty Dominoes #4* is among the most significant—and most boldly intimate—work in the series. Underscoring its importance, it was the only work from this series featured in Harper's 1977 exhibition at the Renwick Gallery.

In *Labyrinth* William Harper created a visually rich abstract composition that alludes to the maze built by Daedalus for King Midos of Crete to contain the half-man, half-bull figure of the Minotaur. Using a combination of precious and commonplace materials—gold, semi-precious stones, pearls, and the shell of a snail—Harper created a brooch that contains spiraling lines which, while seeming to lead inward—or outward—ultimately go nowhere at all. With the shield-like form of the enamel, the composition is divided into irregular quadrants, each separate and distinct from the other, suggesting impenetrable enigmas. On the back of the brooch, the artist has inscribed sharp lines in the metal, creating a drawing of the labyrinth to which the title refers.

# Jan Arthur Harrell
## Born 1952

*Introspection Instrument: Deer*
2004
Enamel on copper, deer hoof,
mirror, sterling silver,
and rusted washer
1¼ x 10 x 3¼ in.
3.2 x 25.4 x 8.3 cm

Jan Harrell is best known for her complex and visually opulent installations that explore gender-based issues in moving, humorous, and always thought-provoking ways. Her 'magnum opus,' an on-going, multi-part installation called *Vanitas: The Muse in Her Boudoir*, was first presented at the Goldesberry Galley in Houston in 2010. Comprising what the artist describes as a "vanity set for a larger-than-life persona, a muse who is bawdy and joyful, embracing life to the fullest," the exhibition included a wide array of the artist's enameled sculpture. While some works in *Vanitas* celebrate pure visual opulence, others elicit a layered response, an artful confounding of attraction and repulsion, new and old, beauty and obsolescence.

Born in Houston, Harrell moved with her family to Sukagawa, Japan, when she was just six months old. Her father was a textile engineer who loved to deconstruct and rebuild equipment and appliances and her mother, who was deeply interested in Asian art, studied sumi-e painting while the family lived abroad. Harrell asserts that, "my joy in life is a direct product of these two wonderful people." In an interesting way, through repurposing commonplace tools (funnels, paint brushes, rusty saw blades, etc.) to discover new meaning in the mundane, Harrell's work reflects her parents' complementary interests in mechanical form and pure beauty.

Harrell also acknowledges that her first eight years spent in Japan had a profound impact on her own artistic sensibilities. Her love of lush silks and brocades, as well as her fascination with the richly patinated married metals seen in samurai weapons, and her fondness for the spare, uncluttered Japanese design aesthetic, shaped her future direction and interests in art.

She returned with her family to Lubbock, Texas, in 1960. Harrell studied jewelry and enameling in high school then continued her interest at Texas Tech University, one of the few places where enameling was taught. She studied with Donna Read, majoring in jewelry with a minor in enameling, and was awarded her BFA in 1974. Her earliest work includes spun copper bowls enameled in spare colors with complex design patterns. This progressed to hand forming intricate metal shapes that would become the basis for the exploration of more personal issues. Combining elements such as barbed wire, a real baby deer leg, and other found materials with metal that she forged, hammered, chased, and treated in various finishes including enamel, Harrell explored personal objects of adornment and ritual. With time the size of the objects grew from small jewelry to hand-held or wall-mounted pieces. After raising a family, she resumed her studies at the University of Houston where she was awarded an MFA in sculpture in 2007. She currently teaches enameling at the Glassell School of Art in Houston where she has worked since 1992.

*Introspection Instrument: Deer* is part of a series of nine objects the artist made between 2002 and 2005. These highly original forms in the shape of hand-held mirrors or magnifying glasses combine enamel on copper with a variety of found and manufactured objects including deer hooves, wood, nuts and bolts, rusty washers, rubber, glass, and gold foil. In several of these instruments, including this piece, letters and numbers appear on an enamel orb suggesting the possibility of language. However, these signs and symbols are scrambled rendering any form of direct communication impossible. Harrell's talismanic devices with their reflective surfaces suggest that no matter how cryptic or elusive, the answers to life's mysteries lie within.

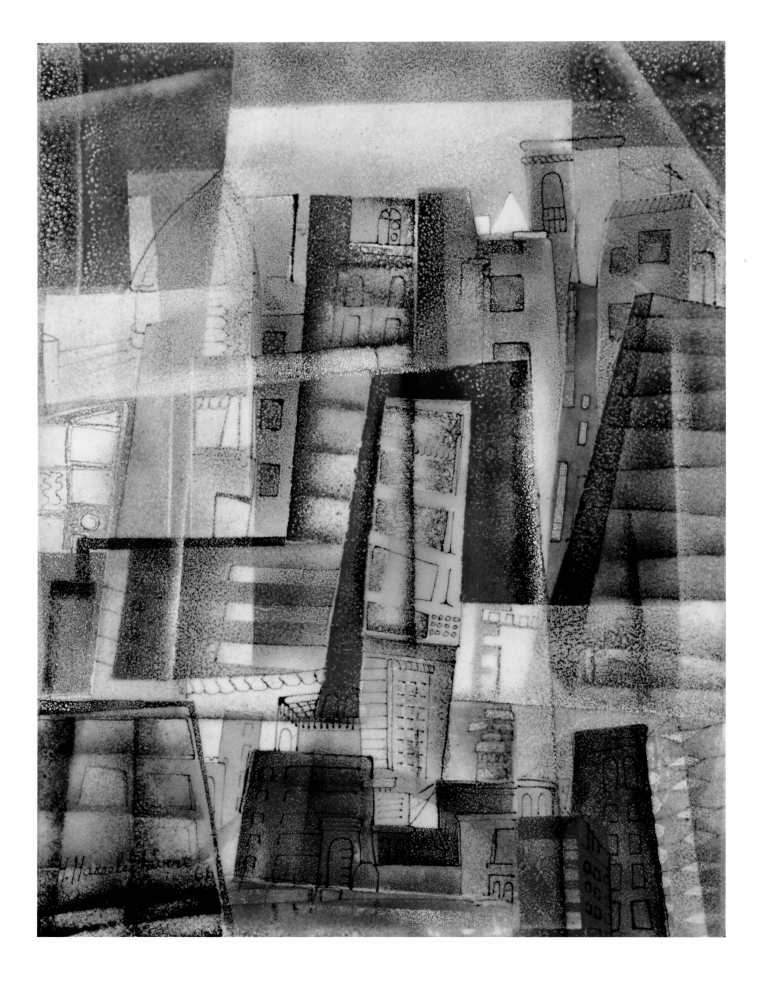

# Harold L. Hasselschwert
## 1930–1990

*Plaque* (*Cityscape*)
1966
Enamel on copper
12½ x 9¼ in.
31.8 x 23.5 cm
Signed in the lower left:
*H. Hasselschwert 66*

Harold Hasselschwert is best known for his richly ornate gold and silver jewelry with brilliantly colored champlevé enamel decoration. Describing Hasselschwert's approach to his work, Tom Madden, an artist and former Hasselschwert student, stated, "Above all Hal was a romantic. His work reflected a fascination with beauty and the exotic. He did not limit his jewelry design to any single style, but rather embraced many different historical sources and artists. Details from Indian, Oriental, and Asian cultures, along with elements from the Baroque, Art Nouveau, and Expressionism, combined to produce uniquely personal objects."

Harold Hasselschwert was born in Toledo, Ohio, a city recognized since the late nineteenth century as the capital of the glass making industry in this country. In 1948 during his senior year in high school Hasselschwert became interested in enameling and enrolled that summer in a workshop at the Cleveland School of Art. After serving in the Navy during the Korean War, he returned to northwestern Ohio to study at Bowling Green State University where he was awarded both his BA (1958) and MA (1959) degrees. He subsequently taught metals and enameling at Bowling Green from 1965 to 1990.

In 1960 Hasselschwert was awarded a Fulbright Fellowship and traveled to India to study at the Government College of Arts and Crafts in Lucknow. While there he explored champlevé enameling. Much of his later work done using this technique was influenced by his Fulbright experience. In discussing his fascination with champlevé, Hasselschwert later stated, "This technique necessitates skill in engraving and a fine understanding of enameling methods and practices. The enamels used are almost always transparent and approach the brilliance of jewels. Characteristic of my adaption of this ancient technique are simple forms richly ornamented by flowers, vines, birds, and organic cell-like motifs. I want a finished work to convey the idea of romance, opulence, and formality."

Hasselschwert's work was included in numerous group and one-person shows at the Toledo Museum of Art between 1950 and 1988. Between 1958 and 1970, he was regularly featured in the prestigious Decorative Arts and Ceramics Exhibition at the Wichita Art Association, winning first prize in the jewelry category in 1962 for a silver and champlevé enamel pendant. Reflecting his expanding role in the national arena, he was included in the Museum of Contemporary Craft's *Craftsmen of the Central States* in 1963 and in the influential exhibition *The Art of Enamels* organized at the State University of New York at New Paltz in 1973. Today, examples of his work are in the collections of the Butler Institute of American Art in Youngstown, Ohio, and Bowling Green State University.

This formally complex, Cubist-inspired panel is a rare example of Hasselschwert's two-dimensional work. In this 1966 composition, planes of subtle pastel color overlap one another as buildings emerge and recede in space, providing a vivid image of the rich complexity of life in the urban environment. *Cityscape*, once owned by Dr. William Jerome III, president of Bowling Green State University from 1963 to 1970, was included in a 1966 one-person exhibition at the Toledo Museum of Art. A significant piece in the artist's career, it was one of only five enamel on copper plaques chosen for that exhibition which featured more than fifty examples of Hasselschwert's jewelry.

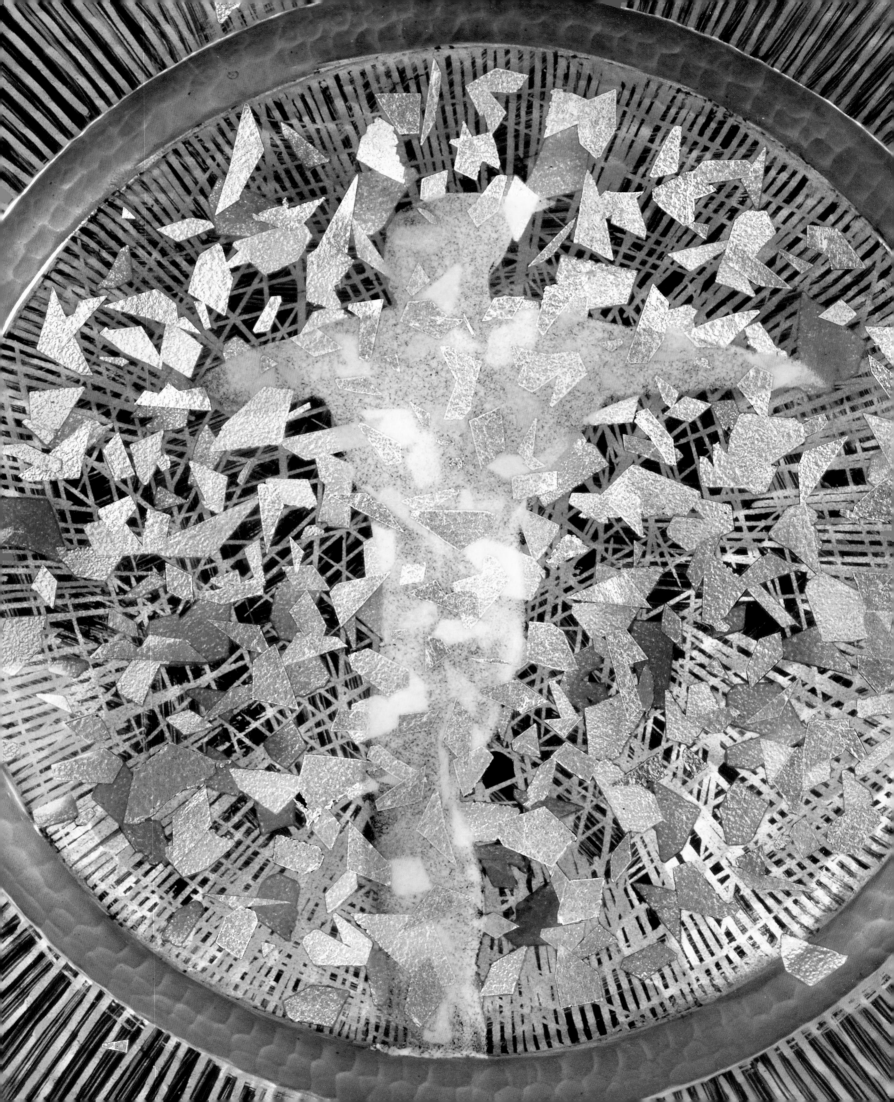

# Harold B. Helwig
## 1938–2012

Harold B. "Bill" Helwig was among the most imaginative and technically adept artists working in the twentieth-century enamels field. The tender beauty of his poetic compositions is matched only by the virtuosity with which he executed them. Relationships; human sexuality in its wondrous diversity; desire for the other, coupled with a quest to know oneself; and spiritual yearning, in all its traditional and distinctly nontraditional forms, are the subjects that engaged his imagination for more than forty years.

Born in Wellington, Kansas, Helwig spent part of his childhood with his grandparents who encouraged his thirst for knowledge, urging him to constantly explore because "there is always more to know." In 1956 Helwig enrolled as a premed student at Fort Hays Kansas State College. However, by 1958 he had changed his major to art. After studying with Joel Moss, a student of the preeminent American watercolorist John Marin, Helwig began to pursue watercolor as his principal interest. In 1959 he was introduced to enameling while assisting the jeweler Deirdre Burant prepare for her master's exhibition. Learning on his own through trial and error and by using Kenneth Bates's *Enameling: Principles and Practice*, he became fascinated with the medium. After military service in Europe, where he visited art museums as often as possible, he was appointed assistant director of the Creative Craft Center at the State University of New York at Buffalo in 1964. While there he resumed enameling at the encouragement of Jean Delius, a nationally prominent metalsmith. From then on, enameling became his preferred medium.

Helwig's enamels from the late 1960s—intricate compositions, executed on both three-dimensional vessels and two-dimensional plaques—frequently depict human figures in complex, highly charged relationships. These early grisaille images are grainier, more vaporous, and less distinct than Helwig's later more clearly articulated compositions. In the early 1970s he began to cut into his copper plates and plaques to create dynamic sculptural forms in metal to which he applied his sensuous figurative imagery. With its mingling of images, which include seashells of various sizes, black and white pearls, a female head viewed in profile, and a nude male figure emerging from a shell, *Venus Giving Birth to a Black Pearl* of 1974 is a complex example of Helwig's work of this period. Additionally, he fumed the surface to create an iridescent effect on the white-over-black enamel.

Over time Helwig's work took on an increasingly rich color palette as he continued to explore a wide array of techniques, employing them in a fresh and original manner. *Sentinel: Amid Time* is among the most luminous compositions Helwig ever produced. With its centrally placed figure, spectral and with arms outstretched, Helwig's composition takes on a profoundly spiritual dimension. Early in his career, Helwig described his interest in creating objects that would persist beyond his life and carry forward the very essence of his being. He stated, "In my work I embody an enduring meaning of my way of life and thereby an object is formed that has duration: from this one can come to understand the nature of beings living and dead, and what endures is the unswerving directive, the inner law of one's being, which determines all action." With its lines radiating from the center of the composition and its brilliant cacophony of randomly placed silver and gold *paillons*, *Sentinel: Amid Time* fully embodies Helwig's objectives and is a tour de force in virtuosic enameling.

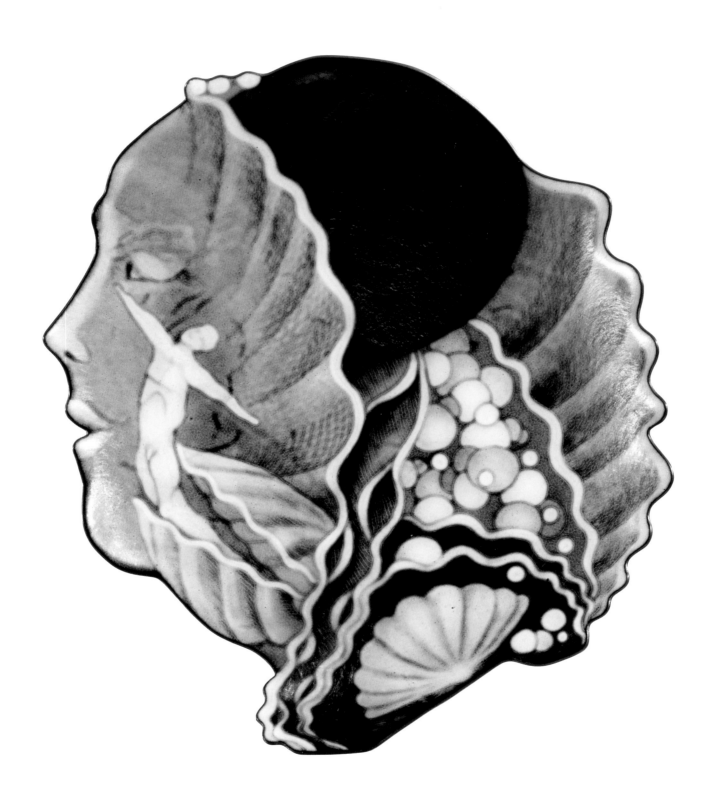

*Venus Giving Birth to a Black Pearl*
1974
Enamel on copper
⁷/₈ x 7⁷/₈ x 6⁷/₈ in.
2.2 x 20 x 17.5 cm
Signed on the reverse:
*HB Helwig 70024*

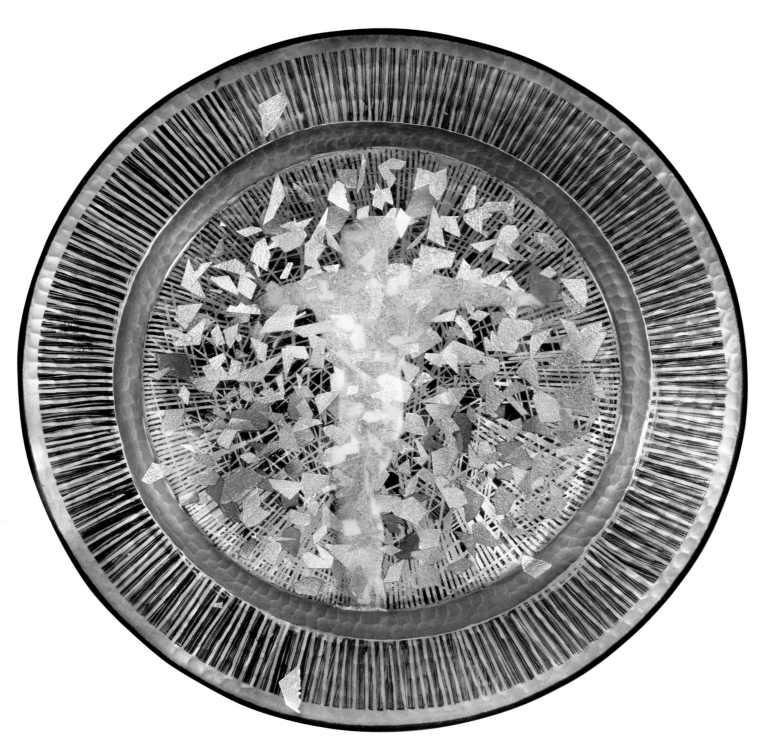

*Sentinel: Amid Time*
1992
Enamel on copper
¹/₄ x 11³/₄ x 11³/₄ in.
.6 x 29.8 x 29.8 cm
Signed on the reverse:
*Harold B. Helwig 1992*
Label on the reverse indicates title,
date, and venue of exhibition

# Maggie Howe

*Le Jazz Hot*
c. 1950
Enamel on copper, wood
6½ x 23 x 1¼ in.
16.5 x 58.4 x 3.2 cm
Signed on the end
of the horizontal bar:
*Maggie Howe*
Labeled on the reverse:
*Le Jazz Hot*

Very little is currently known about the life and work of the American artist Maggie Howe, who established a studio in Cuernavaca, Mexico, in the 1950s where she influenced an entire generation of Mexican enamelists. According to an article by Carol Miller Zapata published in *Craft Horizons* in 1965, Howe was "an ex-cellist who came to Mexico to study law and became the cosmopolitan capital's most dynamic and vivid color linguist." Zapata observed that Howe's favorite subjects were flowers, crickets, and insects, which she frequently depicted on platters, ashtrays, and enameled candlesticks. She displayed and sold her work at an exhibition center called Bazar del Sabado, which she helped organize in 1961. This weekly craft market brought together some of the region's best talent, both known and unknown, and allowed their work to be seen and purchased. She exhibited in 1965 at La Sirena Gallery in San Antonio, Texas. In a review of this show, Zapata observed that, "the artist's work embraces all the refinements of her medium, and she appears to superb advantage in the complex realms of champlevé, with its jewel-like dimensions, and cloisonné."

Inventive in its structure, *Le Jazz Hot* is a rare example of Howe's work in the cloisonné technique. Seven panels, each representing a musical note, are mounted on ebonized wood to suggest a melody in a musical composition. Each of the panels is an abstract image outlined in silver wire set against a vibrantly red background. The individual cells are filled with opaque white, as well as transparent blue, purple, and red over silver that animate each panel as light reflects off the surface. The piece is a witty interpretation of the syncopated rhythms of jazz as suggested by the title.

Howe did not confine herself to the traditional techniques of cloisonné and champlevé. She also excelled in the basse-taille technique as well as sifting and stenciling methods. Much of her commercial work employed these techniques. In a later article in 1972, Zapata acknowledged that Howe was "one of the first artists in Mexico to use vitreous enamel as an art medium." According to Miriam Fastag, a specialist in Mexican enameling of the twentieth century, the prominent Mexican artist Miguel Angel Pineda studied with Howe between 1958 and 1960.

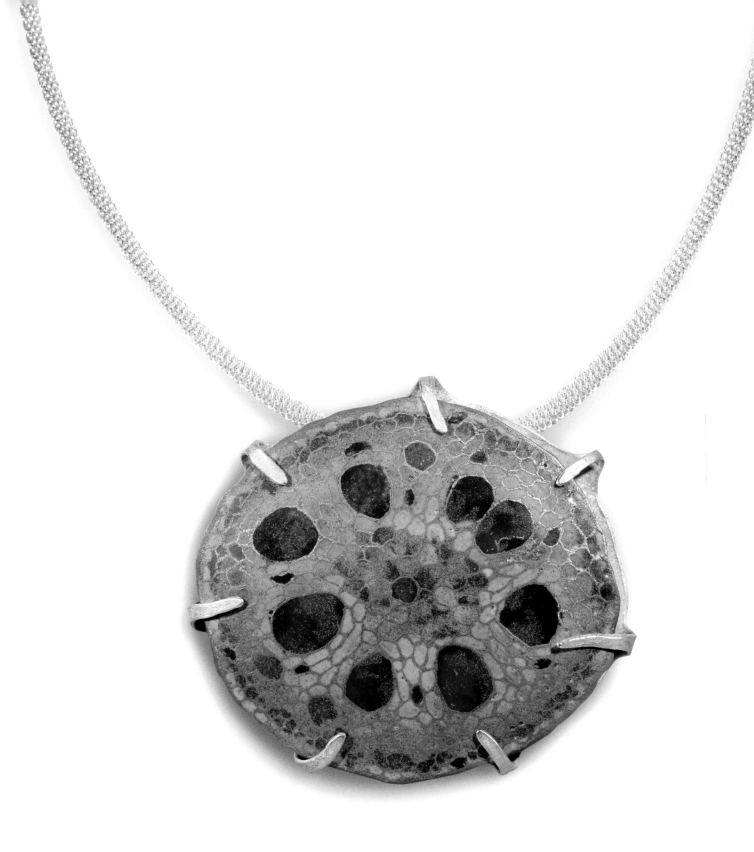

130

# Melissa Huff
## Born 1956

*Bare Bones Mandala*
2009
Enamel on copper, fine silver,
and sterling silver
Pendant:
2 x 2⅛ x ⅜ in.
5.1 x 5.4 x 1 cm
Signed twice on the reverse
of the pendant: *MH*

The images that occur in Melissa Huff's jewelry are firmly grounded in her study of plants and plant anatomy. However, for Huff, botanical structure is simply a point of departure. By exploring nature's growth processes, she hopes her work will communicate a sense of development over time, reflect a certain organic complexity, and suggest the mysteries which underlie all natural phenomena.

Born in Englewood, New Jersey, Huff began her studies in art in 1990 at the University of Illinois. While there she moved from painting into the metals and jewelry program and soon gravitated towards enameling as a way to explore the interplay of color, pattern, texture, and organic form. She studied with Alan Mette and Billie Jean Theide and was awarded her BFA in metals in 1995.

In 2004 Huff was featured in Linda Darty's *The Art of Enameling* and in 2005 her work appeared in *The Penland Book of Jewelry*. Several of her pieces were also included in the 2009 publication *500 Enameled Objects*. She has been featured in several issues of *Metalsmith* and has participated in numerous invitational and juried exhibitions. Her work is in private collections throughout the country as well as in the collection of the Racine Art Museum in Wisconsin.

Huff's preferred technique is champlevé, in which recesses are created in the metal into which enamel is filled and fired, resulting in a final surface that is part enamel and part metal. For most of her "Mandala" series, these recesses are formed through acid etching the metal, a subtractive process of removing selected parts of the surface. In *Bare Bones Mandala*, Huff took as her subject the cross-section of a water lotus root that has an interesting pattern of circular chambers surrounding the central structure. She purposely created a very shallow etch of the copper with the intent of using opaque enamels while allowing the copper substrate to partially emerge and contribute to the overall palette of the piece. She placed the enameled panel in a setting made of fine silver with the prominent prongs becoming an integral part of the composition.

In discussing her process for the "Mandala" series, Huff has stated, "Many of the mandala pieces begin with drawings of cross-sections of roots, stems, and other plant anatomy, revealing the inner cellular structure that suggests nurture, growth, and the elemental processes of life." While based in an observation of nature, in this case the root of the lotus, her work becomes a metaphor for life itself. As she states, "Much of the work intentionally retains a certain ambiguity—an ambiguity of material, of provenance, and of meaning. Inviting contemplation, these objects attempt to reflect an ancient reverence for that which sustains life itself." In this work, Huff equates the cellular structure, the essence of the plant's life, to the Buddhist symbols of purity (lotus) and the universe (mandala) with the resulting pattern a gateway to meditation.

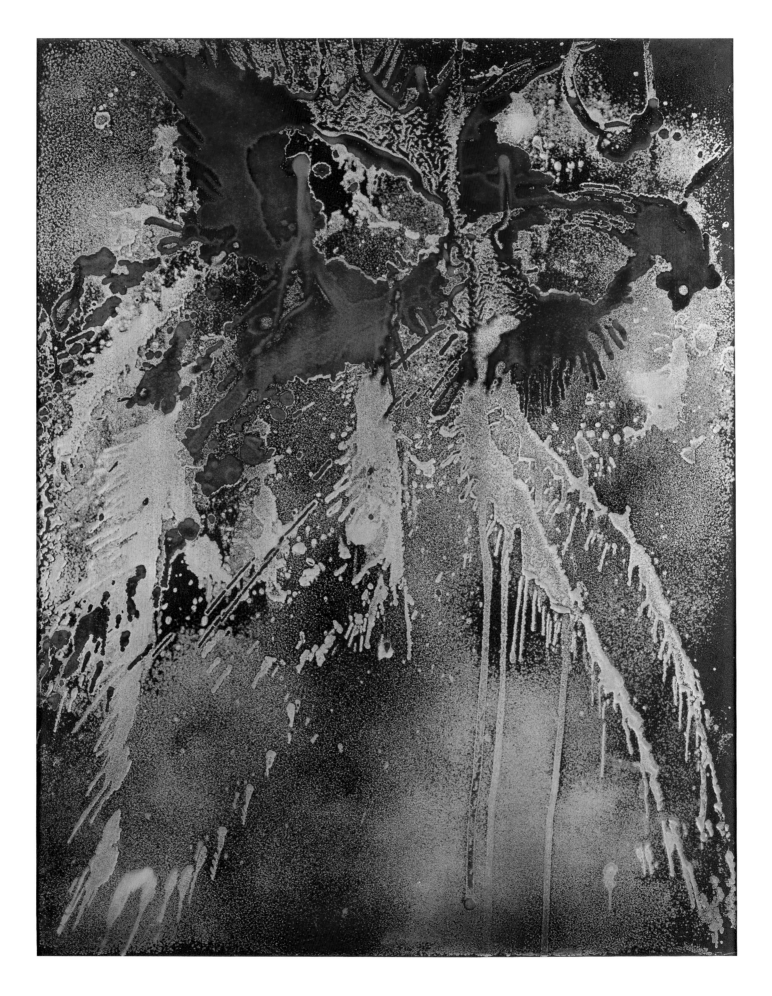

# Paul Hultberg
## Born 1926

*Lepidopteral Pyrotecnics*
1965
Enamel on copper
24 x 18 in.
61 x 45.7 cm
Signed on the reverse:
*Paul Hultberg '65*
*"Lepidopteral Pyrotecnics"*

Among the most progressive artists working in enamel in the mid-twentieth century, Paul Hultberg was born in Oakland, California. After taking classes at Fresno State College and the University of Southern California, he moved to Mexico City to study with the renowned muralist Jose Gutierrez at the Instituto Politécnico Nacional. With the knowledge he acquired from Gutierrez, Hultberg returned to Los Angeles in the late 1940s to start his own mural-painting business. During this period, he explored methods to create large mural compositions that would be integral to the design of modern buildings. In the early 1950s he took a position at the school of the Brooklyn Museum of Art, where he taught painting and drawing. There he met Walter Rogalski, a printmaker, and they undertook a yearlong experiment using painting and printmaking techniques in combination with enamels to create provocative new work.

After experimenting with the medium on a small scale, Hultberg started applying new techniques to his murals. This was to lead him to a highly unorthodox method of enameling. Woodrow Carpenter, president of Thompson Enamels, described Hultberg's process, "Starting with thin copper sheets, a design was drawn with a brush and thin adhesive, enamel powder sifted on, and then all un-adhered enamel was brushed off leaving bare areas. The panel was then fired in a furnace of his own design." Hultberg also used a method of firing outside the kiln. Laying each panel on heat-resistant bars, below which a cart equipped with gas torches moved from one end to the other, he was able to raise the temperature high enough to fuse the glass onto the metal. According to Carpenter, "The enamel was fused to the copper while the bare areas oxidized. Upon cooling the panel was rolled flat. The oxidation popped off leaving a glass design on a background of various colors of copper oxide. When a resist was used on portions of the bare copper, un-oxidized areas remained after the firing and were silver plated."

In 1956 Hultberg moved his family to Gate Hill, an artists' cooperative near Stony Point in Rockland County, New York. In the same year he submitted a multi-panel composition, *Burnt Sun*, to the Syracuse Ceramic National and his work gained national recognition. Hultberg was hailed as an innovator and his work was compared to that of Abstract Expressionist painters such as Jackson Pollock and Franz Kline. The comparison seems apt as Hultberg worked in a spontaneous, powerful, and intuitive manner. In the 1959 exhibition *Enamels*, held at the Museum of Contemporary Crafts, five of Hultberg's large works were shown, including a six and a half by eight feet, four-panel screen, the largest work in the show. In 1969 his work was included in *Objects: USA*. Hultberg received numerous architectural commissions, including one for the historically significant Pan Am Building (now MetLife) in New York.

While relatively small in scale, *Lepidopteral Pyrotecnics* has much of the power and spontaneity of the artist's larger compositions. He produced this work using his outside-the-kiln, torch-firing process. Splashing vibrant color across the surface of the panel, Hultberg created images that suggested to him the abstract bodies of moths or butterflies, wings spread open in flight, while also evoking the awe-inspiring vision of fireworks in a night sky.

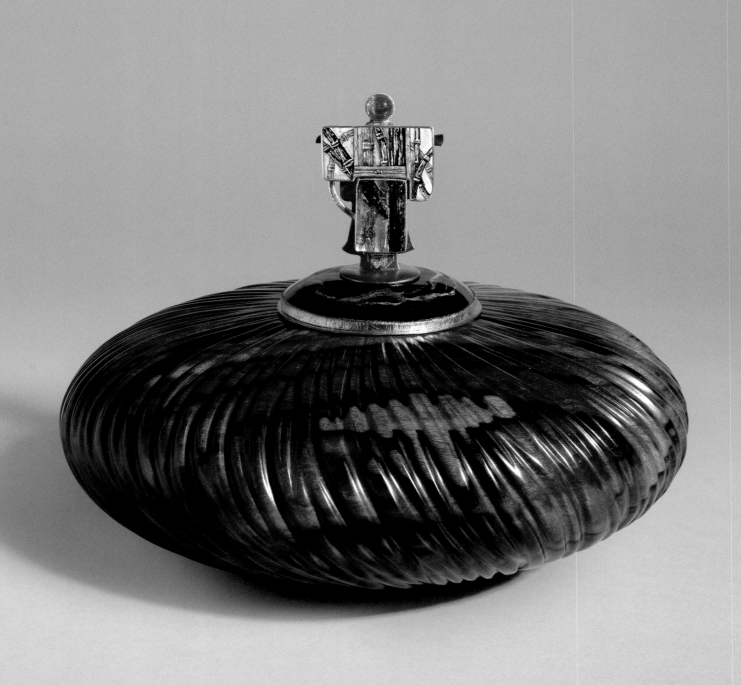

# Marianne Hunter
## Born 1949

*Kabuki Kachina Conducts
the Orchestra*
2013
Enamel, 24K and 14K yellow gold,
silver, black tourmaline,
and rutilated quartz
2⅞ x 1¾ x ¼ in.
7.1 x 4.5 x .6 cm
Signed on the reverse: *Kabuki Kachina
Conducts the orchestra of bamboo—bass
and alto singing in the wind—hollow reeds
ringing—symphony of yielding strength
Marianne Hunter 2013 #2627 24K 14K a.s.*
(opposite and below)

# William Hunter
## Born 1947

*Macassar Sunrise*
2013
Macassar ebony
4½ x 9½ x 9½ in.
11.4 x 24.1 x 24.1 cm
Signed on the base: *Bowl #1600
"Macassar Sunrise" Wm. Hunter 2013*
(opposite)

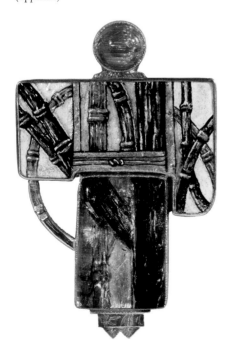

A masterful enamelist, Marianne Hunter asserts that her work is not about technical facility or elegant style; rather she is concerned with the redemptive power of creative vision and the uplifting potential of storytelling. As she states, "The sustaining motivation for my work remains the same whether the subject is the natural, cultural, or mythical world: to become immersed in the beauty and mystery of the world and sometimes, through my work, to momentarily turn away from what is painful in the world by overpowering it with benevolence. Each piece is a story I tell myself while I am working."

Hunter was born in Los Angeles. Graduating from high school in 1967, she and a friend purchased an enameling kit together from a local hobby shop. She later described this initial introduction to the medium as a "defining moment in my life." She began to experiment with the materials in the kit and fell in love with enameling and its rich artistic potential. She continued to study enameling on her own, reading as many books as she could find, including Oppi Untracht's *Enameling on Metal*. The images of grisaille enamels reproduced in Untracht's book had a lasting influence on her development. For more than a decade she continued to explore this technique, attracted to its exacting technical demands, its bold black and white contrasts, and its subtle gray tonalities. She explains, "These images inspired me to pursue story-telling in black and white. I didn't have painting enamel at the time or know that it even existed. So I developed a method of working dry, white over black, and I did that exclusively for about thirteen years." Around 1979 she began to incorporate vibrant hues along with opulent gold and silver foils in her work as she experienced what she describes as "a euphoric sense of doors opening." Since that time she has been producing exquisitely wrought, brilliantly colored enamel jewelry that incorporates all manner of material from precious stones and metals to feathers, fossils, and pearls.

While influenced in part by the sumptuous beauty and rich narrative content of Art Nouveau jewelry, Hunter's work reflects her own unique aesthetic. Fascinated by Native American traditions as well as by Japanese art, she has produced a series of work over the past several decades in which she combines elements of Eastern and Western cultural tradition. She calls these pieces "Kabuki Kachina."

In works such as *Kabuki Kachina Conducts the Orchestra*, Hunter juxtaposes the beauty of quartz with its natural inclusions with an exactingly detailed image of Asian bamboo rendered in enamel. This dialogue takes place on the body of a standing female figure dressed simply in a Japanese kimono or robe. In the lower half of the figure, areas of bamboo detailed in ink on rich gold foil over textured and engraved silver are visible through the translucent body of the quartz. In this evocative pendant, Hunter creates a unity of opposites, the conjoining of nature and exquisite craftsmanship. As she often does, the artist has inscribed a poem of her own composition on the back of the piece. The poem's power lies in its terse phrasing and its layered imagery. The pendant is accompanied by a black tourmaline and gold necklace.

When not worn, *Kabuki Kachina Conducts the Orchestra* is mounted on an enameled copper lid set on a macassar ebony vessel made by the artist's husband William "Bill" Hunter, one of the leading figures in the contemporary wood field. Hunter created *Macassar Sunrise* in 2013 as part of his ongoing exploration of linear surface rhythms as a counterpoint to the rich figure of the wood and the sculptural form of the vessel.

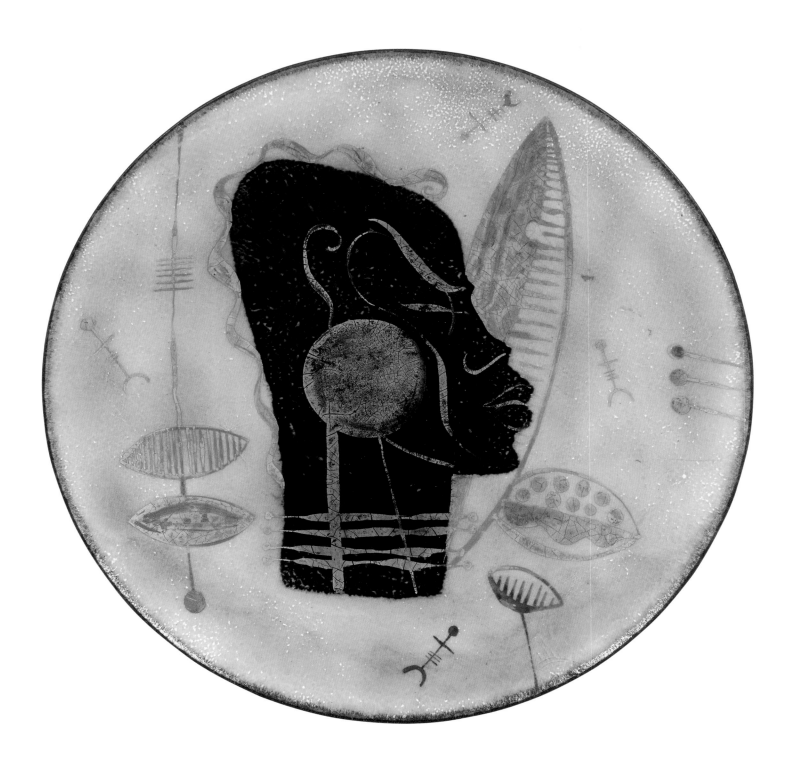

# Sterling Vance Hykes
## 1917–1974

*Plate*
c. 1950
Enamel on copper
³/₄ x 7³/₄ x 7³/₄ in.
1.9 x 19.7 x 19.7 cm
Signed on the reverse: *Hykes*

Sterling Hykes was born in Tennessee and moved with his family to Cleveland in the early 1920s. Their journey north was part of what is now referred to as the 'Great Migration,' a period during which over 1.6 million African Americans, seeking jobs, economic opportunity, and greater social mobility, moved from the rural South to urban centers in the Midwest such as Cleveland, Chicago, and Detroit, and to the Northeast. When he was in his teens, Hykes worked as a dishwasher in a restaurant on Cleveland's then-fashionable Euclid Avenue. His earnings covered the cost of his school supplies and helped support his family. As later reported in a 1968 article in the Cleveland *Plain Dealer*, Hykes's experience washing dishes strengthened his resolve to continue his schooling and to become an artist. As he stated, "I never expected to really make it as an artist but I had to try so I could leave the drudgery of dishwashing. It was a struggle growing up with three brothers and a sister, but well worth it." Hykes's teachers recognized his artistic talents from an early age and, when he was still in the third grade, he was designated the school artist at Giddings Elementary. He graduated from Cleveland's Central High School, the oldest publicly funded high school west of the Alleghenies, and in 1941 he enrolled as an evening school student at the Cleveland School of Art, studying metals with Mildred Watkins and enameling with Kenneth Bates. In 1943 he also studied figure drawing with John Teyral and painting and composition with Carl Gaertner.

A highly versatile artist, Hykes produced work throughout his career in a wide range of media from painting and sculpture to ceramics and enamel on copper jewelry. Between 1941 and 1957 he frequently submitted work to the Cleveland Museum of Art's May Show and was regularly featured in the Enameling on Metal, Jewelry, or Sculpture categories. He also taught art during this period at Karamu House, a widely influential cultural center for Cleveland's African-American community.

Hykes often chose subjects for his enamel plaques and plates that reflect his interest in African art and his African-American heritage. This image of the head of an African warrior with wavy stylized hair, decked with various body ornaments, and seen in profile is set against a lush yellow background with the warrior's shield prominently visible against smaller pictographs and other abstract elements. Hykes's plate exemplifies his abiding interest in combining formalist concerns with rich cultural traditions.

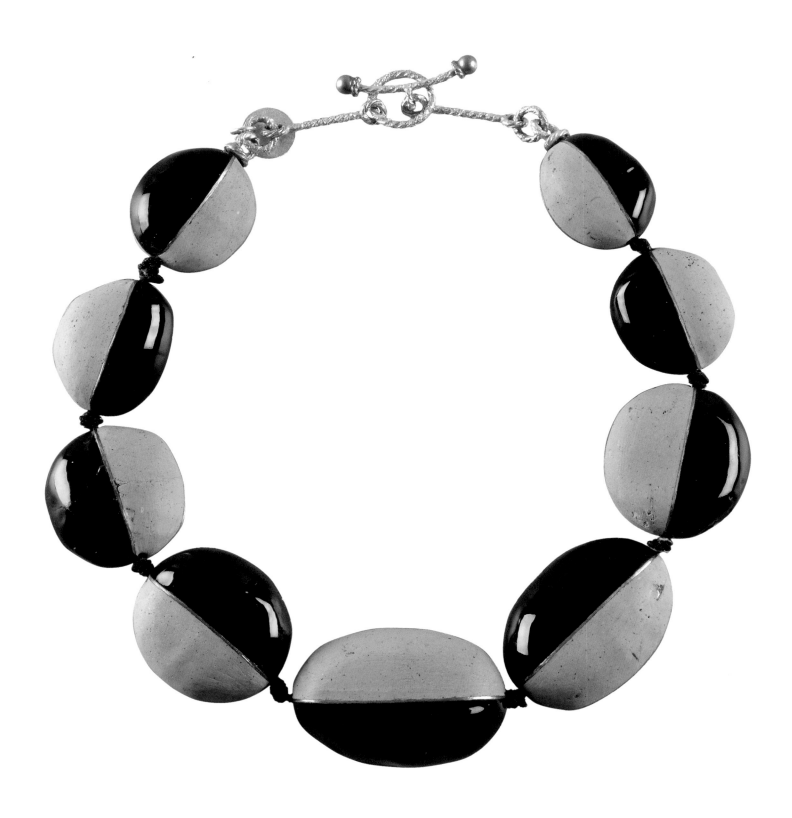

# June Jasen
## Born 1952

*Wide Mouth Bass*
2007
Enamel, copper wire cloth, brass wire, and low-fired ceramic materials
3½ x 4½ x 4¾ in.
8.9 x 11.4 x 12.1 cm
Signed on the bottom: *Jasen*
Gift of the artist

Throughout the course of her career, June Jasen has explored a wide variety of subjects from figurative images of playful dress-up dolls to landscapes that reflect her environmental concerns and subjects from nature—particularly honeybees and fish—that celebrate the diverse sources of food that help sustain life on this planet. With a solid grounding in traditional enameling technique, she has also "pushed the material" to new levels while investigating original forms and formats.

Jasen was first introduced to enameling in 1972–1973 through a multi-disciplinary craft class at the University of Cincinnati. Her instructor Beverly Semmens, who, while trained as a weaver, possessed a remarkably extensive knowledge of enameling, encouraged her students to master the basics before attempting to create jewelry or other forms of enameling. This commitment to the fundamentals and to exacting craftsmanship has remained with Jasen throughout her career. She was awarded her BFA in 1973 and, after a year of post-graduate work at George Washington University, she pursued graduate studies at New York University where she received her MA in Arts Education and Interdisciplinary Arts in 1976. In 1974 she also participated in two courses that further solidified her commitment to enameling—the first was offered by Harold B. Helwig at Peters Valley School of Craft in New Jersey and the second was a class given by William Harper at Penland.

Around 1979, reflecting her love of fashion and her desire to incorporate "fun" into her process and her imagery, she began a series of figurative brooches. These doll-like figures in cloisonné have variable costumes and were fastidiously composed. However, according to the artist, their real significance was in her use of low-fired ceramic materials in combination with the cloisonné. These dress-up dolls received an enthusiastic critical response and led to Jasen's inclusion in the 1979 exhibition *Good as Gold: Alternative Materials in American Jewelry* organized by Lloyd Herman and circulated throughout North and South America by the Smithsonian Institution Traveling Exhibition Service.

In the late 1990s Jasen began a new series of work in which she formed copper wire mesh into irregularly shaped vessels and abstract sculpture. She then enameled the surface of these forms and applied ceramic decal transfers and gold leaf. Of this series, the artist has said, "These pieces stem from my interest in ergonomics and my idea of pushing the materials of enameling to yet another level while integrating compatible pyro-materials using both traditional and experimental enameling techniques. The copper mesh cloth allows me to hand shape each piece (without the use of heavy hammers and other forces to forge the metal into new shapes) before the enameling process begins, as well as, reshaping the piece during the heating or firing process." These organic forms which tend to reshape themselves during the firing process only to be reshaped once again by Jasen after they emerge from the kiln have been described by critics as "frozen moments in time."

With its leaping fish decal, *Wide Mouth Bass* reflects Jasen's multifaceted interest in nature, nutrition, and the environment. It is also a fine example of her work using enameled wire mesh accented with gold leaf.

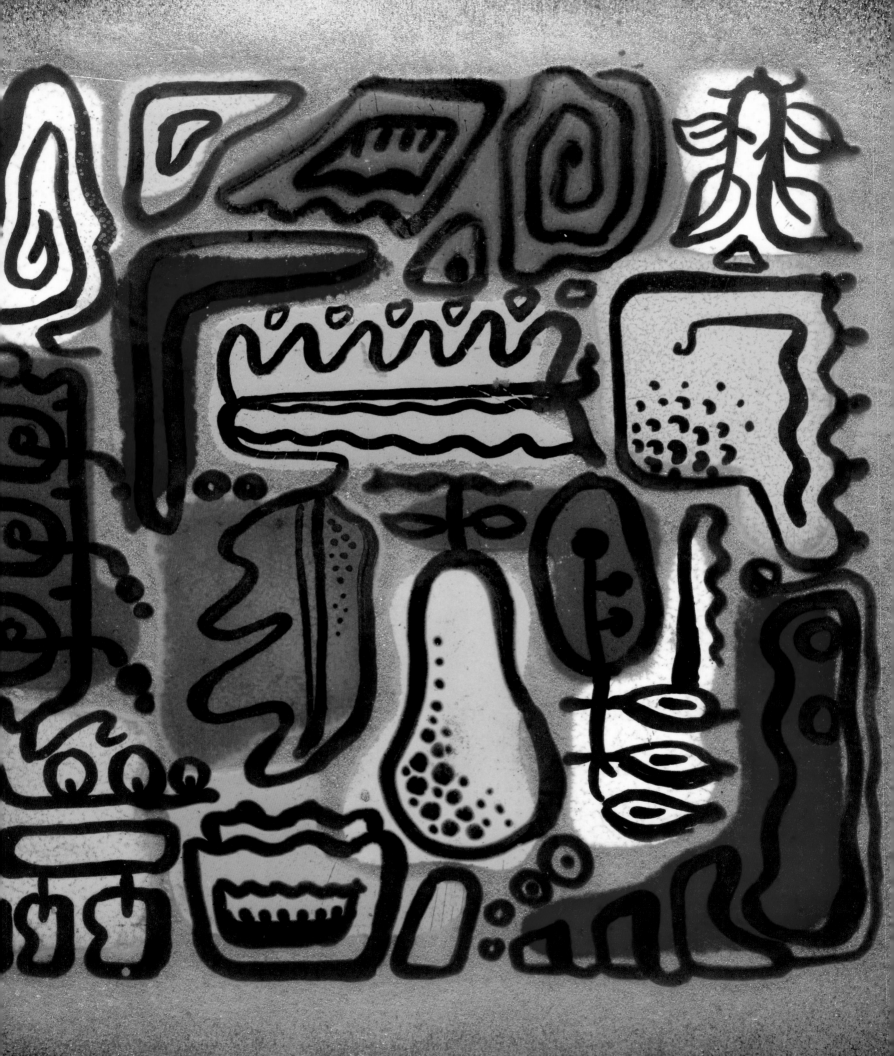

## Charles Bartley Jeffery
### 1910–1992

A master of the cloisonné technique, Charles Bartley Jeffery was born in Paducah, Kentucky, and educated in public schools in Fostoria, Ohio. He moved to Cleveland in 1928 to attend the Cleveland School of Art and Case Western Reserve University. In 1932 he earned a BA from the university in education and design, as well as a four-year diploma from the Cleveland School of Art. The following year he was awarded an MA in art education.

Jeffery devoted much of his time to teaching—his greatest passion—and dedicated his weekends and holidays, especially the summer, to making objects. His first exploration of craft was in ceramics. By 1932 he began submitting his ceramics to the Cleveland Museum of Art's May Show and over the next seven years his work gained prominence. In 1937 two of his pieces, a vase and a plate, won a second prize in the Nineteenth Annual May Show. In the same year he was awarded a prize by the French government for two of his pottery pieces, which were shown in the American crafts section of the Paris International Exposition. He first presented his enamels in 1939, when he exhibited ten pieces in the May Show and one piece at the Eighth Annual National Ceramic Exhibition in Syracuse. This was the beginning of a long and prolific career producing enamels, which would continue until 1981.

Jeffery's work was included in the May Show forty-one times, winning numerous awards over the years. In total, he submitted an astounding 383 works to that show between 1932 and 1976. In 1954 the Cleveland Museum of Art awarded him its most prestigious honor, the Horace Potter Memorial Award. He also participated in several other invitational and juried exhibitions, including the Ceramic National (thirteen times) and the Wichita (thirteen times). His work was included in all three important enamel exhibitions that took place in the 1950s: *History of Enamels: VII–XX Century* at the University of Pittsburgh in 1950; *Enamel: An Historic Survey to the Present Day* at the Cooper Union Museum for the Arts of Decoration, New York, in 1954; and *Enamels* at the Museum of Contemporary Crafts in 1959. Kenneth Bates and Edward Winter were the only other enamelists featured in all three shows. Besides teaching in Shaker Heights public schools for twenty-two years, Jeffery taught at the Cleveland Museum of Art, the Cleveland Institute of Art, and at numerous other schools throughout the country. Although he worked in a variety of enamel techniques, he made a specialty of cloisonné.

Much of his output consisting of religious subjects—crosses, votives, and tabernacles—was derived from Byzantine iconography. He was also influenced by stained glass of the Gothic period, such as the windows at Chartres Cathedral and those at Sainte-Chapelle in Paris. Using silver wire to create his design and filling the recesses with a great range of enamel colors, he made works that resemble the windows he so admired, but on a much smaller scale. His finished pieces were then mounted on carved wood forms, which were supplied by Joseph Wooddell, a craftsman renowned for his woodwork. According to Jeffery's son Bart, his father and Wooddell were close personal friends and Wooddell typically made his wooden boxes and mounts following Jeffery's detailed designs.

*Box*
1951
Enamel on copper, walnut
2¹⁄₈ x 5³⁄₄ x 5³⁄₄ in.
5.4 x 14.6 x 14.6 cm
Signed on the base of the box:
*Jeffery Sept. 27, 1951*

*Crucifix: Last Supper*
c. 1950
Enamel, silver, and ebony
3³⁄₄ x 2⁷⁄₈ in.
9.5 x 7.2 cm
Gift of the Jeffery Family

The diminutive scale of *Crucifix: Last Supper* suggests that it was intended to be used for private devotion. In this piece, Jeffery captures the weighty magnitude of his subject in an exquisitely rendered intimate format. The miniature plaque with its distinctively delineated figures of Christ and the apostles is set in a piece of rare ebony, making this work particularly significant to the artist.

While best known for his mastery of cloisonné enameling, Jeffery also excelled at numerous other techniques. The handsome walnut *Box* with enamel lid was made using a looser, more painterly technique. Its vivid color and bold design underscore Jeffery's solid training in graphic design as well as his awareness of diverse approaches and formats. Breaking away from the medieval-inspired imagery of his ecclesiastical work, this plaque is representative of his abstract compositions of the early 1950s.

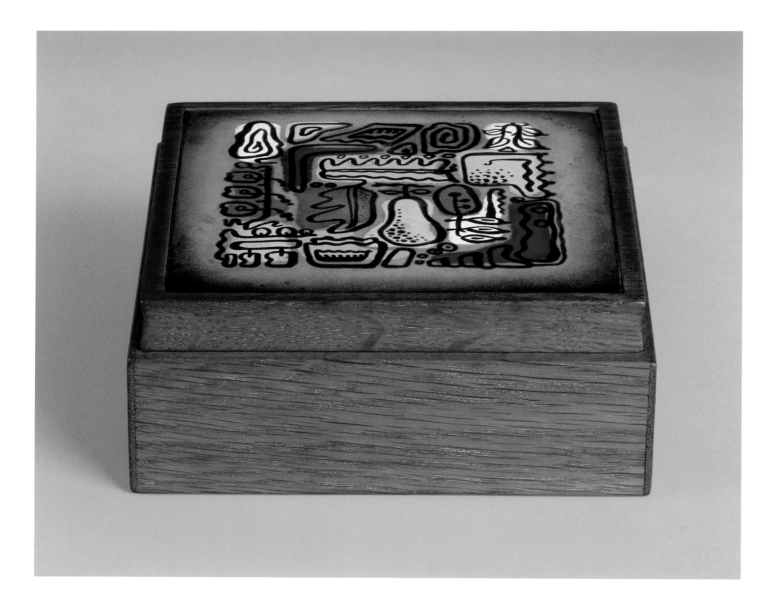

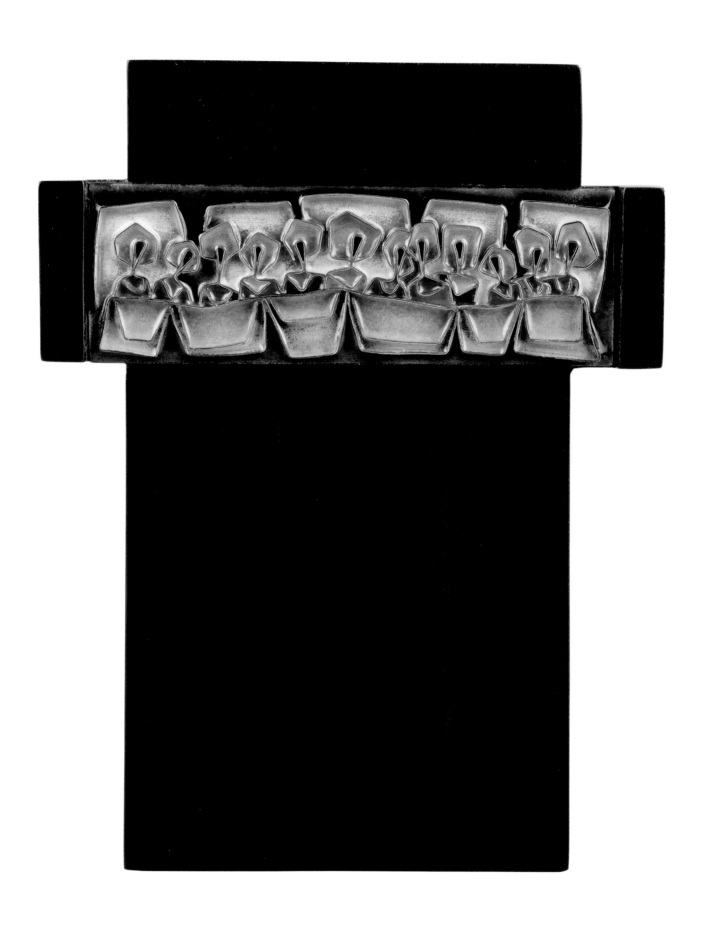

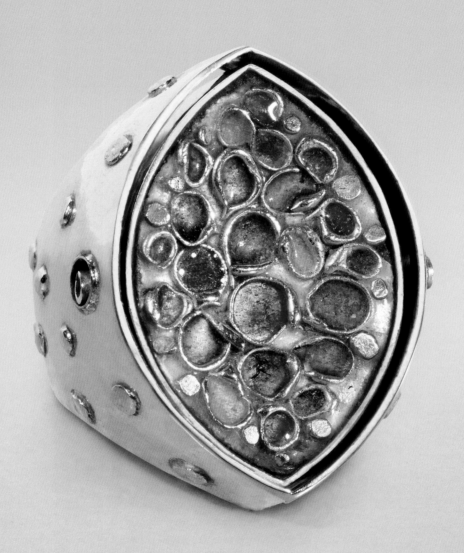

## Mary Amelia Kretsinger
1915–2001

*Double-sided Ring*
c. 1960
Enamel, gold, and diamonds
1¼ x ⅞ x ⅞ in.
3.2 x 2.2 x 2.2 cm
Signed: *MK* (the artist's mark)
Purchased with funds donated in loving
memory of Eleanor L. Nelson

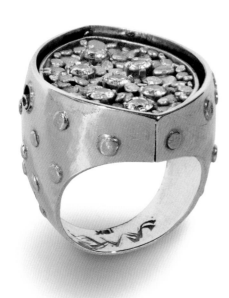

The nationally prominent artist Mary Amelia Kretsinger is best known for her inventive approach to metalwork and enameling. Her work, including jewelry and three-dimensional objects, combines experimental metalsmithing and enameling techniques with innovative approaches to design. Whether a wearable form of jewelry or a precious object, her pieces are characterized by rich surface decoration, tactile variety, and dazzlingly beautiful color.

Born in Emporia, Kansas, Mary Kretsinger received her bachelor of arts in 1937 from the University of Kansas with a combined major in history and art history. In 1941 she was awarded her MA by the University of Iowa, where she received solid training in painting and the graphic arts. She later studied metals with Rudolf Brom in Kansas, and with the prominent Danish-born silversmith Adda Husted-Andersen at the Craft Students League in New York. She taught at Emporia State College in Kansas until May 1963, when she left teaching to focus on her artwork full-time. She participated in many juried annual exhibitions, especially at the Wichita Art Association, and her work was featured in numerous nationally prominent shows, including a critically acclaimed and influential 1955 jewelry exhibition at the Walker Art Center in Minneapolis; the 1969 national touring exhibition *Objects: USA*; and *The Art of Enamels* organized by the State University of New York at New Paltz in 1973. Examples of her work are in the collections of the Museum of Arts and Design, the Wichita Center for the Arts, and Spencer Museum of Art at the University of Kansas.

In describing her interests Kretsinger stated, "I work in precious metals, enamels, and precious stones to create unique pieces of jewelry. I do not mass-produce. I am interested in the sculptural approach to jewelry and hope eventually to produce sculpture using silver, gold, and enamel."

While Kretsinger sought new expressive potential in the medium of enameling, much of her training in the field was accomplished through learning on her own and by trial and error. As she observed, "My approach to enamel has been largely experimental. Consequently I have spent a lot of time which could have been spent turning out finished products, simply seeking answers to how to turn old techniques into twentieth-century design expressions."

In addition to creating inventive wearable forms—brooches, rings, necklaces, and other forms of jewelry—Kretsinger was especially interested in ecclesiastical commissions. About 1963 she stated, "I wish to go into commissioned work and work with architects, but this is very hard to begin. I expect to bend every effort in this direction in the next year because liturgical work interests me more than jewelry. It seems to have more universal and less personal appeal and also has social value lacking in the production of jewelry." In the ensuing years, Kretsinger produced commissions for the Episcopal Seminary in Virginia; Holy Cross College, Worcester, Massachusetts; Saint Alban's Chapel, Dallas, Texas; Saint James' Episcopal Church, Wichita, Kansas; Saint Andrew's Episcopal Church, Emporia, Kansas; and Brandeis University, Waltham, Massachusetts.

This *Double-sided Ring* is one of Mary Kretsinger's most unusual pieces. The main setting, which is made of gold, is hinged so that the ring can spin to reveal two distinct sides: one with gold pebbles set with seven diamonds, each held by prongs; the other a multi-colored cloisonné pattern resembling jeweled pebbles. The ring's ovoid body is enhanced by raised rivets. An exceptional piece, it belonged to the artist's friend Josephine A. Wallace.

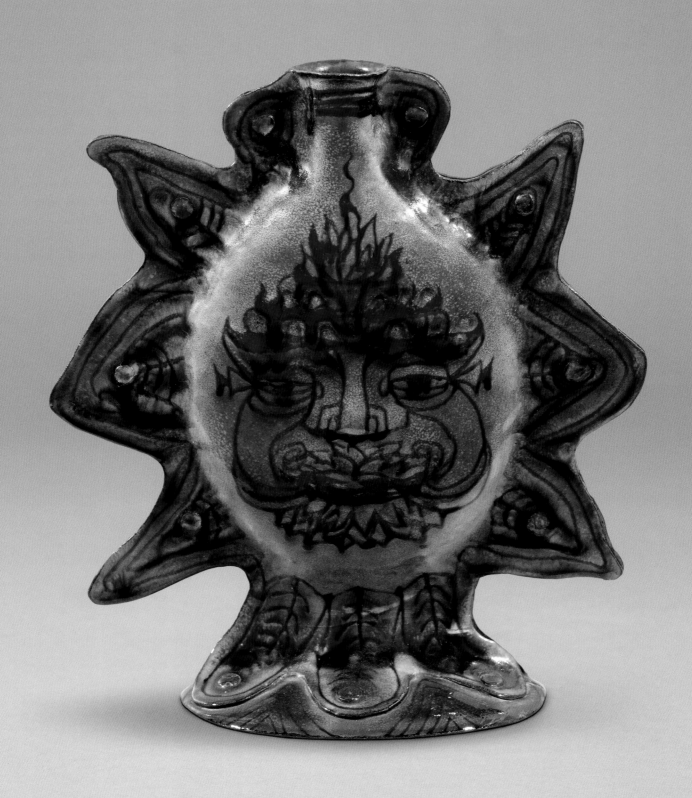

# Kalman Kubinyi
## 1906–1973

*Sun Vase*
c. 1955
Enamel on copper
8³/₄ x 7⁵/₈ x 3³/₈ in.
22.2 x 19.3 x 8.6 cm
Signed on the lower right:
*K Kubinyi*

Born in Cleveland, Kalman Kubinyi was the son of Hungarian immigrants who had moved to this country around 1901. The young Kubinyi received his earliest training through art classes at the Cleveland Museum of Art. He then went to study at Cleveland's Educational Alliance of the National Council of Jewish Women, where he worked with the acclaimed sculptor William Zorach. He subsequently attended the Cleveland School of Art, graduating in 1927. In the summer of 1928 Kubinyi made his first trip to Europe, where he visited relatives. Upon his return, he was given a prestigious commission to make twenty-two linoleum block prints for *The Goldsmith of Florence*, a 1929 publication that won numerous design awards. His earnings enabled him to make another trip to Europe in the summer of 1929. He visited his uncle Alexander von Kubinyi, a highly regarded artist who lived and worked in Munich. Von Kubinyi was at the time exploring various printmaking and illustration techniques, often of a highly experimental nature. Kubinyi eagerly learned everything his uncle had to teach. Equipped with this new knowledge, Kubinyi returned to Cleveland and took a teaching position in printmaking at the John Huntington Polytechnic Institute. He quickly became one of the most prominent and influential printmakers in Cleveland. Employing skills that he had learned in Munich, he invented new methods of printmaking as well as produced exceptional work using traditional techniques. He began to submit his work to the Cleveland Museum of Art's May Show and won numerous prizes.

At the onset of World War II, Kubinyi, wanting to make a contribution to the war effort, got a job at S.K. Wellman Company, a manufacturer of brakes for airplanes. Around 1941 he and a friend decided to build an enameling kiln. Although Kubinyi experimented at the time with enameling, he was too preoccupied with his regular job to focus on his art. However, his wife, Doris Hall, who was at home raising two children, had the time and started to experiment with enamels. Although Kubinyi continued to produce prints until 1950, enameling gradually became his main focus. In 1946 his enamels were shown at both the Cleveland Museum of Art's May Show and the Ceramic National in Syracuse. He went on to exhibit his enamels annually at the May Show until 1957. He won several honorable mentions and a third prize in 1949 and 1950 and a second prize in 1952. Several of his pieces were purchased for the museum's collection. His efforts in the medium ranged from small functional objects to large-scale sculptural and architectural applications.

In addition to being an adept enamelist, Kubinyi was a gifted and highly inventive metalsmith. He hand-raised most of his plates, plaques, and sculpture and he created inventive forms which his wife subsequently enameled.

*Sun Vase* is an imaginative and whimsical bottle-shaped vessel. With its radiating appendages, it is a personification of the sun, eyes wide open on the front and asleep on the back. This work exemplifies Kubinyi's combined skills as both a metalsmith and an enamelist.

# Andrew Kuebeck

Born 1985

*Sailor*
2012
Enamel, silver, and fine silver
5 x 2¹/₂ x ¹/₄ in.
12.7 x 6.4 x .6 cm

Andrew Kuebeck's "Identity" series celebrates male beauty and the history of gay representation in the popular media through an audacious body of work, including wearable forms and sculpture that are at once alluring, arresting, and often humorous. His provocative male images are often based on so-called "beefcake" photography, the male equivalent to "pin-up" or "cheesecake" photography popular in this country in the period following World War II. With a closeted, pre-Stonewall gay male subculture as their target audience, these provocative photographs touted the virtues of health and fitness through scantily clad, beefy male figures often presented in exaggerated poses, holding tools or props associated with classic male pastimes such as exercise, wrestling, sport fishing, or archery. These photographs were advertised in the back pages of popular magazines, offering a covert strategy for celebrating male beauty through association with muscularity, sport, and fitness. Kuebeck's richly layered imagery is both an homage to this genre of photography and an unabashed celebration of the beauty of the male body.

Trained as a photographer as well as a metalsmith, Kuebeck received his BFA in three-dimensional studies from Bowling Green State University in 2008 and his MFA in jewelry design and metalsmithing from Indiana University in 2011. He has taught at Bowling Green in Ohio since 2012.

Among a small handful of contemporary enamelists and jewelers who explore gay male themes in their work, Kuebeck begins his process by photographing models and their props in poses inspired by those seen in classic beefcake photography. He then sorts through his images and selects those he finds most engaging based on the beauty of the pose and the directness of the model's gaze, as well as on more formal compositional elements. He subsequently prints the photographic image onto a decal and transfers the decal onto a sheet of enamel-coated silver, hand-sawn to conform to the shape of the image. Once the piece is fired, the decal burns away leaving the image in red iron oxide on the enamel surface. He then backs the silver with a second sheet of embossed silver. To Kuebeck, the use of silver provides a means of honoring the beefcake genre as well a strategy for assuring the image's longevity.

Concerned at the lack of images of male nudes in contemporary studio jewelry, Kuebeck said: "Attending Indiana University, the home of the Kinsey Institute, I took it as a personal goal to correct what I perceived as a dearth of nude male representations in contemporary art jewelry. As an undergraduate I became aware of photographers like Arthur Tress, Bob Mizer, Duane Michals, the duo Pierre et Giles, and others whom I saw liberate the male nude in contemporary photography. In their images I saw power, sensuality, notions of dominance and passivity, and countless narratives each seamlessly employing the male nude. As a metalsmith I take it as my goal to create jewelry which explores these themes while adding variety to the subject both visually and conceptually."

Andrew Kubeck's *Sailor* is part of his "Identity" series, an on-going body of work in which he explores issues related to gay male sexuality and cultural identity. In this alluring brooch, a nude male figure straddles a prop in the shape of a fish whose greatly exaggerated body only partially conceals his penis. While the figure's eyes are locked in a sultry, "come-hither" gaze, the enormous size of the fish (and its association with male sexuality) takes on a heightened level of humor in its extreme exaggeration. Kuebeck has said of this piece, "Virility and masculinity often find surrogates in the forms of animals, which can display sexualized masculine power without having to directly show the phallus. I'm looking to exaggerate this display to the point of the absurd."

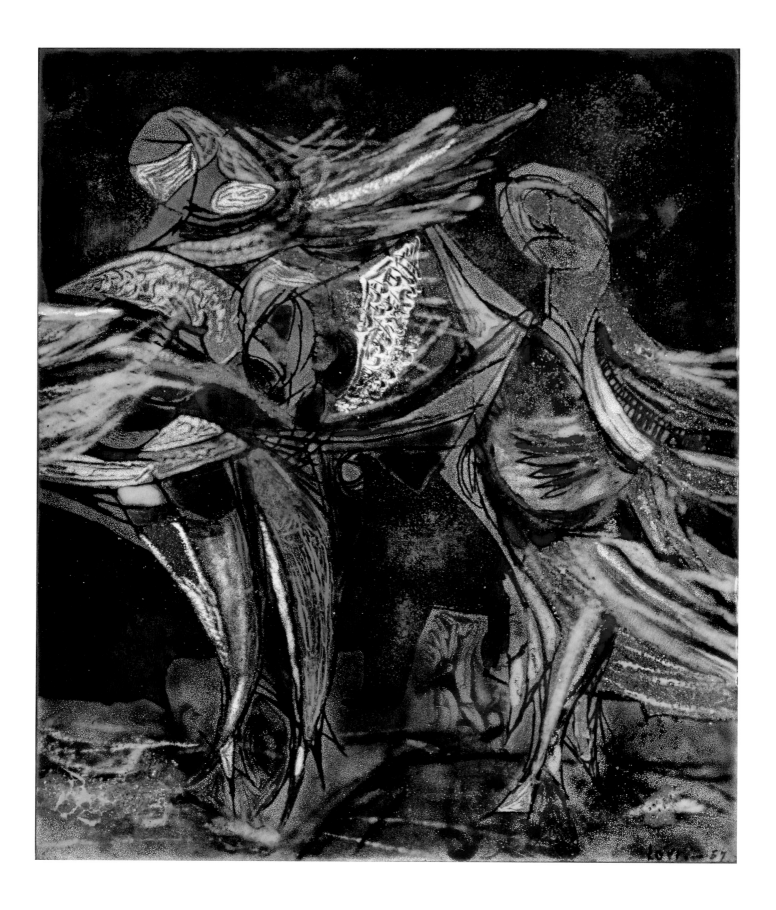

# Richard Loving

Born 1924

*Plaque* (*Dancing Figures*)
1957
Enamel on copper
18½ x 15½ in.
47 x 39.3 cm
Signed on the lower right:
*Loving 57*

Born in Vienna of American parents who were working in Europe, Richard Loving moved to New York with his family in 1929. He attended the prestigious high school at the Society for Ethical Culture, where he took classes in art and literature. He subsequently attended Bard College in the early 1940s but interrupted his studies to join the army. After serving in the army and with the intent of becoming a painter, he enrolled in the New School for Social Research, where he took a fresco-painting course. He supplemented his education by taking classes at the Art Students League and attending the New York Medical College to study anatomy. According to the artist, just being in New York during this exciting post-war period was by far the greatest learning experience. The museums, galleries, and libraries were an immense resource. Loving was able to absorb and be influenced by the events and cultural activities taking place in New York at the time. Abstract Expressionism dominated the New York art scene, and Loving was drawn to its power and expressive potential but, at the same time, he was intrigued by the old master paintings he saw at the Metropolitan Museum of Art and the Frick Collection.

In 1949 Loving met Wally Cox, a silversmith (and later a noted Hollywood comedic actor) who introduced him to enameling. Loving supplemented his training by reading books on technique and by studying Limoges enamels at the Met and the Frick. However, he was not content to work small or tight. He was a painter who loved the figure and the broad, painterly gesture. Not surprisingly, over time his work became larger and more expressive.

In 1953 he moved to his wife's family farm in Mundelein, Illinois, north of Chicago, where he built two large kilns—the larger one capable of accommodating twenty-by-thirty-inch panels—and his work further expanded in scale. While there, he was also able to develop his technique and to further refine his style. Throughout the 1950s as his work gained wider exposure, he exhibited in the Chicago area, supplementing his income by teaching enameling workshops. As his reputation advanced to a national level, four of his panels were included in the 1959 exhibition *Enamels* at the Museum of Contemporary Crafts.

In 1961 he was hired to teach at the Art School of the Art Institute of Chicago. Although at first he taught painting, drawing, and enameling, enameling was slowly phased out of the curriculum. Ultimately he became a full-time painter-draftsman and stopped enameling altogether around 1970. However, between 1950 and 1970 he produced a solid body of work melding his interest in gesture and expression with his extraordinary talents as an enamelist. His work of this period stands out for its unique approach to the medium.

Loving's training as a painter is evident in his wall plaque of *Dancing Figures*. In this work, the artist's broad, sweeping gestures read like lush, painterly strokes of a brush lending the work a power rarely seen in enamels of this period. In their gestural qualities, the figures resemble avian creatures enacting a ritual involving strutting and the fluttering of wings. The piece mediates between the formalist concerns of Abstract Expressionism and the classical language of figurative composition. The vibrant color and highly charged energy seen in this piece is emblematic of Loving's work of the late 1950s and early 1960s.

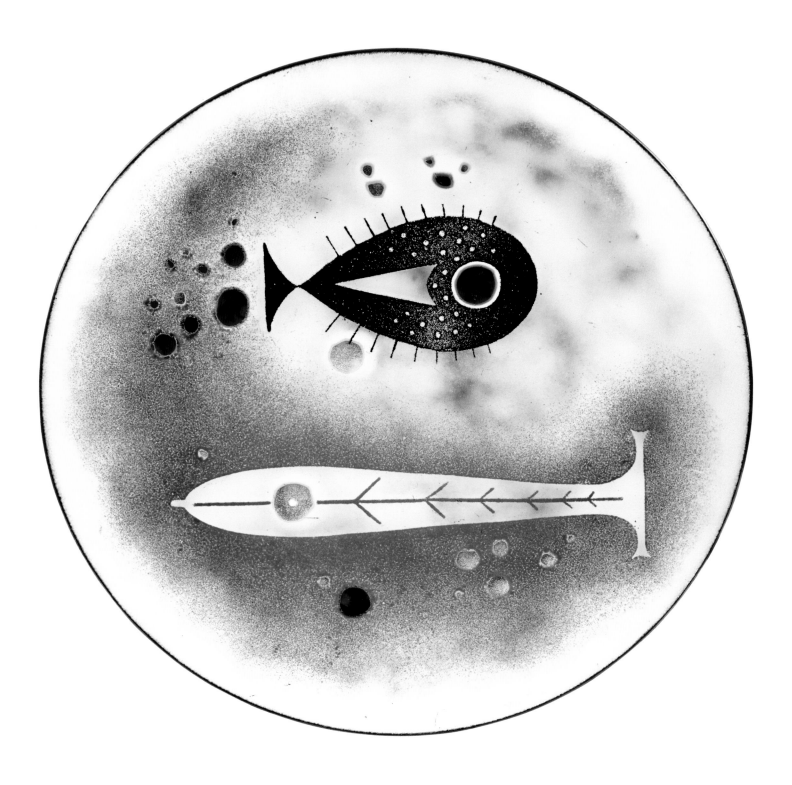

# Elizabeth Madley

1917–2008

*Plate* (*Fish*)
c. 1955
Enamel on copper
³/₄ x 8³/₄ x 8³/₄ in.
1.9 x 22.2 x 22.2 cm
Signed on the reverse:
*Elizabeth Madley*

Born in South Pasadena, Elizabeth Madley attended the Chouinard Art Institute in Los Angeles from 1940 to 1945, taking numerous classes in drawing and painting. While there she also studied design and advertising art. Upon graduation, she attempted to pursue a career in advertising. However, her mother's health declined and Madley became her principal caregiver. After her mother's death she decided to resume her studies and happened upon an enameling course offered at Pasadena City College. With this course as her foundation, Madley embarked on a career in enameling in the late 1940s.

Her work was first featured in the 1951 exhibition at the Los Angeles County Fair in which she won third prize. She gained national exposure in 1952 when her work was juried into Wichita's Decorative Arts and Ceramics Exhibition in which she was awarded an honorable mention, and then included in the Seventeenth Ceramic National in Syracuse, where two plates with stylized fish won a purchase prize and were added to the museum's collection. Meanwhile, in the same year, Madley participated in the art exhibition at the California State Fair and received second prize for her enamels; the Los Angeles County Fair exhibition in which she was awarded first prize; and the Scripps Annual. Besides participating in the Wichita from 1953 to 1966 as well as the Ceramic National in 1958, Madley showed her work in 1955 at the Long Beach Museum of Art. In 1959 three works, two plates and a panel entitled *Persian Portraits* were included in the influential exhibition *Enamels* at the Museum of Contemporary Crafts.

As is the case with the plate she made about 1955, Madley's work frequently included highly abstract renderings of natural subjects such as leaves, fish, and insects. In these works she created visually rich contrasts between amorphous, cloud-like forms, made by dusting powdered glass across the surface of the plate, and raised, jewel-like shapes, built up by melting small chunks of glass onto the enamel. An additional element of humor often appears in her work as large-eyed bugs and fish float freely across the seemingly vaporous enamel surface.

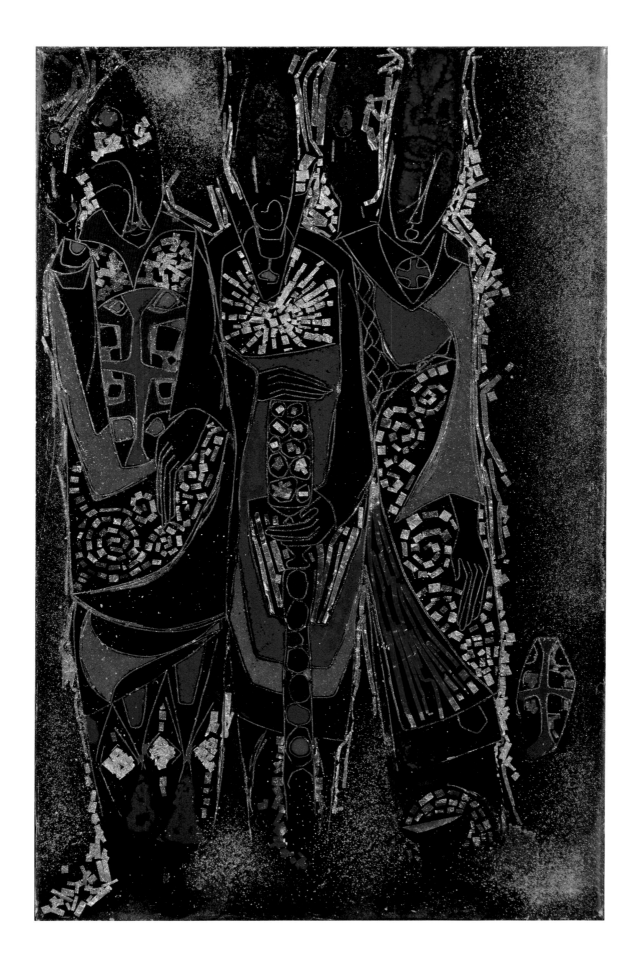

# Norman Magden
## Born 1934

*Plaque* (*Three Kings*)
c. 1969
Enamel on copper
8 x 5⅛ in.
20.3 x 13.1 cm
Signed on the reverse:
*N. Magden DeKalb Illinois*

Norman Magden is best known for his wall plaques and panels, executed using the cloisonné technique, that feature highly abstracted imagery inspired by his interest in medieval art, decorative arts, and design. In these works, his use of metal foils adds a dazzling jeweled effect to his compositions.

Born in Cleveland, Magden enrolled at the Cleveland Institute of Art in 1952, majoring in crafts and art education. He was initially interested in ceramics which he studied with the renowned artist Toshiko Takaezu. He also studied basic design with Kenneth Bates and soon changed his primary focus to enameling. Ceramics and metalwork continued to attract him as he produced and exhibited work in both media throughout his early career. Magden also received a doctorate in art history from Case Western Reserve University. As an undergraduate, he was drawn to medieval imagery, especially the sculpture on the facades of Gothic cathedrals, and he studied the Cleveland Museum of Art's rich collection of medieval enamels.

Magden also took a class at the institute taught by the enamelist Charles Bartley Jeffery. Jeffery, a nationally recognized artist best known for his ecclesiastical enamels, instilled in the young artist a love of cloisonné enameling and reinforced his use of medieval imagery. A year after his graduation from the institute in 1956, Magden began exhibiting his work. In 1958 he submitted three enamel plaques to the Butler Institute of American Art's juried Ohio Ceramic and Sculpture Show. He won a purchase award, and his work *The Royals* was added to the museum's collection. He exhibited another ten times at the Butler, and three more of his enamels were added to its permanent collection. He also regularly exhibited at the Cleveland Museum of Art's May Show between 1956 and 1967, and in 1965 one of his enamels was acquired for their collection. He participated in Ceramic Nationals between 1960 and 1966, and in the Decorative Arts and Ceramics Exhibition in Wichita in 1966. In 1962 his work was selected for inclusion in *Young Americans* at the Museum of Contemporary Crafts.

Over the years, Magden has held teaching positions at several universities. He taught art history and jewelry at Kent State University from 1964 to 1967. He then moved to Northern Illinois University at DeKalb, where he remained for twenty-six years. Magden stopped enameling in the early 1970s. According to the artist, he felt that he had gone as far as he could in the medium and was ready to explore other art forms. Today he is a Professor Emeritus of Media Arts at the University of Tennessee, Knoxville.

Although Magden frequently depicted religious subjects and themes in his work, it's not known whether this plaque depicts the visit of the three kings at Christ's birth or whether they are simply richly garbed royal personages. With its vivid color further augmented by the brilliant *paillons*, small pieces of gold and multicolor foils, this plaque typifies Magden's work of the late 1960s.

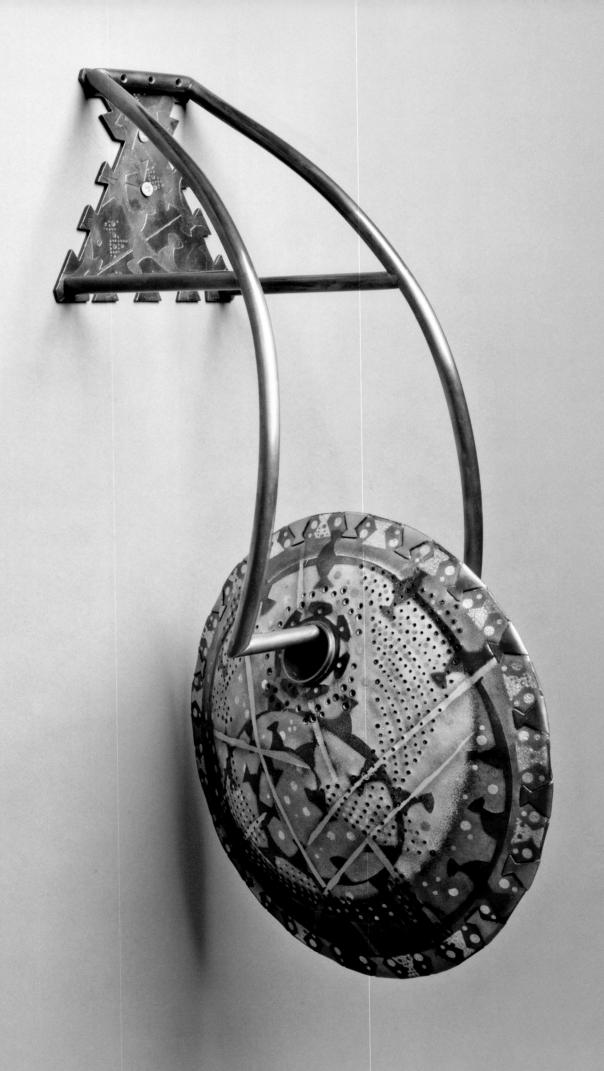

## James Malenda
### Born 1946

*Stations of the Cross IX:*
*Jesus Falls for the Third Time*
2012
Enamel, copper, gold and silver foils
26 x 16 x 16 in.
66 x 40.6 x 40.6 cm
Photography: Hub Willson

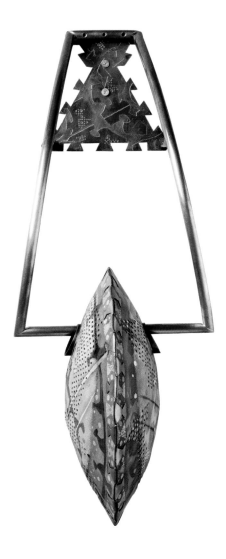

James Malenda's work transcends categories as he explores traditional subject matter using a highly inventive approach to process, materials, and formats. A sculptor and enamelist, Malenda has been creating evocative forms in glass and metal for the past thirty years.

Born in Kingston, Pennsylvania, James Malenda studied at Kent State University in Ohio where he was awarded a BFA in 1971. While there he was introduced to enameling by William Harper, who was one of the emerging young leaders in the contemporary enamels field. "What I remember about Bill was not so much his teaching but the work he would occasionally bring to class. I think I learned a great deal from his 'Dirty Dominoes' and 'Personal Geographies' series. From this experience I knew that I had to make art to be able to teach art." Malenda continued his studies in metals at the State University of New York at New Paltz where he worked with metalsmiths Kurt Matzdorf and Bob Ebendorf. He was awarded his MFA in 1975.

Malenda has been a Professor of Fine Metals at Kutztown University in Pennsylvania since 1987 where enameling is a fundamental part of the curriculum. He has been featured in a number of important exhibitions including a one-person exhibition at the Galerie Schmuck und Objekt Ute Wolff-Brinckmann in Erfurt, Germany, in 2006; the Seventh Enamel Festival in Morez, France, in 2009; and *Re-Make/Re-Model* at the Metal Museum in Memphis in 2009. He has also been included in several of the biennial exhibitions organized by the Enamelist Society. His work is in the collections of the Museum of Arts and Design and the Racine Art Museum in Wisconsin.

In 1993 he began a series of abstract wall-mounted pieces titled the "Stations of the Cross," referring to traditional Catholic liturgy. The series commemorates the passion of Christ through fourteen episodes starting with his condemnation, proceeding to his crucifixion, and culminating in his burial. In exploring this theme, Malenda has found new meaning in a venerable Christian subject. He described his interest in the following terms, "With this series I hope to capture the spirit and passion of these centuries old icons and transcend the dogma of organized religion while communicating the intrinsic and eternal values which the Stations has represented for ages."

Malenda's *Stations of the Cross IX* portrays the moment Christ falls for the third and final time. As the last fall before his crucifixion, it represents the penultimate statement of Christ's humanity and suffering. Of this piece, Malenda has said, "In *Station IX* the color application, formal choices, and shape represent a battered body and confused state of mind which is swiftly spiraling out of control." The weight of the copper disc in Malenda's sculpture, suspended from the wall and supported only by sleek copper tubes, may also serve as a metaphor for the magnitude of Christ's earthly burden. The crenellated edge of the metal brace attaching the piece to the wall—whose profile is repeated in stenciled designs on the surface of the disc and in the metal that joins its two halves—suggests the intensity of Christ's pain. Malenda's *Stations of the Cross IX* is a powerful metaphorical statement regarding human suffering and the transformative nature of faith.

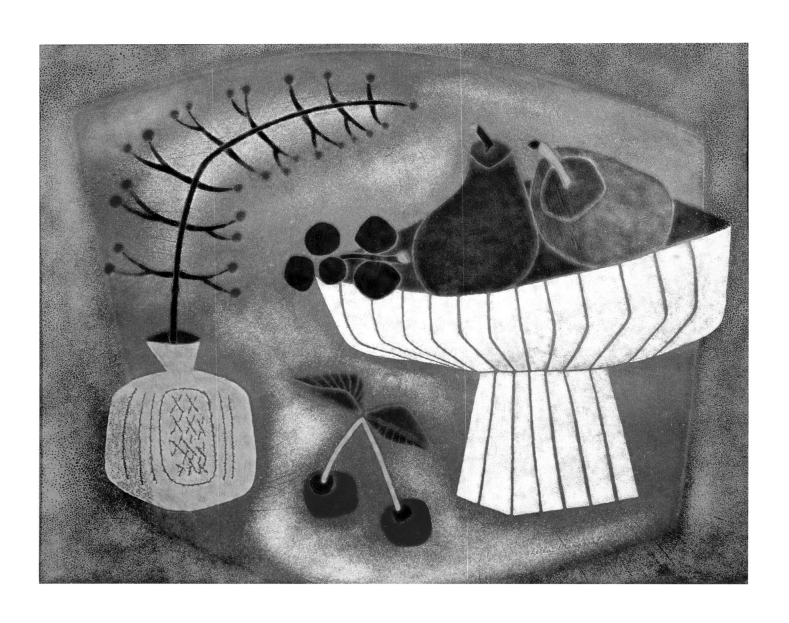

# Zella Eckels Marggraf
## 1910–2008

*Plaque* (*Still Life*)
c. 1950
Enamel on copper
9½ x 12 in.
24.1 x 30.5 cm
Signed on the lower right:
*Zella Marggraf*

Zella Eckels Marggraf was born in Westfield Township, Ohio, a small farming community north of Columbus. The eldest of three children, she moved when she was twenty to Akron where she lived with relatives and worked as a clerk and stenographer for the B. F. Goodrich Company, one of the world's largest tire and rubber manufacturers.

In 1936 she married Edward E. Marggraf, an elementary school teacher who had grown up in Akron. Sharing her husband's commitment to education, she enrolled in classes in 1941 at Cleveland's Case Western Reserve University where she was awarded her BS in teacher training in 1944. At the time, Case Western Reserve students interested in art could complete their studio requirements by enrolling in classes at the Cleveland School of Art, located just down the street from the university. Through this cooperative program, Marggraf took a broad variety of classes from painting, life drawing, and landscape, to design, mechanical drawing, and metals. This training provided solid grounding for her later interest in a wide array of media. After the end of World War II, Marggraf and her husband moved to Los Angeles where she taught at Palms Junior High School in 1953 and at the Los Angeles Valley College from 1960 to 1975.

Marggraf's work was included in numerous art and design exhibitions in the Los Angeles area during the 1950s and 1960s, including *California Design Five* at the Pasadena Museum of Art in 1959 and *California Design Ten* in 1968. She worked with a wide variety of materials, from the textile designs that were featured in *California Design Five*, to glass, ceramics, jewelry, and enamel.

Marggraf's skill as a designer as well as her mastery of the enameling medium are apparent in this intimately viewed and abstract still life. A white ceramic compote with grapes, pear, and persimmon is delicately balanced with a patterned bud vase from which emerges a branch tipped with red berries. In between, on the abstracted tabletop rests a clump of cherries, all set against a blue background. In this piece the artist combines opaque and transparent enamels to form a visually rich but subtle composition. She creates textural variety within the work through contrasting areas of built up enamel—forming the body of the compote, the berries on the bough, and the fruit—and more vaporous areas of pink, blue, and white, created by lightly sifting the powdery enamel onto the surface of the copper plate.

# Mary Ellen McDermott
## 1919–1998

*Smorgasbord*
1952
Enamel on copper
4¼ x 12 in.
10.8 x 30.5 cm
Signed on the lower right: *McDermott*
Paper label on the reverse from the
Twenty-ninth Annual May Show Akron
Art Institute providing the title and other
related information

In a 1955 interview in Cleveland's *Plain Dealer* entitled "Puts Her Art on Enamel Panels," Mary Ellen McDermott succinctly described the appeal of her medium, its versatility, and its sense of luxury, "Enamel is one of the ageless art mediums. It is more permanent than oils and it never fades. You can get effects in enamel you can't get in any other way because it is translucent and it looks precious to begin with." While she explored a variety of subjects, McDermott was most interested in religious themes. In addition to her more secular work, she was awarded numerous ecclesiastical commissions for churches in northeastern Ohio.

Born in Akron, Ohio, Mary Ellen McDermott studied at the Cleveland School of Art, where she was awarded a BFA in 1940. While there she met Bernard McDermott, an industrial design student, whom she married in 1941. Trained in numerous disciplines—including painting, watercolor, fashion illustration, and jewelry design—she produced work in a wide range of media over the course of her long and productive career. After about 1953, however, enameling became her preferred medium.

She taught painting, enameling, jewelry, mosaics, and drawing at the Akron Art Institute from 1949 on, and painting, enameling, and design at the Cleveland Institute of Art from 1961. When Kenneth Bates retired in 1968, she was appointed chairman of the Enamel on Metal Department at the Cleveland Institute of Art. She remained in that role until her retirement in 1986. Artist William Harper, who studied with her in 1965 while Bates was on sabbatical, remembers McDermott as a "free spirit" and a tolerant teacher who encouraged her students to explore the medium's full artistic potential.

In 1954 she submitted a religious-themed work *Apostles* to the Butler Institute of American Art's Ohio Ceramic and Sculpture Show where she won a purchase award and the work was added to the museum's collection. Her approach was somewhat unusual as she presented each of the twelve apostles on a separate panel, enameling them in rich, glowing color. Her first national exposure occurred in 1956, when two of her enamels were included in the Syracuse Museum of Fine Arts Ceramic National. She quickly established a reputation for her unique and masterful approach to enameling. In 1961 she began submitting work to the Cleveland Museum of Art's May Show and went on to present her work there twelve more times (1961–67, 1969, 1972, 1974, 1976, 1977, 1983). Her enamels, which included genre scenes, still lifes, and abstract compositions, were complex in their structure, and she made extensive use of her exceptional skill as a draftsman and designer.

In 1959 she was considered among the most significant contemporary enamelists and three of her works dealing with religious themes, a reliquary, and two wall plaques, *Coronation* and *Incarnation*, were included in the influential exhibition *Enamels* at the Museum of Contemporary Crafts. She was also commissioned to create a work for the show demonstrating the "painted enamel" technique. The work, entitled *Triptych: Resurrection*, was one of very few pieces illustrated in color in the exhibition's catalogue and it was purchased for the museum's collection.

With its complex composition spanning two panels, *Smorgasbord* exemplifies Mary Ellen McDermott's abilities as a designer as well as her mastery of the medium. Influenced in part by the still-life paintings of Cubists Pablo Picasso and Georges Braque, McDermott created a visual feast in enamel depicting all the requisite components of a Swedish smorgasbord, including the fish. Her simulation of textures, particularly wood grain, is especially rich in this work. *Smorgasbord* was exhibited in the Akron Art Institute's Twenty-ninth Annual May Show in 1952.

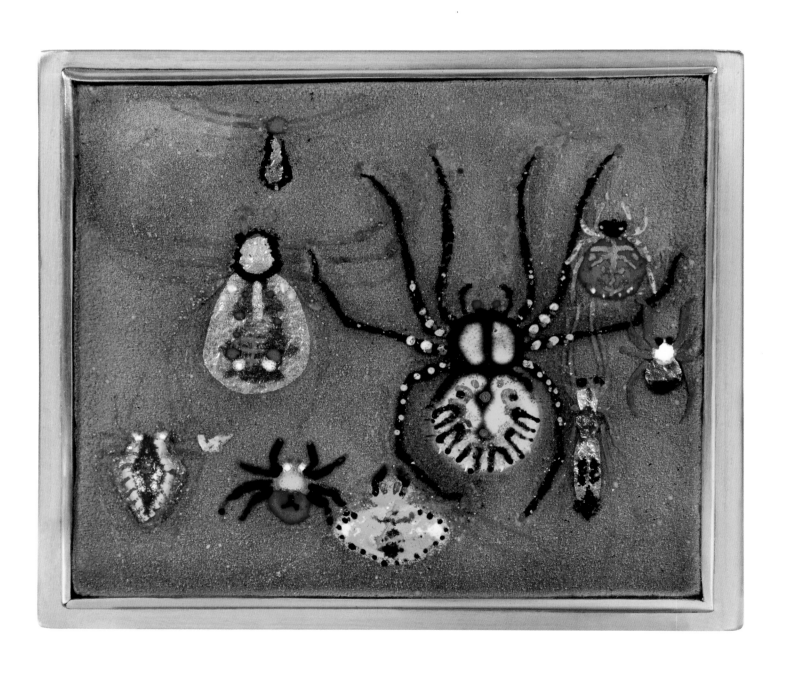

# John Paul Miller
## 1918–2013

*Insect Box*
c. 1950
Enamel on copper, brass
1⁷/₈ x 4 x 3¹/₂ in.
4.6 x 10.2 x 8.9 cm

John Paul Miller's fastidiously crafted jewelry depicts natural creatures both large and small, wearable forms in enamel and gold that are, at once, visually opulent and mildly unsettling. An inventive designer, his repertoire of forms was extensive including brooches, pendants, rings, earrings, cuff links, bracelets, and elaborate necklaces. In his work, which critics have likened to miniature sculpture, Miller portrayed nature's tiniest, often most beautiful, and sometimes most arresting, creatures, including bugs of all sorts, spiders, moths, and occasionally snails and sea creatures such as cephalopods and hermit crabs. Deeply interested in nature—spending summers hiking, camping, and backpacking in the mountains in the western United States—he created representational forms in gold and enamel mediated by his astute design sensibilities.

Born in Huntingdon, Pennsylvania, John Paul Miller was raised in Cleveland. As a teenager he studied enameling with Kenneth Bates in a Saturday morning enameling class at the Cleveland Museum of Art. His mastery of the medium, no doubt, began in those early classes. He enrolled as a student at the Cleveland School of Art in 1936 and was awarded his BA in Industrial Design in 1940. While there he studied basic design with Bates and industrial design with Viktor Schreckengost. He also learned about metalsmithing and jewelry design from Fred Miller, a fellow student who became his lifelong friend and colleague. After serving in the Army during World War II, he taught design and watercolor at the Cleveland School of Art from 1946 to 1983. He also taught in the school's metals department from 1970 until his retirement in 1983. Among his students are some of the leading figures in the contemporary metals and enameling fields including Thomas Gentille, John Marshall, and William Harper.

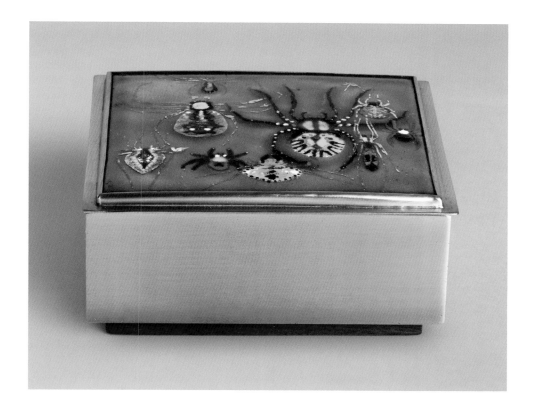

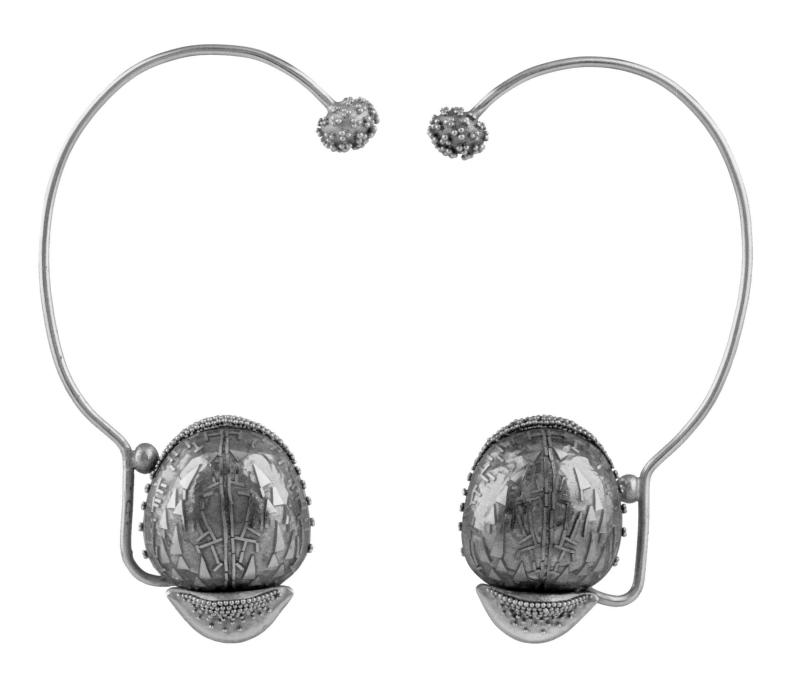

*Pair of Scarab Ear Cuffs*
c. 1960
Enamel on gold
2¼ x 1½ x ½ in.
5.7 x 3.8 x 1.3 cm
Signed on the reverse of each ear cuff:
*JPM 18K*

John Paul Miller is further recognized for having introduced granulation to the postwar studio jewelry field. This ancient technique of affixing small beads of gold or silver to a similarly corresponding substrate dates back to the third century BCE. It remained in use until the Middle Ages. It was forgotten for more than a century until the early 1800s when it was rediscovered during the archaeological expeditions that yielded, among the vast treasures, intricate granulated jewelry and ornaments. Miller reinvigorated the technique in the mid-1940s and employed it as one tool in his vast arsenal, creating exceptionally beautiful forms in gold that dazzle the eye and celebrate nature's tiniest creatures.

Miller was featured in the groundbreaking 1959 exhibition *Enamels* at the Museum of Contemporary Crafts and his work, a pendant titled *Flounder and Fossil*, was reproduced on the cover of the exhibition's catalogue. This work was commissioned by the museum and acquired for its collection. An additional group of nine pendants and earrings were included in the exhibition. He also had a one-person show at that same museum in 1964 and in 1969 he was included in *Objects: USA*. His work is in the Cleveland Museum of Art; the Museum of Fine Arts, Boston; the Renwick Gallery, Smithsonian American Art Museum, Washington, D.C.; and the Museum of Arts and Design.

The artist described his interest in nature in the following terms: "I was always fond of animals, all animals... animals and life in the wild, the natural world, were a really important part of my life. So when I got involved with jewelry... and with granulation, I began to think about things in nature. There was something about their design that suggested the character of granules." Throughout his career Miller produced bold wearable forms that, while extraordinarily beautiful, were not—neither in their scale nor in their subject matter—for the timid or the faint of heart.

His expertise in the enameling medium and love of nature are apparent in his handsome box with an enamel plaque set in its lid. While more pictorial and illustrative than his gold jewelry, the plaque depicts a delightful, mildly menacing array of bugs, beetles, and spiders. These creatures are forerunners to the dazzling three-dimensional forms that Miller would create in his jewelry. According to the artist, he made this box for Kae Dorn Cass, one of his instructors at the Cleveland School of Art.

John Paul Miller's incomparable talents as both a goldsmith and an enamelist are apparent in this stunning pair of ear cuffs. To avoid pinching the ear lobe, these cuffs were designed to be worn around the ear with a scarab-shaped form at the base concealing the ear lobes. Transparent layers of luminescent enamel cover the scarab allowing visual access to the richly varied gold surface below. The lower third of the scarab as well as the gold sphere at the top of the cuff are covered in gold granulation, Miller's signature technique, lending further opulence to this exquisite pair.

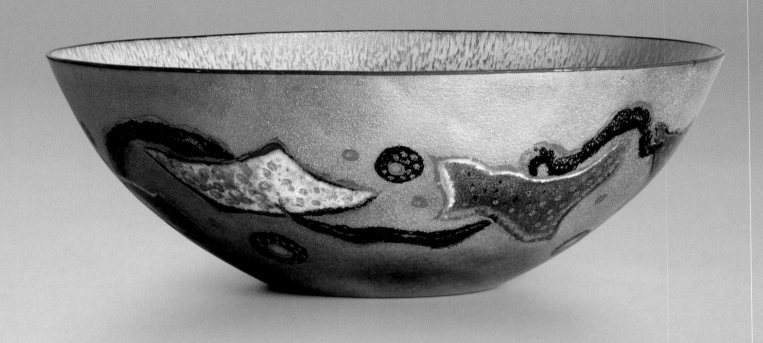

# Josephine Natko
1913–2007

# Michael Natko
1909–1977

*Zephyr Ballet*
c. 1955
Enamel on copper
3¹/₂ x 9⁵/₈ x 9⁵/₈ in.
8.9 x 24.5 x 24.5 cm
Signed on the base:
*Zephyr Ballet Natko*

Both Josephine "Jo" Natko and her husband, Michael, were award-winning Ohio-based enamelists who frequently participated in the Cleveland Museum of Art's May Show. Jo's work—initially her ceramics and later her enamels—was regularly featured in the exhibition between 1944 and 1950 and then again between 1952 and 1955. Michael's work was shown in 1949 and 1950 and between 1952 and 1955. Both Jo and Michael won honorable mentions, prizes, or special awards in these popular annual exhibitions.

Jo and Michael Natko were childhood sweethearts. Born in Ohio, they grew up as neighbors and were married in 1933, shortly after Jo graduated from high school. About that time they went on a fateful cruise in the Caribbean with several other young couples. When their sailboat began to take on water, they were stranded on the island of St. John in the U. S. Virgin Islands. To earn a living, Jo painted watercolors of the local scenery and Michael made seashell frames for Jo's compositions. At the start of World War II, they returned to Cleveland and Jo enrolled as a scholarship student at the Cleveland School of Art. She graduated in 1946. Although Michael worked in a defense plant during the war years, Jo shared what she learned every day with him as they began to embark on their career in enameling together.

The work included in the annual May Shows was always produced and signed separately by either Jo or Michael Natko. However, after 1954 they frequently collaborated. As an article published that year in the *Cleveland Press* stated, "It took two embattled years, they say, before they perfected the routine they now follow. They collaborate on every piece they do. Today their design has a smoothness making it hard to believe it's not the work of just one person." Another article from the period described their collaborative process in greater detail. "Michael starts off with a sheet of copper on which he draws the shape of the design. He makes the bowls by spinning them on a lathe which gives more fluency of form, he feels, than buying a stock shape.... He then puts on the background color which he fires. Then Jo takes over on the design using a brush or dry method of enameling or a combination of both... She is inspired by things around her—grasses and weeds in the fields or fruit from the trees in the back yard."

In addition to the Cleveland Museum of Art's May Show, Jo and Michael Natko's work was juried into exhibitions in Syracuse and at the Butler. It was also included in the 1950 exhibition *History of Enamels* in Pittsburgh. Their work is in the collection of the Cleveland Museum of Art and the Everson Museum of Art.

Of the six Natko pieces in the Enamel Arts Foundation collection, two are signed *Jo Natko* and four are signed simply *Natko*, suggesting that they were produced as a collaboration between husband and wife. With the single word *Natko* on its base, *Zephyr Ballet* was presumably made jointly by the two artists, with Michael spinning the bowl to the desired shape and Jo decorating it. The swirling abstract forms that float across the exterior of the vessel suggest simultaneously the passage of fleeting clouds and the rhythmic lines of dance.

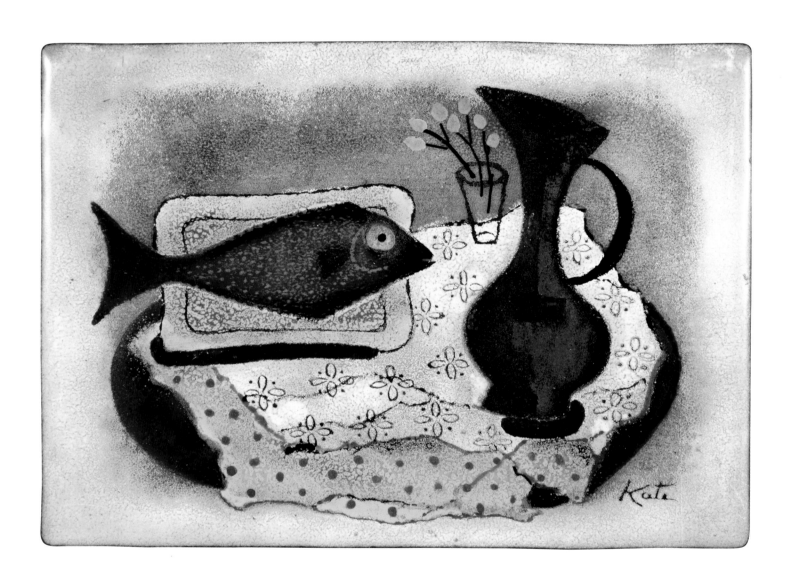

# Kate Neufeld

1905–2004

*Plaque* (*Still Life*)
c. 1950
Enamel on copper
5½ x 7½ in.
14 x 19.1 cm
Signed on the lower right: *Kate*

Kate Neufeld is best known for her powerfully expressive enamels depicting a variety of subjects ranging from historic, religious, and mythological scenes to still life and genre. She also portrayed animals and birds in brilliant colors reminiscent of the folk art she remembered from her childhood. Her work was typically executed in the Limoges technique, the painterly approach to enameling. Neufeld also often designed inventive frames and mounts in which to present her work.

Neufeld was born in southern Russia. The daughter of an affluent industrialist of German descent, she was raised in Waldheim, a Mennonite community in the Ukraine. After her father was executed by the Red Army in 1920, her mother remarried Jacob H. Janzen, a prominent Mennonite bishop. The family fled to Canada in 1924, settling in Waterloo, Ontario. In 1935 Neufeld followed her brother, the painter and graphic artist Woldemar Heinrich Neufeld, to Ohio to study at the Cleveland School of Art. While there she mastered the art of enameling through her studies with Kenneth Bates. After studying in Cleveland, Neufeld moved to New York and subsequently to New Milford, Connecticut, in 1949. Never married, Neufeld lived with her brother and his family until her death at ninety-nine in 2004.

After she left Cleveland, Neufeld made boxes for Rena Rosenthal whose New York gallery specialized in German and Austrian contemporary crafts. Rosenthal supported the work of European émigrés in the United States and frequently commissioned various artists, including Karl Drerup, Mizi Otten, and Ruth Raemisch, to produce work that she sold in her gallery on Madison Avenue. Neufeld often collaborated with fellow artist Frances Felten, creating enamel plaques that could be set in Felten's metal boxes. Neufeld also participated in several national juried exhibitions including the Decorative Arts and Ceramics Exhibition in Wichita. In 1958 her work was shown at the New Britain Art Museum in Connecticut in a two-person exhibition with her brother. At the 1964 World's Fair in New York, she displayed three of her enamels in the Vatican Pavilion. In 2011 her prints, paintings, textiles, and enamels were featured in a one-person exhibition, *A Mennonite Discovers Her Artistic Voice*, at the Gunn Memorial Library in Washington, Connecticut.

The subject of the still life, undoubtedly influenced by the Cubist compositions of Pablo Picasso, Georges Braque, and Juan Gris, was very popular in American art in the late 1940s and early 1950s. Two other examples in enamel, one by Marggraf and the other by the Woolleys, are included here. In all three, the arrangements are spare and include only a small number of objects discretely arranged on a tabletop. Neufeld's plaque depicts a fish on a platter, a dark green pitcher, and a clear vase in the distance with blue blossoms. These objects sit on a clearly delineated round wooden table covered by a white drape with blue flowers and a brilliant chartreuse tablecloth. Adroitly composed, Neufeld's panel is simple in its structure yet powerful in its juxtaposition of vividly contrasting colors and values.

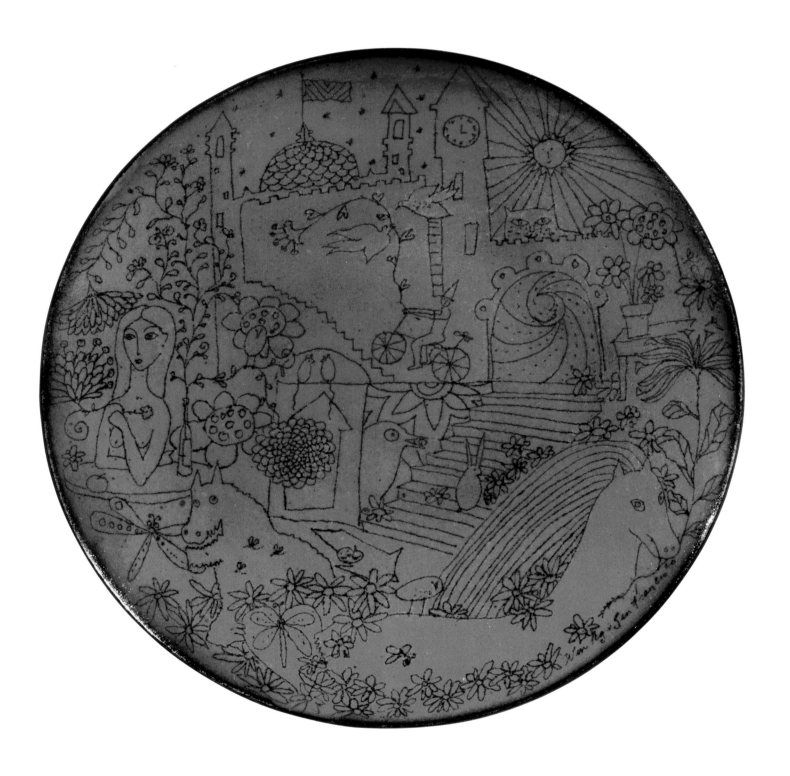

# Win Ng

## 1936–1991

*Bowl*
c. 1965
Enamel on copper
1¼ x 10¾ x 10¾ in.
3.2 x 27.3 x 27.3 cm
Signed on the lower right:
*Win Ng San Francisco*

In 1960 critic Yoshiko Uchida described Win Ng in the pages of *Craft Horizons* as, "one of the most versatile young craftsmen in the San Francisco area. A veritable dynamo of creative energy, he has successfully turned his hand to clay forms, enamels, metals, watercolors, oils, collages, and fabric design, having at one time exhibited or won prizes in most of these media."

The second son of Chinese immigrants Fook On Ng and Kow Yuan Ng, Winfred "Win" Ng was born in San Francisco. While attending junior high school between 1948 and 1950, he worked as a "clean up boy" in the studio of the enamelist Jade Snow Wong. It was there that he developed his lifelong passion for ceramics and enameling. After completing high school in 1954, he was drafted into the U.S. Army and served for two years in France. Upon completing his tour of duty in 1956, he returned to San Francisco and enrolled in classes at San Francisco City College and San Francisco State University. In 1958 he studied ceramics at the California School of Fine Arts, where he was awarded his BFA in 1959. Later that year he pursued graduate studies in ceramics at Mills College in Oakland.

Ng received national attention for his work at a remarkably early age. In 1957 when he was only twenty-one, his enamel bowl with a fish motif was accepted for the prestigious Decorative Arts and Ceramics Exhibition in Wichita. One of the jurors that year was the ceramist Antonio Prieto, with whom Ng later studied at Mills. Undoubtedly Prieto recognized great talent in the work of the promising young artist. Ng subsequently entered two enamels in the 1958 exhibition in Wichita and two examples of his ceramic sculpture in 1959. He also submitted ceramic sculpture to the Wichita in 1961 and 1962. He received further national attention in 1961, when he was awarded a purchase prize for his ceramic sculpture in the Twenty-first Ceramic National at the Syracuse Museum of Fine Arts.

In 1959 Ng and his life partner, Spaulding Taylor, started a design business that eventually became Taylor and Ng, a retail shop specializing in well-designed decorative arts and crafts. In the mid-1960s Ng developed and marketed a body of work called Connoisseur's Collection and Sampler's Collection, which included items of various colors, sizes, and prices. Described as "completely hand crafted and individually formed," these collections were sold at high-end department stores throughout the country. The pieces are signed in English and Chinese scripts, and inscribed with a numbering system like that used by his mentor Jade Snow Wong. A letter of the alphabet designated the shape and size, while a series of numbers represented the glaze.

The enamels Ng produced in his studio in the late 1950s and early 1960s are unlike his more commercial collections and do not normally bear the numbers. For each of these pieces he used a unique approach to form. Some, like this humorous bowl made about 1965, employ a sgraffito drawing technique, while others have richly built-up, decorative surfaces. In this whimsical composition, a gigantic cat, a crazed dog, and an assortment of creatures both real and imagined, cavort in a lush landscape while a nude female figure oversees the realm. This work reflects the playful side of Ng's fertile imagination.

# Peter Ostuni
## 1908–1992

*Plaque* (*Indian Warriors*)
c. 1955
Enamel on copper, sand
21 x 45 in.
53.3 x 114.3 cm
Signed on the reverse:
*Peter Ostuni*

Born in New York, Peter Ostuni studied painting at the Cooper Union School of Art from 1932 to 1936. After graduating, he taught children's classes at Westchester County Community College and in 1939 he assisted the head of the painting department at the Cooper Union.

In 1951 Ostuni received a commission to create murals for the first-class cocktail lounge on the luxury liner *S.S. United States*. Referred to as the Navajo Cocktail Lounge, it was located between the ballroom and a first-class foyer and featured four portholes overlooking the promenade deck. The panels Ostuni created formed a frieze fifty feet long around the perimeter of the curvilinear room and depicted his interpretations of Native American sacred symbols, most prominently the *Yei* that represents a deity who controls the elements. For this commission, the artist pursued an approach inspired by that used by the Navajos to create their sand paintings. Using traditional imagery, which he abstracted and formalized, Ostuni applied powdered enamel, in various textures and colors, by sifting it through his fingers onto flat cutout copper forms. After these design elements were fired, they were applied to a sand-coated aluminum panel and mounted on the wall of the cocktail lounge. These murals were published in the November 1952 issue of *Craft Horizons*, garnering critical acclaim for the artist and his inventive approach to enameling.

Ostuni had previously created enamel panels in a more traditional manner. However his innovative approach to the *S.S. United States* commission with the heightened texture and robust colors of the enamels, as well as the great scale of the murals, brought him prominence in the field. He went on to create several large-scale murals using various techniques for companies such as Prudential Life Insurance, Newark, New Jersey; U.S. National Bank, Denver, Colorado; and the Tudor Bar of the Palace Hotel, San Francisco, among others.

In 1959 his work was featured in *Enamels*, the exhibition organized by the Museum of Contemporary Crafts, and in 1961 he was featured in the *Imperial Exposition 1961*, also organized by that museum. Considered an important leader in enameling, he represented the field at several American Craft Council conferences.

The plaque of Indian warriors was created in the same technique Ostuni had used on the set of murals for the *S.S. United States*, but on a smaller scale. This piece, made about 1955, underscores Ostuni's fascination with the subject and his continuing interest in this inventive approach to enameling. As he did in the mural, Ostuni attempted to emulate Native American sand paintings by using related techniques. First he cut the copper shapes of the Indian warriors on horses, two with bows and arrows belonging to one tribe and the third, with a spear, from an opposing tribe. He clearly designated each warrior by assigning a dominant color: red, blue, and brown, while leaving the skin features in raw copper. Resorting to the same method used for the Navajo Cocktail Lounge, he sprinkled the enamel onto the copper forms, applying greater control in most areas to achieve clearly delineated color blocks. Once fired, the forms were placed on the prepared panel. With its overlapping figures of horses and riders, this composition is more complex, though smaller and less grand, than any of those created for the *S.S. United States*. This panel represents a rare example of Ostuni's finest and most inventive work.

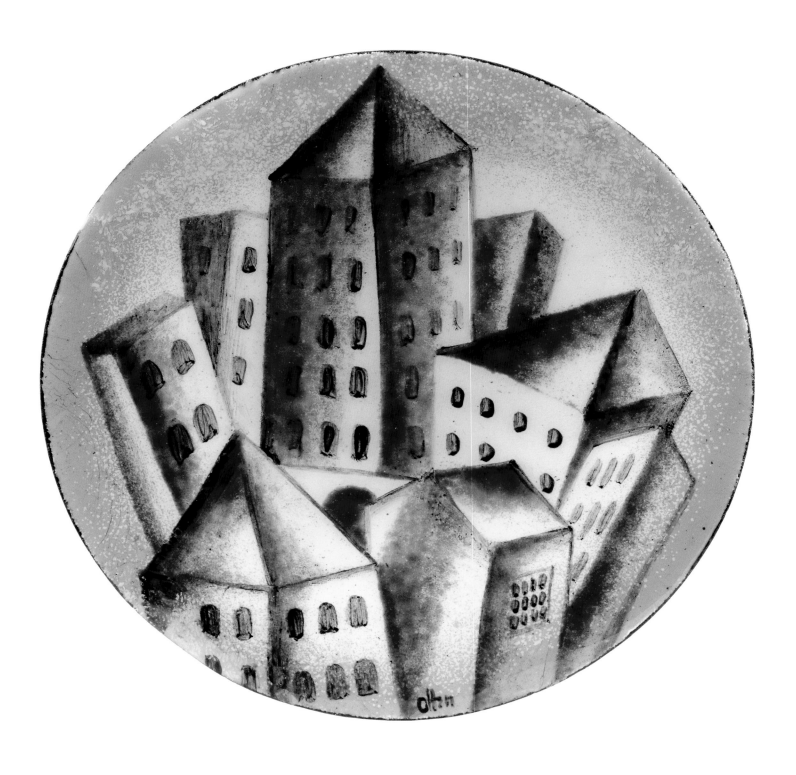

# Mizi Otten
## 1884–1955

*Plate*
c. 1945
Enamel on copper
1 x 5³/₄ x 5³/₄ in.
2.5 x 14.6 x 14.6 cm
Signed on the lower center: *Otten*

Born in Vienna, Mizi Otten knew at an early age that she wanted to be an artist. Despite the objections of her parents, who thought it an unbecoming profession for their daughter, she attended art school, studying painting and decorative arts in Vienna and Munich. After graduation she became a member of the Wiener Werkstätte, the prominent Viennese design group. As was typical of every member of the group, Otten excelled at a variety of crafts, including printmaking, textile and wallpaper design, wood and ivory carving, and embroidery. While working at the Wiener Werkstätte she met several enamelists, including Josef Hoffmann. Otten quickly became fascinated with the medium. However, as she recalled, it was, at the time, among the most jealously guarded of all the crafts. One evening, after everyone had gone home, she broke into the enamel workshop, helped herself to a few materials, and started to experiment with the kiln. She was soon creating enamels and found a ready market for them.

By 1925 her work was considered of such exceptional quality that it was included in the Austrian pavilion at the International Exposition in Paris. She won the silver medal for enameling. Among the many attendees at this prestigious and historically significant exposition was Rena Rosenthal, an important American dealer whose New York gallery specialized in contemporary German and Austrian decorative arts. She and several other dealers purchased Otten's work and began selling it in the United States. Twelve years later in 1937 Otten again won the silver medal for enamels at the International Exposition in Paris. In 1938, with the threat of war looming, she immigrated to the United States. By the time she arrived in New York, her work was already well known in this country.

The year 1939 brought the artist exposure throughout the United States. Five enamels were juried into the Eighth National Ceramic Exhibition in Syracuse, nine works were shown in the *Exhibition of Decorative Arts* in Denver, and five works were included in the prestigious *Golden Gate International Exposition* in San Francisco. By 1940 Otten was firmly established as a prominent enamel artist in the United States. She went on to participate in three more of the Syracuse Ceramic Nationals—in 1940, 1941, and 1948. Her work was shown at the Metropolitan Museum of Art in New York in the early 1940s. In February 1944 a profile of Otten was published in *Craft Horizons*. In this article the artist discussed how her style in enameling had changed since coming to the United States. She stated that Americans preferred a more naturalistic approach as compared to the abstract style she had developed in Vienna. She was happy to embrace this new direction and found tremendous satisfaction in her work. In 1950 she and Kathe Berl co-authored and self-published a manual on enameling technique entitled *The Art of Enameling; or, Enameling Can Be Fun*, which was one of the earliest how-to books to appear in this country.

With its image of monumental skyscrapers clustered in a dense urban setting—an identifiably American subject that must have appealed to the artist when she first arrived in New York—this plate is representative of Otten's finest work. Its element of fantasy and its vibrant pink palette harken back to the artist's early training in the visually rich Wiener Werkstätte style.

# James A. Parker
## 1914–1987

*Plaque*
c. 1960
Enamel on copper, wood
Overall:
12½ x 12½ x 1½ in.
31.8 x 31.8 x 3.8 cm

An inventive jeweler as well as a highly skilled enamelist, James A. Parker earned his living throughout most of his professional life teaching English at San Diego County's Grossmont High School. From the 1950s to the early 1970s, he was also a widely respected member of the Allied Craftsmen of San Diego, one of Southern California's most prestigious organizations. An outgrowth of the city's Allied Artists' Council, this invitational group supported the field by staging spring exhibitions at San Diego's Fine Arts Gallery (now the San Diego Museum of Art) and holiday sales in Balboa Park's Spanish Village.

In addition to receiving local accolades throughout his career, Parker began to develop in the early 1950s a national reputation for the originality of his work. In 1956 he was included in *Craftsmanship in a Changing World*, the inaugural exhibition at the Museum of Contemporary Crafts, and in 1968 he was featured in the Pasadena Art Museum's *California Design Ten*.

According to a 1951 article in *San Diego Magazine*, Parker first encountered modernist jewelry in London in 1939 when he purchased a Georg Jensen ring. Inspired to make his own jewelry by this example of Scandinavian modern design, Parker produced what decorative arts scholar Toni Greenbaum has described as, "among the most eccentric pieces to emerge from the modernist jewelry movement." Greenbaum also suggests that Parker may have been influenced by the work of the northern California studio jeweler Margaret De Patta, whose avant-garde forms were inspired by the European modernist sculptor László Moholy-Nagy with whom she studied in Chicago.

Parker was first introduced to a modernist approach to enameling through his friendship with Jackson and Ellamarie Woolley, fellow members of San Diego's Allied Craftsmen. In his rings, cufflinks, tie bars, and brooches of the 1950s and early 1960s, Parker occasionally used enamel as well as semi-precious stones to enliven his spare geometric designs. However, by the late 1960s and 1970s he had begun to explore enameling as an independent medium, producing a series of wall-mounted plaques using enamel colors and free-form metal shapes to create bold abstract compositions in glass and metal.

In addition to being an inventive jeweler and enamelist, James Parker was a hugely enthusiastic collector of work—particularly enamels—by his San Diego friends and colleagues. Shortly after he passed away, his wife donated his collection to the Wichita Center for the Arts where they now form one of the largest and most significant collections of postwar enamels in this country.

In much of his work—both his jewelry and his wall-mounted panels—Parker explored a dynamic relationship between positive and negative space, using boldly assertive geometric or curvilinear forms and vibrant color as a counterpoint to a darker receding space. In his untitled plaque of about 1960, Parker juxtaposes areas of opaque and transparent enamel to create overlapping geometric shapes including circles, semi-circles, and squares. These forms, silhouetted against each other, float freely in an expansive open frame. The dynamic, constantly shifting figure-ground relationship seen in this composition is characteristic of work Parker produced in the late 1960s and early 1970s. The plaque is in a frame, created posthumously, like those Parker typically used for similar panels.

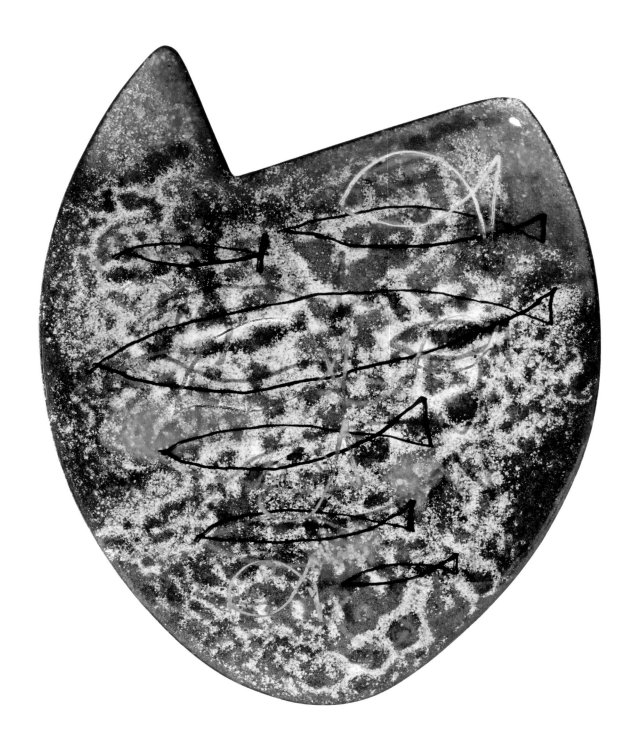

# James Edward Peck
## 1907–2002

*Great Barrier Reef*
1951
Enamel on copper
3¹⁄₈ x 2⁵⁄₈ x ³⁄₈ in.
7.9 x 6.7 x 1 cm
Signed on the reverse:
*Great Barrier Reef JEP 1951*

James Edward "Jimmy" Peck was a member of one of Cleveland's most prominent artistic families, the so-called "painting Pecks." His mother, Edith Hogan Peck, was a painter and his sister-in-law Miriam Smith Peck (also included here), who was in his graduating class at the Cleveland School of Art, had wide-ranging talents as a painter, watercolorist, jeweler, and enamelist. In 1946 all three artists were featured in an exhibition at Cleveland's Ten-Thirty Gallery. James Peck was represented by paintings with titles such as *Steel by the River, Caution: Narrow Bridge*, and *R.R. Crossing, Whitfield, N.H.*

Peck studied painting and design at the Cleveland School of Art from 1929 to 1933 and pursued a career in commercial illustration. In 1946, after three years of service in the Army Air Force during World War II, he was awarded a Guggenheim Fellowship and traveled across the country painting rural landscapes reflecting his interest in trains and railroading.

James Peck's work was included in numerous May Shows at the Cleveland Museum of Art and in the Decorative Arts and Ceramics Exhibition at the Wichita Art Association in 1952. He was also included in the *Twenty-second International Exhibition of Water Colors* at the Art Institute of Chicago in 1943 and in exhibitions at the Pennsylvania Academy of the Fine Arts and the Dayton Art Institute. His work is now in the collection of the Butler Institute of American Art in Youngstown, Ohio.

Peck took up enameling about 1952 after visiting his sister-in-law in Cleveland where he was impressed by her work in this medium. When he returned to his home in Seattle, where he had moved in 1947, he set up an enameling kiln in his studio and began to produce beautifully designed brooches and pendants in a distinctly modern style as well as small plaques emulating current painting styles such as Abstract Expressionism. According to a contemporary review of his work, Peck was "one of the few enamelists in the entire country to combine drawn lines with color masses to decorate enameled jewelry and other objects." Several of his enamels—both sculpture and jewelry—were included in the 1959 exhibition *Enamels* at the Museum of Contemporary Crafts.

*Great Barrier Reef* reflects Peck's love of abstract form, vibrant color, expressive line, and inventive application of enamel. In this richly complex combination of linear and painterly elements, Peck has captured the fleeting qualities of light on water and the darting motions of fish, highlighted in gold enamel, as they move about in this remote underwater world.

# Miriam Peck
## 1910–1984

*Brooch*
c. 1950
Enamel on silver
2 x 2 x ³/₈ in.
5.1 x 5.1 x 1 cm
Signed on the reverse:
*Miriam Peck*

Miriam Smith Peck was born in Cleveland, Ohio. After studying for two years at Oberlin College, she transferred to the Cleveland School of Art where she was awarded a BA in 1933. She received her MA from Case Western Reserve University in Cleveland and taught for many years in the public school system in Akron and Bedford, Ohio.

Trained as a painter as well as an enamelist, she explored a broad range of media throughout her career from jewelry and metalwork, to embroidery, watercolor, pastel, and collage. However, Peck is best known for her enamel jewelry. According to art jewelry specialist Marbeth Schon, Peck created nearly 1,000 pieces of enamel on fine silver jewelry each year, using pre-cut circles, squares, and rectangles. She was regularly included in the Cleveland Museum of Art's May Shows between 1937 and 1952 where she received fifteen awards in watercolor, enamels, and jewelry. Her work was also featured in the Decorative Arts and Ceramics Exhibition at the Wichita Art Association in 1951 and in annual exhibitions at the Butler Institute of American Art. Peck's work is now in the collections of the Cleveland Museum of Art and the Butler Institute of American Art.

Through her marriage to Robert T. Peck, Miriam joined one of Cleveland's most prominent artistic families, the so-called "painting Pecks." Both her mother-in-law, Edith Hogan Peck, and her brother-in-law, James Edward "Jimmy" Peck, were distinguished artists. James had also studied at the Cleveland School of Art, graduating in her same year, and all three were frequently awarded prizes at the Cleveland Museum of Art's annual May Show. The three Pecks exhibited together at Cleveland's Ten-Thirty Gallery in 1946. Miriam Peck, who lived with her husband in New Jersey, exhibited her work nationwide throughout her career. At the time of her death in 1984, when she had moved back to Ohio, she was preparing for an invitational show of collages in Euclid, Ohio.

Miriam Peck's paintings and watercolors frequently depict landscapes and interior scenes, while her enamels, particularly her jewelry, are highly abstract. In this brooch of about 1950, Peck deftly combines opposing elements: bold lines describing sharp, angular shapes versus rounded sculptural forms; silver *paillons* applied in a controlled, regular pattern versus a more gestural application of dense enamel color; the lucidity of transparent enamel versus the mysterious impenetrability of opaque color. Miriam Peck's modest brooch represents an elegant exercise in abstract form and composition.

# Juan Esteban Perez
## Born 1939

*Burning Sunset*
1970
Enamel on copper, silver wire
9 x 9 in.
22.9 x 22.9 cm
Signed on the lower right:
*j esteban 70*
Signed on the reverse:
*EST 119 "Burning Sunset"*
*(9 x 9–dusting–silver cloisonné–*
*drawing) j. esteban 70*

Working within the framework of a fundamentally abstract vocabulary, Esteban Perez has created luminous, brilliantly colored compositions in enamel for the past forty years. He uses a combination of opaque and transparent materials to make work ranging from intimately scaled, wearable forms such as brooches and pendants, to large wall-mounted panels. Some of the artist's early pieces reflect his admiration for the whimsical fantasies of Paul Klee and his later panels reflect his love of Jackson Pollock and Mark Rothko. However, most of his enamels simply revel in the opulent beauty of color and light. While he organizes his work like a painter applying oil to canvas, he is keenly aware of his medium's unique properties as he creates compositions with a layered depth and visual allure only possible in enamel.

Born in Santiago, Chile, in 1939, Perez was educated at the University of Chile's School of Applied Arts. He trained in multiple disciplines including painting and design and was awarded second prize in painting at the *Art and Technique* exhibition in Santiago in 1963. He studied enameling on his own and developed a highly experimental approach to materials. After completing his studies in Chile, he moved to New York in 1965 and taught enameling workshops at the Riverside Church from 1969 to 1971. In 1968 he was featured in a group exhibition at the Metarco Galleries, one of the few commercial venues where the public could see and purchase contemporary enamels. He was given a solo show there in 1975. His work has been presented in numerous exhibitions in the United States and South America.

His work was included in the National Ceramic Exhibition at the Everson Museum of Art in Syracuse in 1970 where it received the prestigious purchase award. In 1980 he was commissioned to produce a large, multi-panel, enamel-on-steel mural called *Constructivist Space Drawing* for the Port Authority Bus Terminal in New York. He completed and installed the piece in 1982. He is represented in several museum collections in the United States and Chile.

In its combination of brilliant color, arranged in a dazzling patchwork pattern, and rich textural variety, *Burning Sunset* is a handsome example of Perez's early compositions. In this luminous panel he used silver wire bent into open rectilinear shapes as a form of surface decoration rather than as a means of containing cells of color. This riffing on the traditional cloisonné technique reflects the artist's inventive approach to enameling.

# Sarah Perkins
## Born 1953

*Caterpillar Stylus*
1998
Enamel on silver, gold,
onyx, and pearl
5¹/₂ x ⁷/₈ x ⁵/₈ in.
14 x 2.1 x 1.6 cm

Sarah Perkins is among the leading figures in the contemporary enamels field. Her hollowware forms, decorated with vibrant color and alluring surface detail, reflect her dual interest in metalwork and fine enameling. Her pieces are at once superbly crafted and richly evocative. Perkins creates vessels—cups, bowls, teapots, vases, and containers—which, while they explore the concepts of use and ritual, defy their functional foundations to rise to the level of intimately scaled abstract sculpture. She also creates jewelry that reveals her mastery of both metalsmithing and enameling techniques. These luscious wearable forms, some small and sedate, others large and commanding, often allude to natural phenomena as Perkins endows her work with complex metaphors and rich, layered content.

Born in Ohio, Sarah Perkins received her BA in 1979 from San Diego State University where she studied jewelry with Arline Fisch and metalsmithing with Helen Shirk. She continued her studies with Richard Mawdsley and L. Brent Kington at Southern Illinois University Carbondale where she was awarded her MFA in 1992. Since 1994 she has taught at Missouri State University, where she is Professor of Art and Design, and has conducted workshops throughout the United States and overseas. Many of the prominent young artists working in the enamels field today have been her students.

Her work has been widely exhibited and has consistently received awards for its excellence. She not only excels in the quality of her craftsmanship but in the variety and range of forms she creates and in the artistic integrity with which she endows each piece or each group of objects.

Regarding the balance of metal and enamel in her compositions, Perkins has said, "As a maker of hollowware, I use properties of the metal: the plasticity, the permanence and the dimensionality. As an enameler, I use properties of the glass: the preciousness, the texture and the color. In my work these properties function together to make a whole, with the two materials complementing and completing each other."

On the subject of vessels, both open and closed forms, and the metaphorical connotations of each, she has stated, "I explore bowls and ceremonial vessels because I am interested in the social implications and uses of these forms. Subtle differences in shape affect the meaning of a piece dramatically: an open form is generous and a tighter one is more austere and self-sufficient." Finally, concerning the importance of the visible presence of the artist's hand in her work, Perkins has said, "In a world of laser cutters and CAD CAM, I am insistent on the value of the hand. Bowls are slightly asymmetrical, piercings have obvious drill holes and the enamel generally has a non-glossy surface. All these things contribute to the warmth and enticement of the pieces."

Throughout her work, Perkins has been engaged in exploring aspects of the natural world. In *Caterpillar Stylus* she created a rich conversation between forms inspired by nature—in particular the shape and color of the humble caterpillar—and, in her use of silver, gold, and semi-precious stones, the elegant artifice of long-standing jewelry traditions. *Caterpillar Stylus* is based on a tomato hornworm, the second stage in the life cycle of a moth. Perkins finds exceptional beauty in this creature considered a pest by most gardeners as it feeds on their vegetables including tomatoes, eggplants, and potatoes. She captures the various greens of the worm's body as well as its distinctive markings. The wires hanging below the black onyx setting represent the chewing propensities of the creature. As Perkins stated, "This piece addresses the idea of natural organisms' requirement to be beautiful and enticing but also able to defend itself, thus the stinger."

*Seeded Container*
2003
Enamel on copper, silver
4½ x 3 x 3 in.
11.4 x 7.6 x 7.6 cm
(opposite)

*Itradan*
2001
Enamel on copper, silver, walnut,
seeds, pearls, and charcoal
4 x 12 x 4 in.
10.2 x 30.5 x 10.2 cm
(below)

In works such as *Itradan*, Perkins investigates the ways in which rituals and social customs are embedded in objects. While she feels that the specifics of those customs often elude us, defying our full comprehension, her pieces explore the mystery of ritual contained in objects. According to the artist, "The cups hold seeds, pearls, and charcoal from a forest fire. The idea of this piece is that I wanted to make an object that was clearly ceremonial in nature but with the details of the ceremony unclear. I am an outsider when it comes to most religious ceremonies but I like the sense of mystery and ritual all the same. It fascinates me that every culture has ceremonies with rituals and objects that belong to them and that we can recognize without understanding it."

Another example that explores humankind's relationship to nature through the metaphor of the ritual vessel, *Seeded Container* of 2003 was intended to hold seeds, the kernels of life, for use in some unknown ceremony. Its voluptuous form and exquisite execution underscore its epic significance. However the tiny opening at the top and the three diminutive feet that support the bulbous body make it an impractical and unstable container. Nonetheless, seeds are suggested on the exterior of the body and particularly on the silver lid that resembles the spiked seeds of an exotic plant. *Seeded Container* reflects the artist's dual interests in fine metalwork and richly colored enamel. The silver lid is enameled in a luscious matte green from which emerge its prominent pointed elements. The upper section of the body contrasts wavy silver cloisonné lines with the brilliant luster of blue enamel. Perkins approaches the lower section in a distinctly different manner, stoning the enamel to a flat, velvety finish that creates a dramatic counterpoint to the brilliant luster of the silver. The feet, shod in silver, continue the dynamic play of glass and metal.

# John Puskas

## 1917–2001

*Plaque* (*Still Life*)
1950
Enamel on copper
12 x 9 in.
30.5 x 22.9 cm
Signed in the lower center:
*J. Puskas 1950*

Born in Cleveland, John Puskas received his BFA from the Cleveland Institute of Art in 1952 after serving in the armed forces from 1943 to 1946. While at the institute, he studied painting with Paul Travis and enameling with Kenneth Bates. In describing his studies with Bates, Puskas observed, "Kenny was my real mentor. He taught me discipline, which I needed most. I have always approached enameling almost as painting, with the same kind of freedom. Kenny always used to say that I had more material on the floor than on the piece I was making."

Between 1949 and 1953—even while he was still a student—Puskas designed and made enamels for Potter and Mellen, a high-end specialty store in Cleveland. He started his own business in the mid-1950s, and his designs were sold throughout the country at department stores, including Marshall Field's in Chicago, Neiman Marcus in Dallas, Gump's in San Francisco, and Higbee's in Cleveland. He served as an art consultant to Case Western Reserve University in Cleveland from 1950 to 1960 and as a staff artist at the educational television station in Cleveland from 1960 to 1970. In the 1960s he taught at Karamu House, a cultural center serving Cleveland's African-American community, and at Cuyahoga Community College from 1972 to 1984. He was an artist in residence for an enamel and metal workshop at the University of Akron in 1976 and served in a similar capacity at Kent State University in 1990–1991, teaching a large-scale enamel workshop.

While he was equally skilled in a broad range of media, enameling was Puskas's preferred medium throughout his long and productive career. He was described in the Cleveland *Plain Dealer* on October 7, 1956, as "owning one of the largest kilns belonging to any independent enamelist" in Cleveland. This enabled him to produce enamels of widely varying scale, from small plates and bowls to large enamel panels.

Reflecting his passion for enamels, as well as his rather dry sense of humor, he remarked in a succinct artist's statement in 1994, when he was seventy-seven years old, "After nearly fifty years of enameling, I suppose I'll just keep on going until they turn off the kiln." Puskas was a gregarious individual who held weekly salons at his home for the Cleveland arts community. He was awarded the Creative Achievement Award by the Enamelist Society in 1999, two years prior to his death.

His work was featured in numerous exhibitions, including the Cleveland May Show (1938, 1940–42, 1950–52, 1954–58, 1966); the Wichita Decorative Arts and Ceramics Exhibition (1951); and the Ceramic National in Syracuse (1951 and 1954). In 1957 his work was singled out by William M. Milliken, director of the Cleveland Museum of Art, for its "bold design and powerful colors," and it was awarded third prize in that year's May Show. Six of his panels and a bowl were included in *Enamels*, the 1959 survey at the Museum of Contemporary Crafts.

Among Puskas's favorite subjects were musical instruments, Cubist-inspired still lifes, interiors, and abstract compositions. In this 1950 plaque, his facility for design is apparent in the complex structure of the still-life composition, boldly defined in dark black outlines, and his interest in color and surface effect are equally present in his rich palette and in the brilliant glaze he used to finish the work.